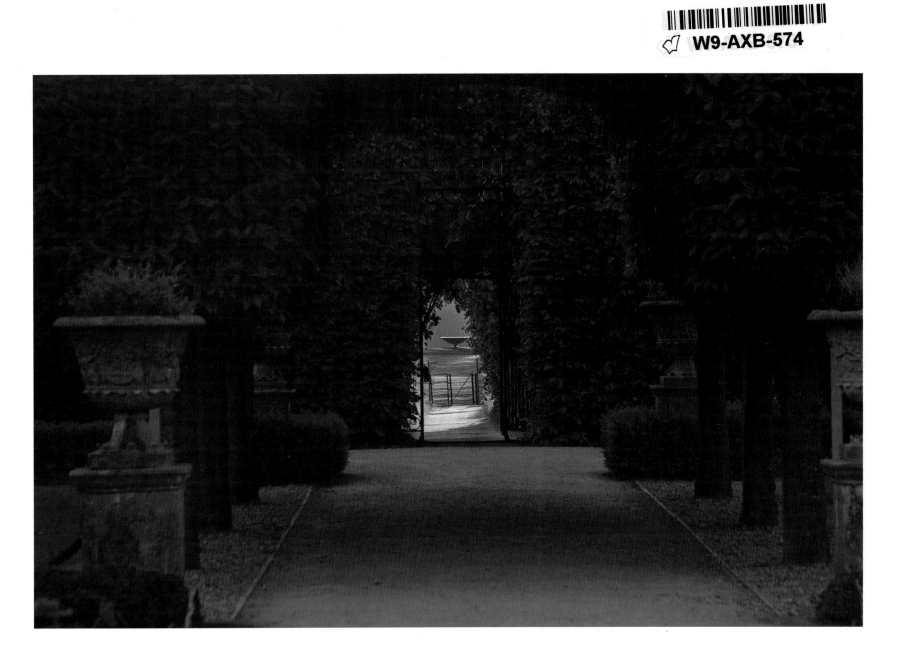

The Art of Flower & Garden Photography

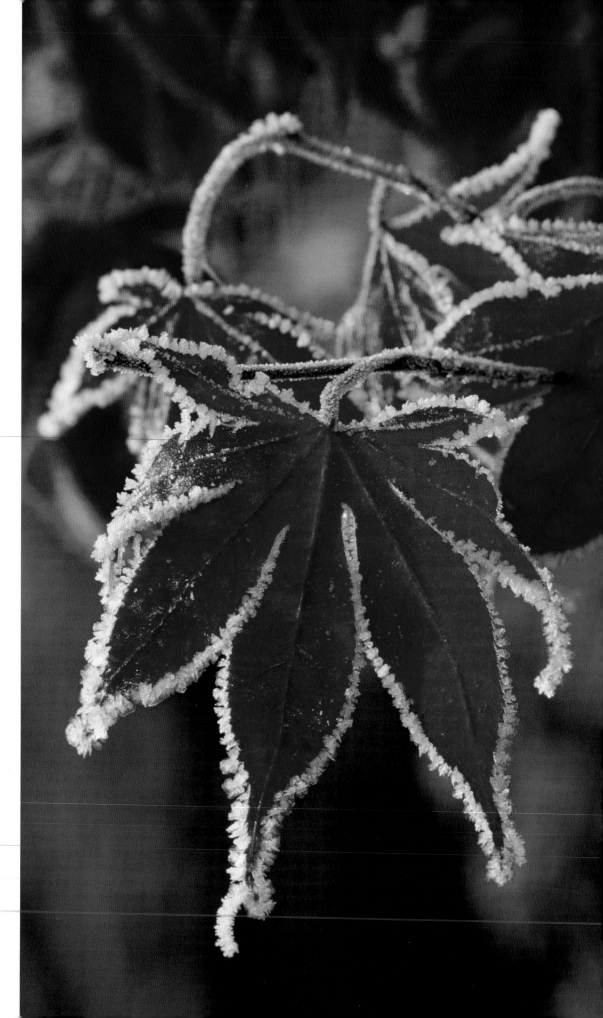

First published 2007 by Argentum, an imprint of
Aurum Press Ltd, 25 Bedford Avenue, London WC1B
3AT in association with the Royal Horticultural
Society.

www.aurumpress. co.uk

The publishers gratefully acknowledge the
assistance provided by Simon Maughan of the Royal
Horticultural Society in preparing this book for
publication.

Photograph of Clive Nichols by Allan Pollock-Morris.

Book design by Eddie Ephraums.

A catalogue record for this book is available from the
British Library.

ISBN-10 1 902538 48 X
ISBN-13 978 1 902538 48 8

Printed in China

Front cover: Lady Farm, Somerset.

Half title page: From within the dark, shadowy formal
garden at Holker Hall, Cumbria, England, I was able to
shoot through an archway to capture the light of the
setting sun as it fell on a slate sundial in the parkland
beyond. Digital image. Canon 1Ds Mark II with 70-
300mm zoom lens. ISO 100 Raw, 4 seconds @ f32.

Frosted leaf of *Acer palmatum* 'Bloodgood'. The
Parsonage, Worcestershire, England. Nikon F90X
with 200mm macro lens. Fuji Velvia ISO 50, 1/30
second @ f5.6.

THE ROYAL HORTICULTURAL SOCIETY

The Art of Flower & Garden Photography

Clive Nichols

ARGENTUM

Contents

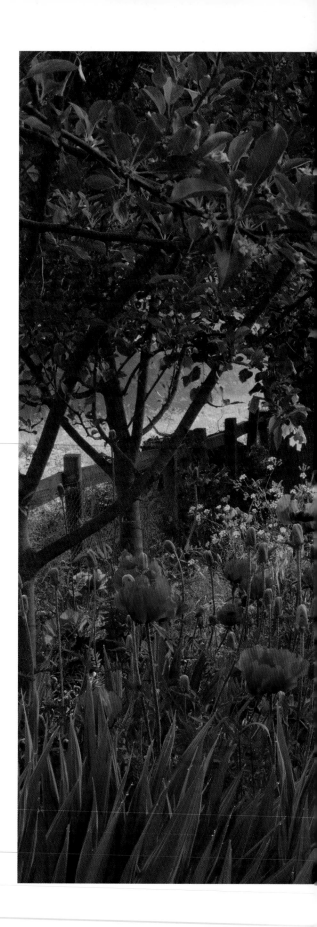

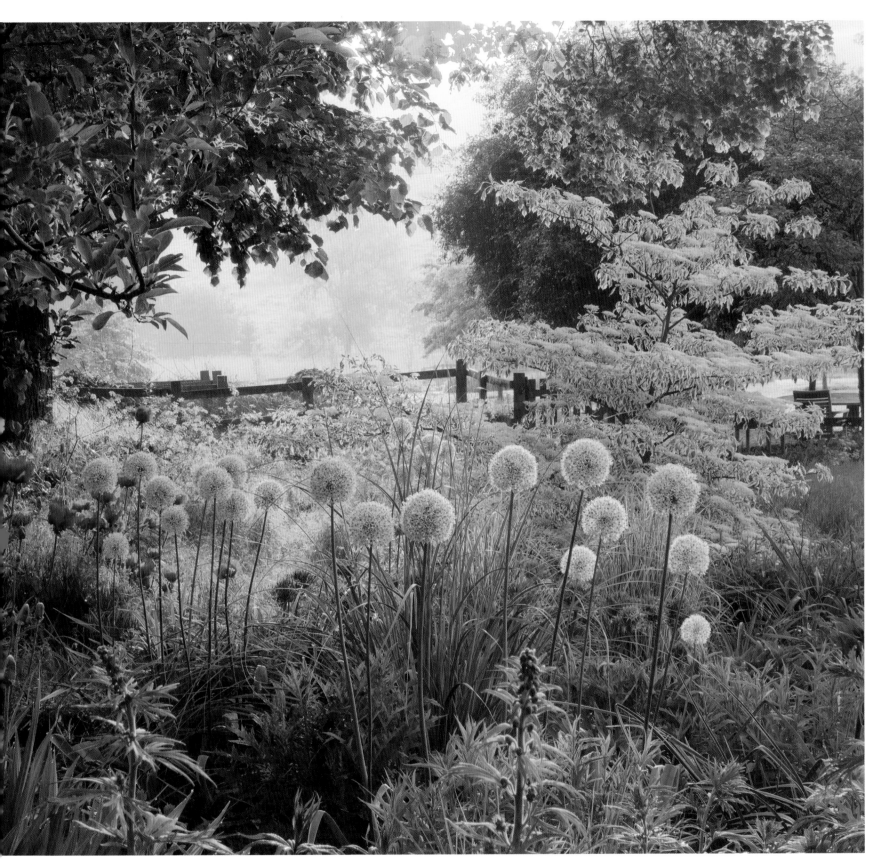

Nothing beats the first light of dawn. I took this shot of backlit alliums and poppies at Pettifers a few moments after dawn. Fortunately the garden is very close to where I live so I didn't have to drive too far to catch this magical moment.

Pettifers Garden, Oxfordshire, England. Digital image. Canon IDs Mark II with 70-300mm zoom lens. ISO 100 Raw, 2 seconds @ f16.

Introduction

For the past fifteen years I have worked as a professional flower and garden photographer, supplying countless magazines, books and calendars with horticultural photographs. During that time I have amassed some 35,000 images from all over the world and I have been lucky enough to spend time in some of the most beautiful places on earth.

My early plant portraits were hard and graphic. Over time they have become softer and more sympathetic to their subjects. Perhaps I understand better now what it is like to be an English aquilegia on a damp, dewy morning in June, or an ancient, snow-dusted tree in the harsh winds of St Petersburg. Certainly I understand the elements that govern my subjects' lives better. Sun, rain, mist, fog and frost, snow and wind, I know, can all be traitors: what you see of them with the naked eye is not always what the camera will reflect. But, now, I also know how to compensate and manipulate so that the people who look at my photographs will share my emotions and perceptions – the romance of roses at dusk, the ethereal light of the sun rising over a lake, the three-dimensional solidity of pyramids of yew.

Composition, colour, light, the three muses of great garden pictures have taught me everything: framing a shot, perceiving patterns, balancing colours. The trickiest of all is light: which seemed for so long to delight in provoking me with its inconstancy, until familiarity with its transient nature allowed me to anticipate its moods.

All these years the muses have been training my eye, helping me to understand how to work with them. What I want to do in this book is pass on the results of that training.

Tulipa 'Burgundy'. Studio. Digital image. Canon 1Ds Mark II with 180mm macro lens. ISO 100 Raw, 1/2 second @ f8.

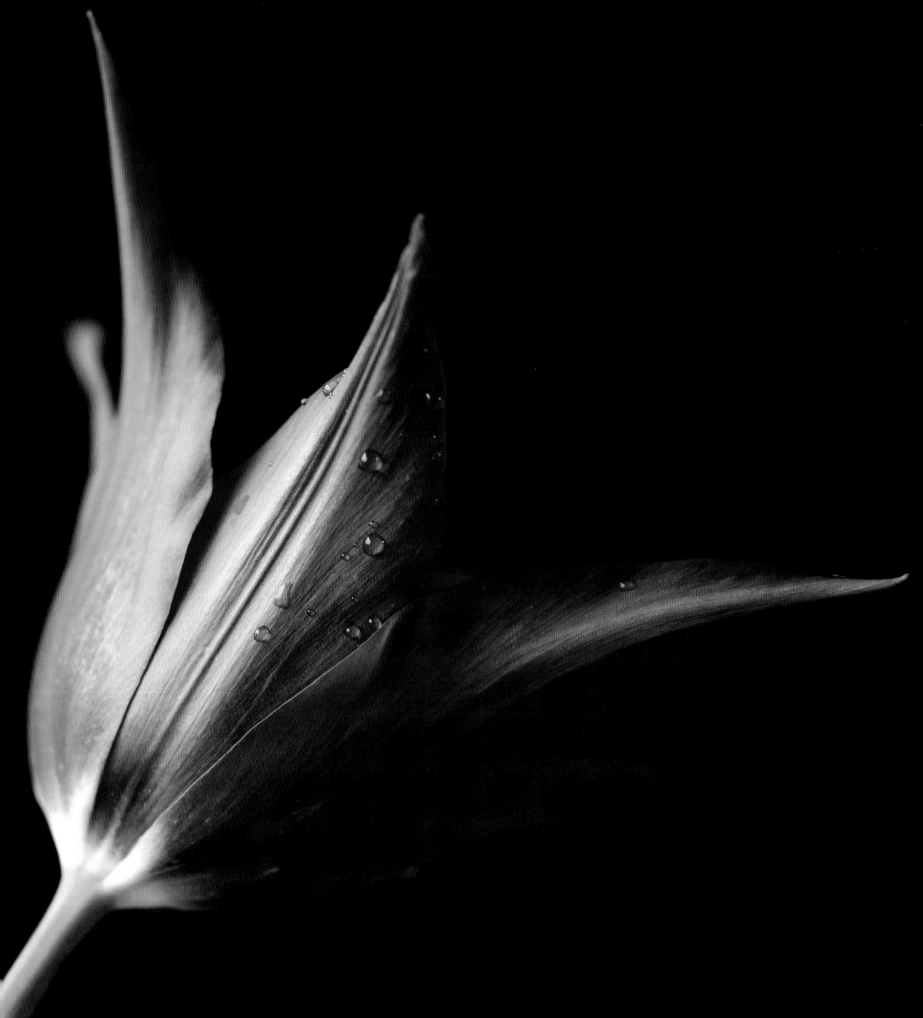

Light

Of all the factors which determine the success or failure of a plant or garden photograph, light is easily the most crucial. An understanding of light and the way it can enhance the mood of a photograph is vital if you aspire to taking great floral images. The quality of natural, outdoor light is transient and constantly changing and over many years of outdoor photography I have learnt to 'feel' or 'sense' what the light is doing, or is about to do. There have been many occasions when I have been confronted with a wonderful garden scene which I then refused to shoot because the light was not 'right'. Ironically, the light that most amateurs think of as the best light for garden photography – brilliant middle of the day sunshine – is actually the most difficult light to photograph in. As the great landscape photographer Joe Cornish says in his book *First Light* – 'Light is the doorway to emotion, and we must learn the combination that unlocks it'.

Late evening sunlight, opposite, slanting in from the righthand side of the picture, saturates the browns and oranges of these oak trees photographed in autumn at the Arley Arboretum, in Worcestershire. On sunny days, I tend to work mainly at dawn and dusk, when the low angle of the sunlight is more flattering to garden subjects.

The Arley Arboretum, Worcestershire, England.
Pentax 6x7 with 55mm wide-angle lens.
Fuji Velvia ISO 50, 2 seconds @ f22.

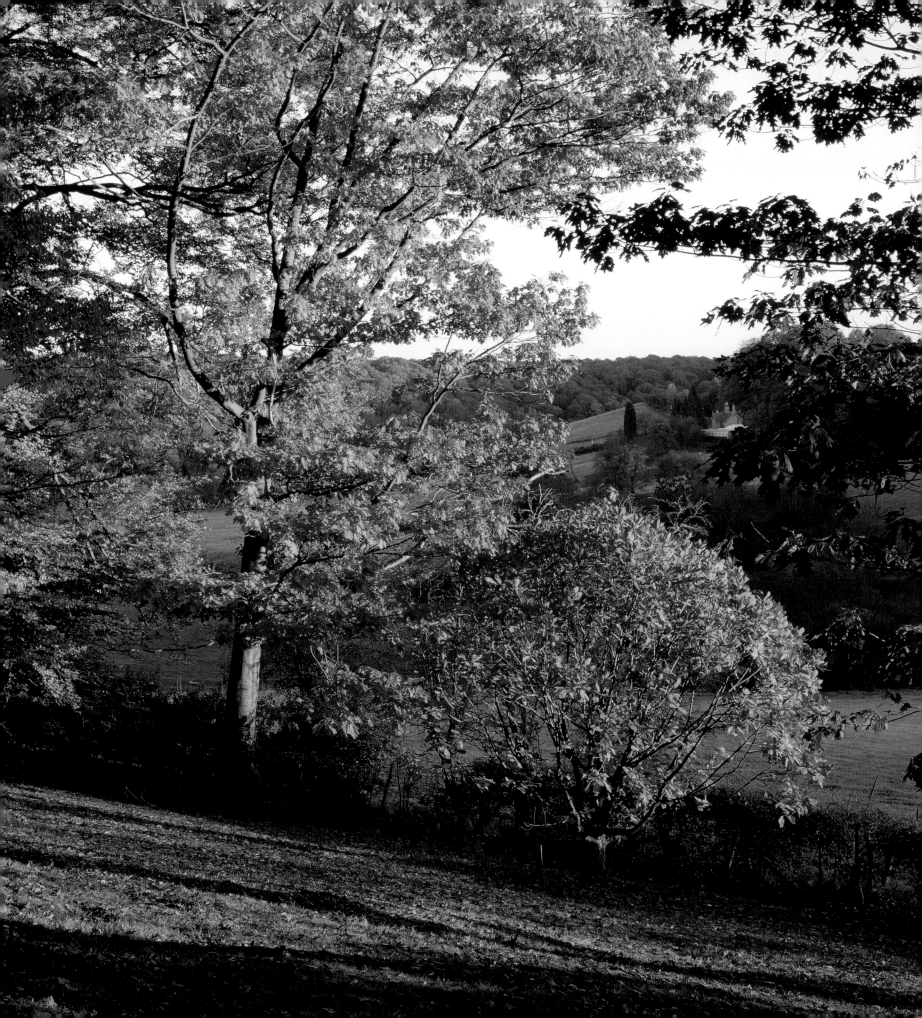

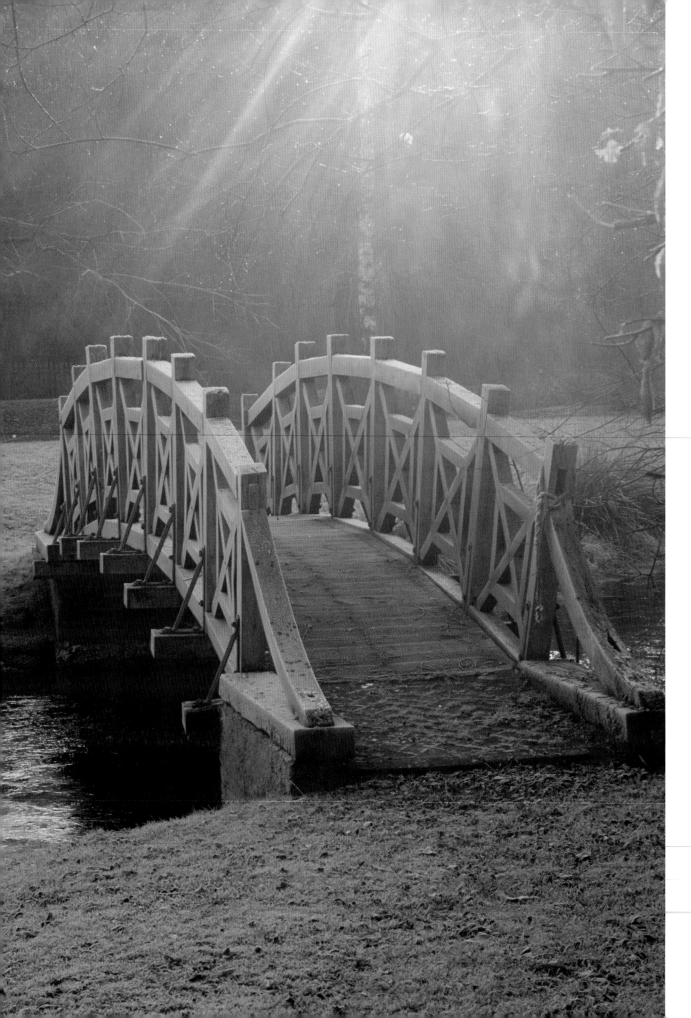

For drama and emotion there is nothing to beat the first rays of golden morning sunshine flooding into a garden. No wonder my best garden images are taken at or just after sunrise.

West Green House Gardens, Hampshire, England. Nikon F90X with 80-400mm zoom lens. Fuji Velvia ISO 50, 1/30 second @ f16.

Opposite, above: Hip of *Rosa moyesii* geranium. Pettifers Garden, Oxfordshire, England. Nikon F90X with 200mm macro lens. Fuji Velvia ISO 50, 1/8 second @ f4.

Opposite, below: *Stipa gigantea*. Lady Farm, Somerset, England. Nikon F90X with 80-400mm zoom lens. Fuji Velvia ISO 50, 1/60 second @ f8.

Dawn light

There is no question in my mind that dawn is *the* time to take outdoor flower and garden shots. The first rays of sunlight can flood a garden scene with drama and atmosphere, often enhanced by the presence of moisture in the air. Even when the early morning sunlight is diffused – by mist, fog or cloud – it is still usually flattering to garden subjects. Furthermore, there is often little or no wind at dawn, so subject movement is eliminated and the choice of aperture and shutter speed is not restricted.

The drawback with shooting gardens at dawn is that I have to get out of bed at unearthly hours, especially in mid-summer, when many gardens in Britain are at their peak. I think nothing of waking up at 2a.m. in order to drive a hundred miles or more to be at a certain location for dawn, which could be as early as 4.50 a.m. If the sun rises in a cloudless sky, I know that I may have only twenty or thirty minutes in which to shoot, after which the sunlight may become too strong. Some garden owners are surprised that I want to shoot so early but are then taken aback by the beauty of their own gardens when they see what they have been missing before their alarms go off.

Fabulous shafts of dawn sunlight pierce the mist and illuminate a wooden bridge over a stream at West Green House, in Hampshire, opposite. I was shooting towards the light in order to add drama to the scene and was careful to make sure that I stood beneath a horse chestnut tree which protected the lens from the sun's rays, thus preventing flare. The picture was taken on a cold, clear morning in the depths of winter.

Backlighting combined with a macro lens enabled me to take this *contre-jour* close-up of a rose hip, rimmed with hoar frost, top right. As I was shooting on film, I deliberately overexposed the shot by one stop and took the picture at 1/8 sec at f4 (my camera meter was saying shoot at 1/15 sec at f4).

Dawn backlight and dewdrops have transformed the pale brown awns of *Stipa gigantea* into golden, translucent treacle, bottom right. To avoid unwanted flare, I used a zoom lens fitted with a large lens hood. I positioned myself so that I was shooting against a dark, shadowy backdrop, which makes the *Stipa* stand out even more from the background.

Overleaf, the garden at Pettifers, in Lower Wardington, Oxfordshire, faces south east and so always photographs best in the morning and especially at dawn when the first rays of sunlight penetrate the lower portion of the garden. I took this picture in June about a minute after sunrise with mist still rising off the surrounding fields. As I was shooting directly into the light, I was careful to make sure that the sun itself was behind the tree in the top righthand corner of the picture, thereby avoiding any possibility of flare appearing in the picture.

Overleaf: Pettifers Garden, Oxfordshire, England.
Pentax 6x7 with 55mm wide-angle lens. Fuji Velvia
ISO 50, 8 seconds @ f22.

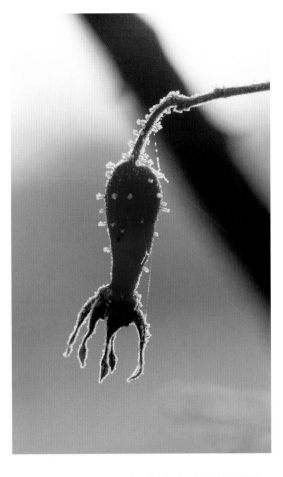

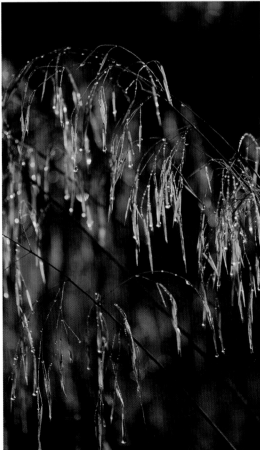

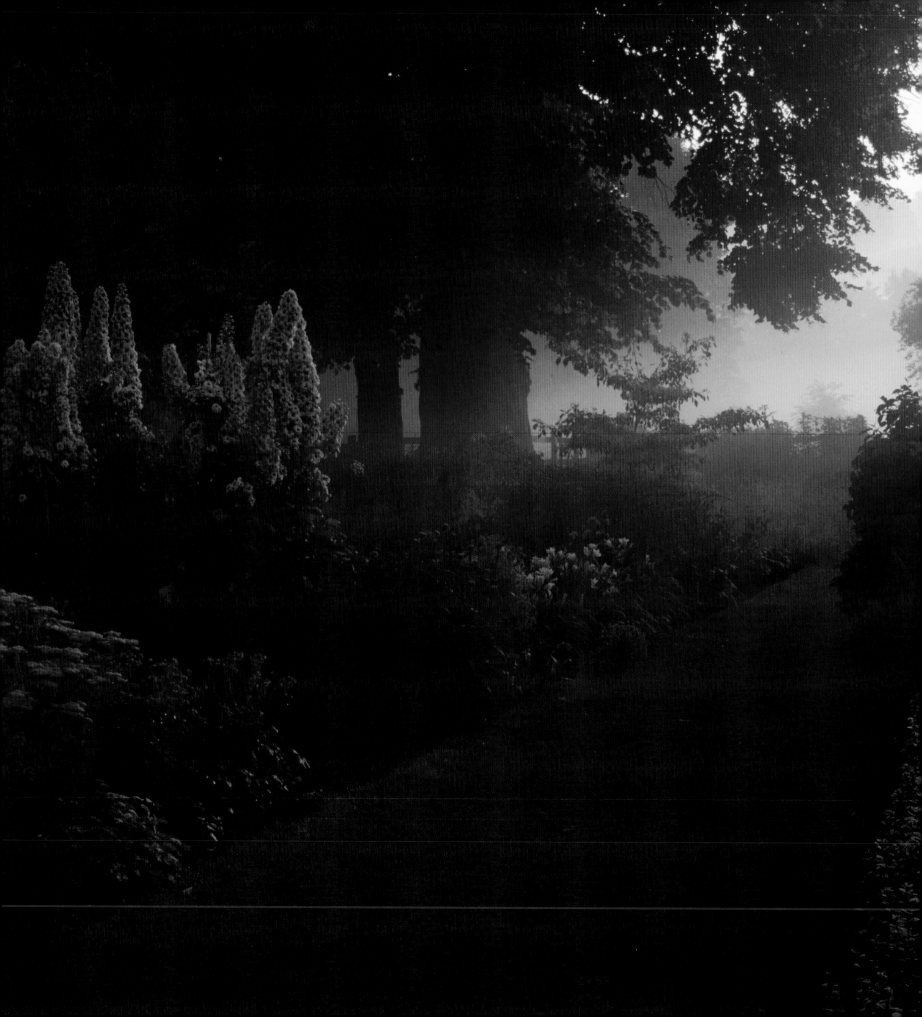

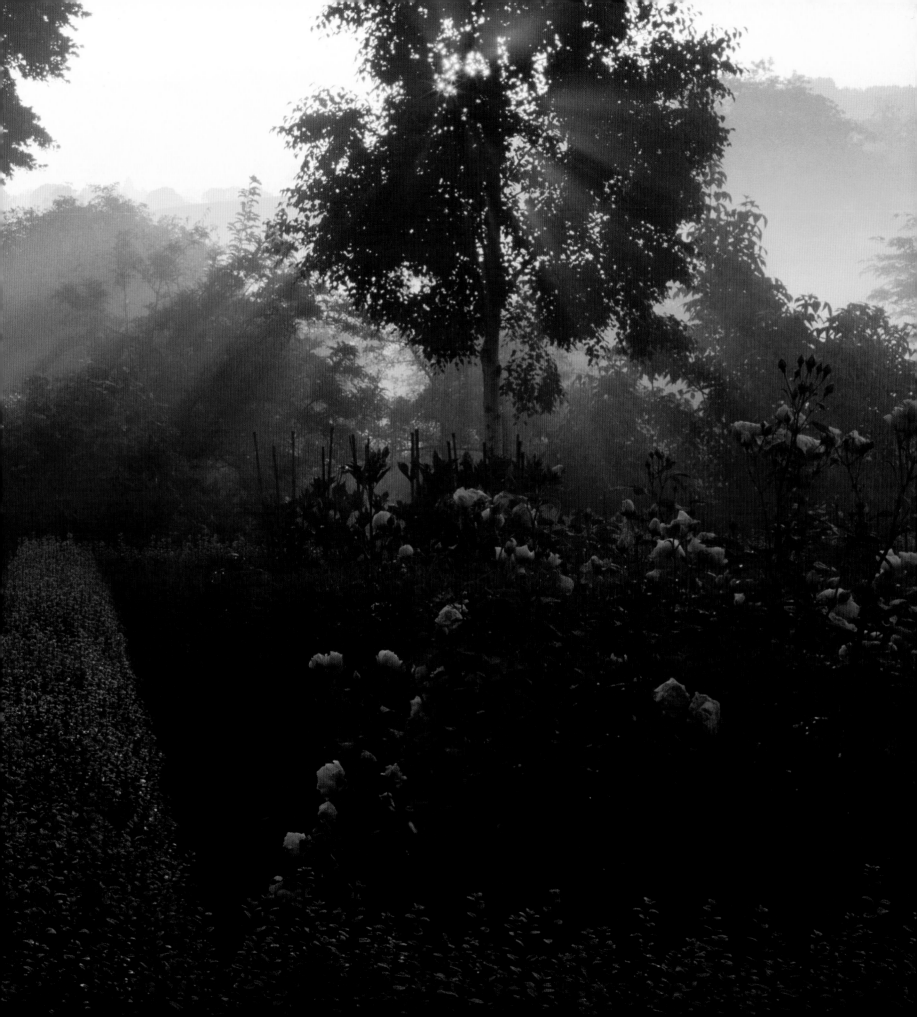

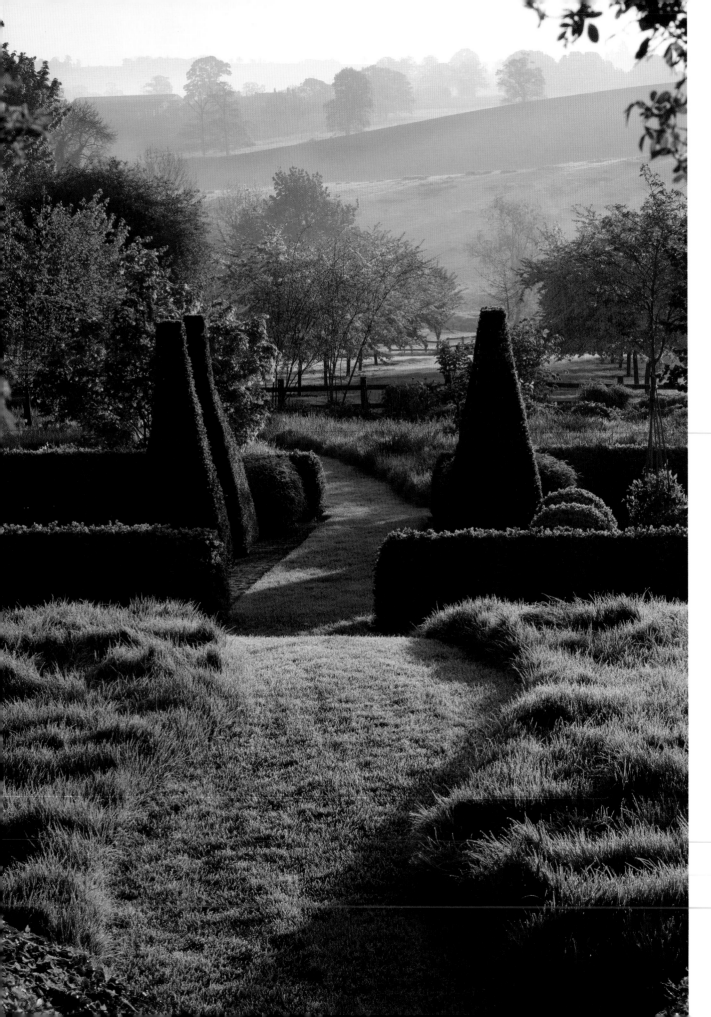

I hid beneath a rose bush to take this early morning picture of the parterre and surrounding countryside at Pettifers in Oxfordshire. Backlight combined with morning dew on the grass has given the scene an almost monochromatic feel, revealing the strong outlines of the yew topiary. Notice how I have used the grass path to draw your eye into and then 'through' the picture.

Pettifers Garden, Oxfordshire, England. Digital image. Canon 1Ds Mark II with 70-300mm zoom lens. ISO 100, Raw, 1 second @ f16.

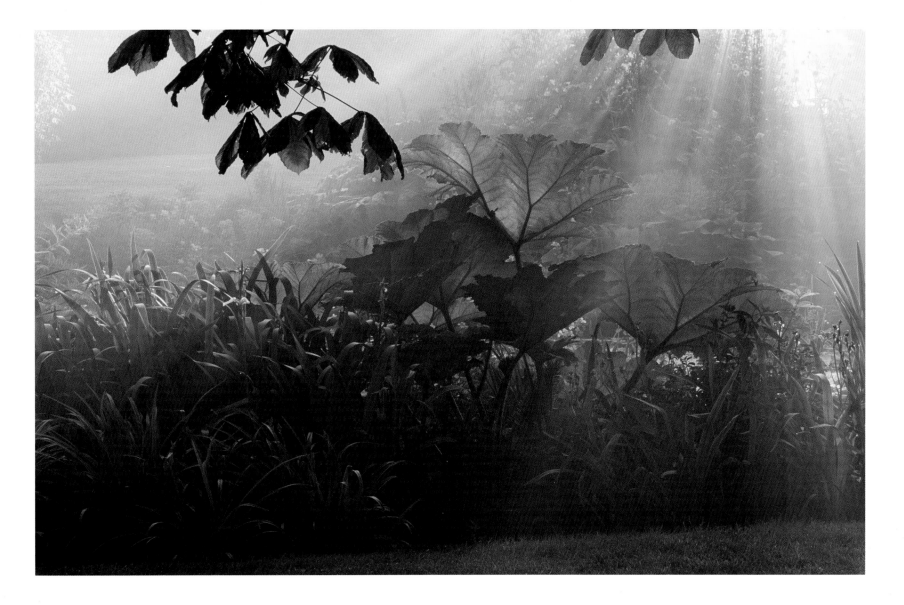

Contre-jour

Whenever possible, I try to take pictures pointing towards the sun, as backlight or *contre-jour* enhances the three-dimensional quality of a garden scene as well as adding drama. The danger of shooting directly into the sun is that sunlight streams straight into the lens, causing flare. Over the years, I have learnt to overcome this problem by using proper lens hoods, often supplemented by my own hand or body, to prevent light entering the lens directly. Since switching to digital photography I now take many more contre-jour shots than I did on film because I can experiment more freely, knowing that if the shot doesn't work I can easily delete it later on the computer. Also, with digital cameras, I can view the shot immediately after it is taken and check the histogram, making any necessary exposure compensation immediately. With film, backlit shots often confuse the camera's metering system, resulting in underexposed pictures, so it is always better to bracket exposures, overexposing by 1 to 1/2 stops. In other words, if your cameras meter is telling you to shoot at 1/60 second at f8, try shooting at 1/30 second at f8 or even 1/20 second at f8.

Above, this shot of *Gunnera manicata* in a bog at Nyewood, in Hampshire, was the reward for an early start and long drive. Taken a few minutes after dawn, I used the canopy of a nearby horse chestnut tree to prevent any direct sunlight hitting my lens.

Private garden, Hampshire, England. Nikon F90X with 80-400mm zoom lens. Fuji Velvia ISO 50, 2 seconds @ f16.

I find strong sunlight the most difficult light to work with. Mostly I avoid it, unless there is strong architectural interest in the composition.

Strong sunlight

Strong, intense sunlight is not the ideal light that many people imagine it to be. As a general rule, I try to avoid such conditions, preferring instead to shoot at the start and end of the day, or on overcast days. The problem with strong sunlight is that although to our eyes everything looks wonderful and we feel great when the sun is shining strongly, the camera is often unable to cope with the extremes of contrast that prevail in such conditions. The result is that most images are a disappointment, with dark, inky black shadows and burnt out highlights.

There are times however when strong sunlight can be cleverly exploited to produce pictures with rich, saturated colours. This picture of the famous *potager* at the Chatêau de Villandry, in France, is a good example. Here I noticed that whilst the Chatêau itself was frontally lit, the sky behind had turned a deep blue-black. Using a polarizing filter, I was able to darken the sky and saturate the colours in the scene. Minutes later I had packed up my camera and taken cover from a thunderstorm.

Chatêau De Villandry, France. Pentax 6x7 with 55mm wide-angle lens. Fuji Velvia ISO 50 second @ f22.

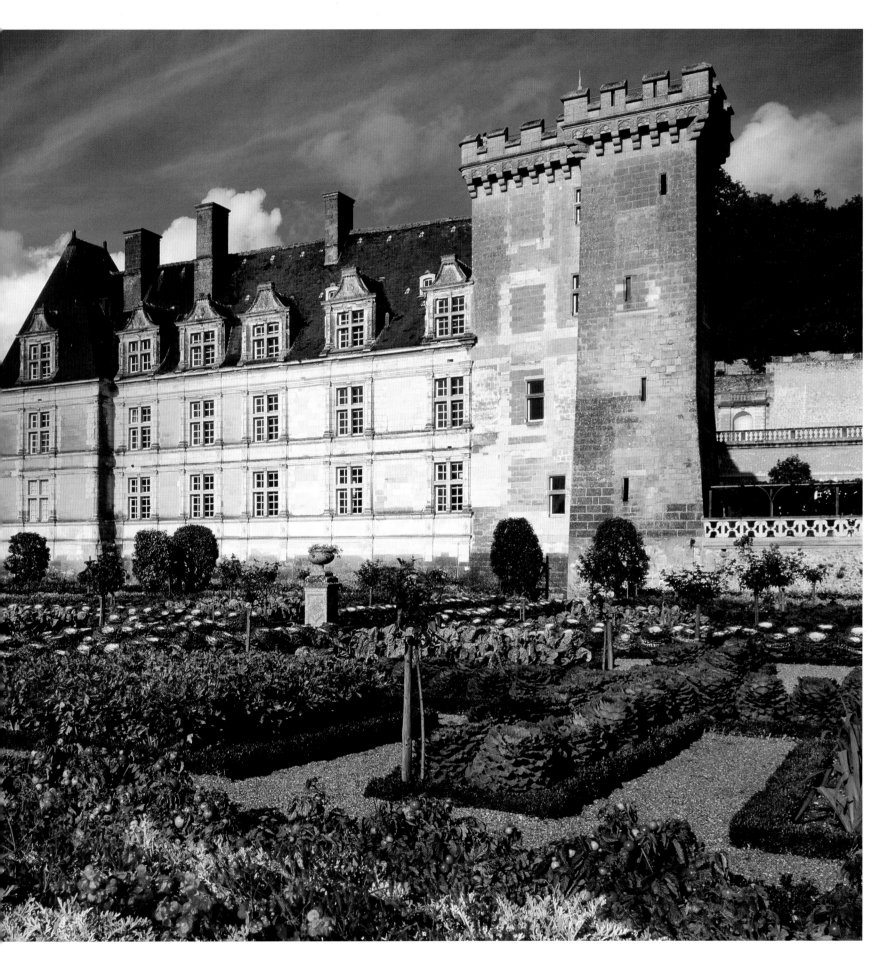

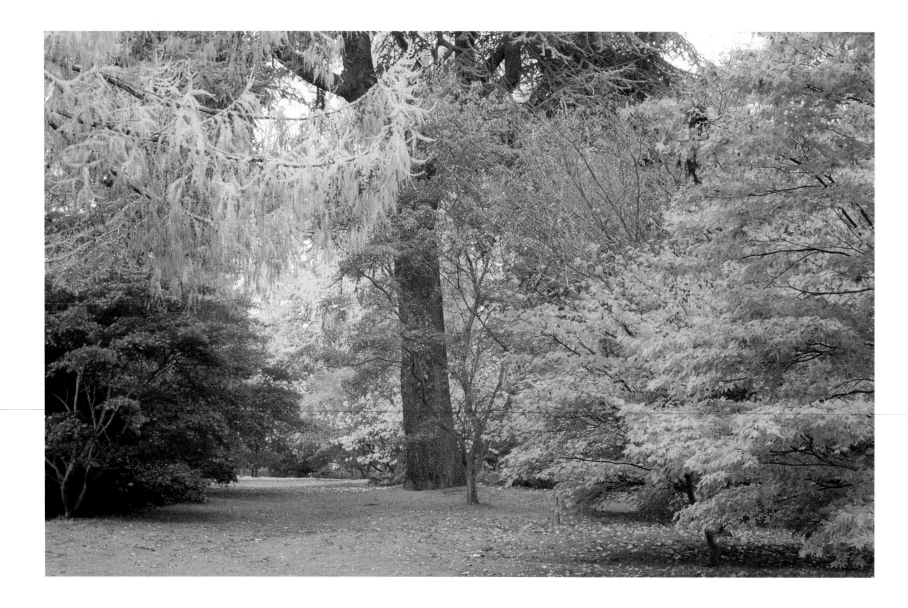

Soft diffused light

Harcourt Arboretum, Oxfordshire, England. Nikon F90X with 80-400mm zoom lens. Fuji Velvia ISO 50, 1/60 second @ f22.

It is much easier to take garden and plant images in soft, diffused light than it is in bright, intense sunlight. The soft light present on an overcast day, although lacking the drama of early and late sunshine, is especially flattering to garden scenes and plants. In such conditions contrast is reduced, so that the problems of lack of shadow detail and bright, burnt out highlights are either reduced or removed completely. Pastel colours can be recorded faithfully without burning out, and strong colours like reds and oranges appear saturated.

One problem with shooting in these conditions is that the sky often lacks colour, appearing instead as a boring strip of white along the top of a picture. For this reason I try to crop it out of the composition, often using zoom lenses for precise framing. The above picture of autumnal colours at the Harcourt Arboretum, near Oxford, is a good example of this. Here I used a zoom lens to frame a view along a glade. The soft, diffused autumn light brings out all the subtle differences in the greens, reds, oranges and yellows of the various trees. The atmosphere of peace and serenity would have been shattered by harsh sunlight.

Opposite left, a bright but overcast day was ideal for bringing out the colour of these bluebells, saturating the subtle blues, greens and pinks in the scene. Opposite right, fine detail is beautifully recorded in this portrait of a silky-soft rose, photographed on a misty, overcast day.

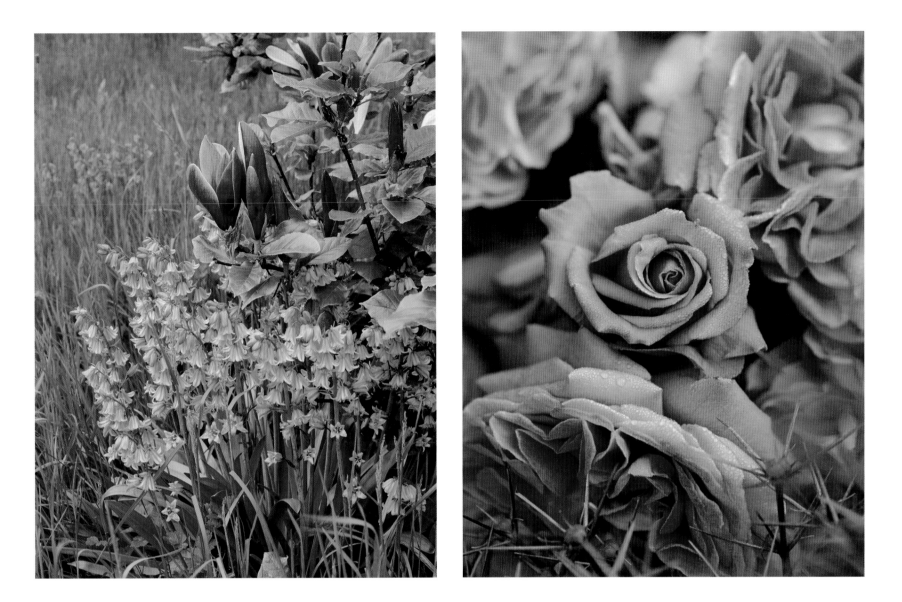

Bright, overcast light is beautiful to work with. Contrast
is reduced to a minimum, so that dark, inky shadows
and bright, burnt out highlights are absent. Colours
become saturated and maximum detail is revealed.

Pettifers, Oxfordshire, England. Pentax 6x7 with
135mm short telephoto lens. Fuji Velvia ISO 50, 1/30
second @ f22.

Rosa 'Magenta'. Pettifers Garden, Oxfordshire,
England. Nikon F90X with 200mm macro lens. Fuji
Velvia ISO 50, 1/8 second @ f11.

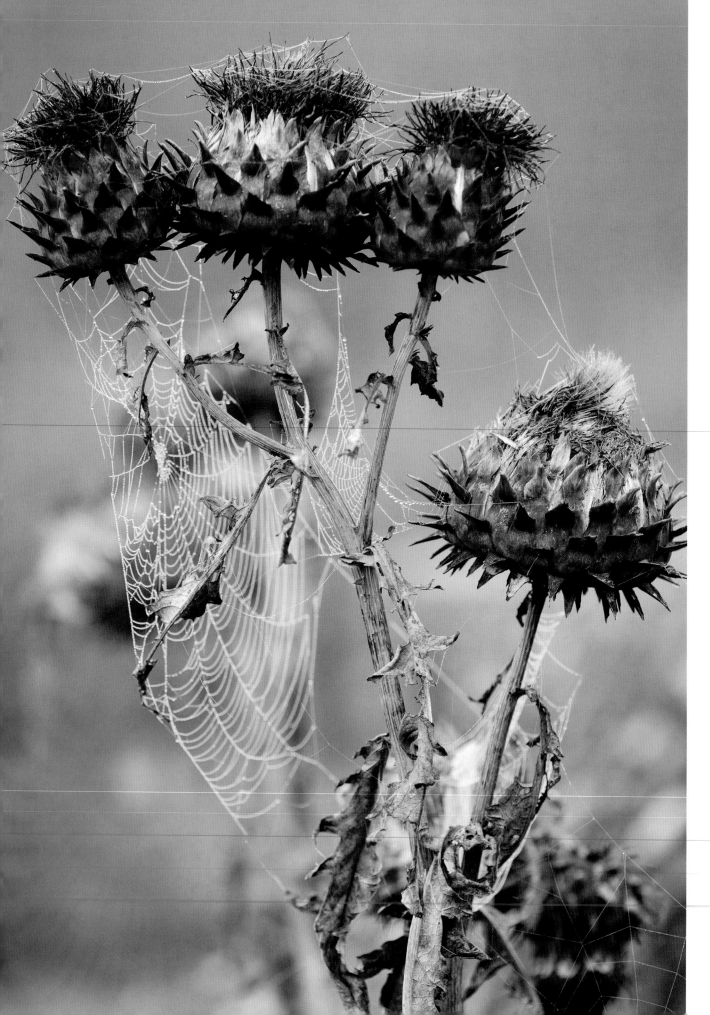

On grey, dull days I have to work harder to find good subjects for photography. I am forced to concentrate on details, examining the texture and subtle colouring of individual plants.

Marchants Hardy Plants, East Sussex, England. Digital image. Canon 1Ds Mark II with 180mm macro lens. ISO 100 Raw, 1/125 second @ f3.5.

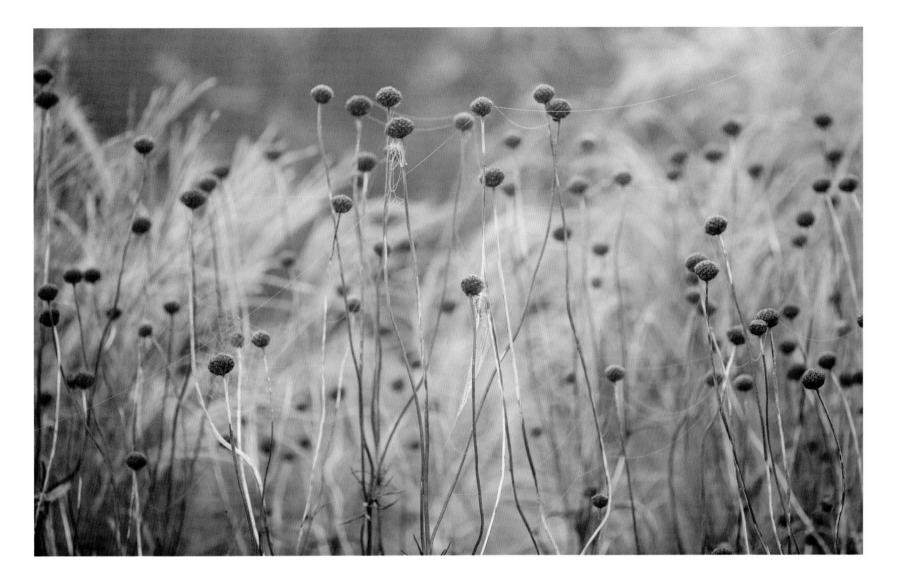

Grey, dull light

In Britain we often encounter dull, grey days, especially in the autumn and winter. On such days, when the light appears rather boring and dreary, it is all too easy to stay in the warmth of your house and dismiss the garden as dull. To get good photographs in these conditions is a real challenge, but my approach is to search out subject matter that suits the mood of the light..

The great Dutch garden designer Piet Oudolf first opened my eyes to what was possible in such conditions when, one rainy September day, he showed me a series of slides that he had taken in his garden the previous winter. In the dullest conditions imaginable, he had taken the most stunning images of faded grasses and seed heads, dripping with moisture and cobwebs. The palette of colours – blacks, dark reds, browns, buffs, golds, silvers, greys – was remarkable.

Both images on these pages have a slightly sad, melancholic feel to them. They were taken on a gloomy October morning at Marchants Hardy Plants Nursery, in Sussex. I used a macro lens to record the fragile, structural beauty of a multi-headed cardoon (*Cynara cardunculus*) cocooned in silver cobwebs (opposite) and a zoom lens to frame the spent seed heads and grasses blowing in the wind (above). Both images were shot on my 17 megapixel Canon camera.

Marchants Hardy Plants, East Sussex, England. Digital image. Canon 1Ds Mark II with 180mm macro lens. ISO 100 Raw, 1/60 second @ f3.5.

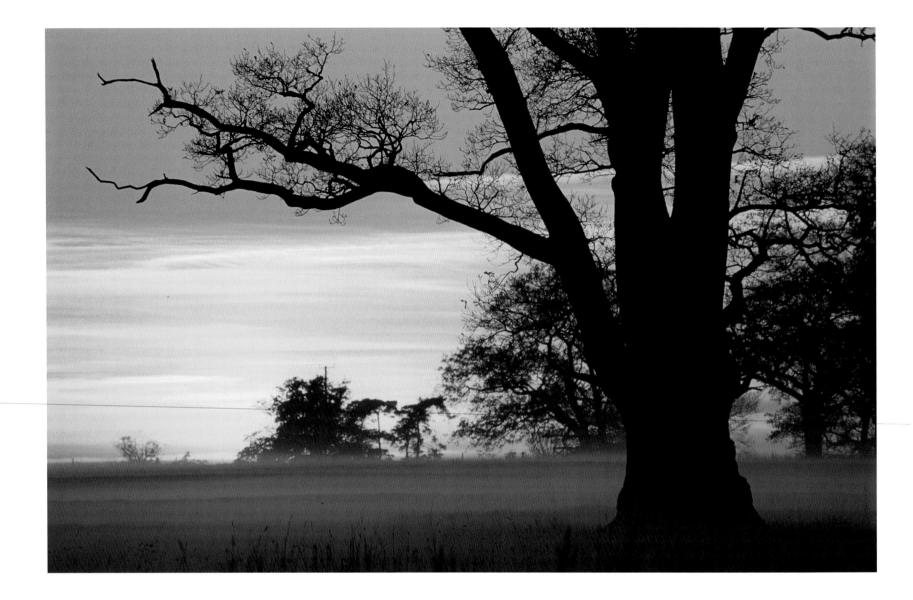

Harcourt Arboretum, Oxfordshire, England. Nikon
F90X with 80-400mm zoom lens. Fuji Velvia ISO 50,
1/2 sec @ f22.

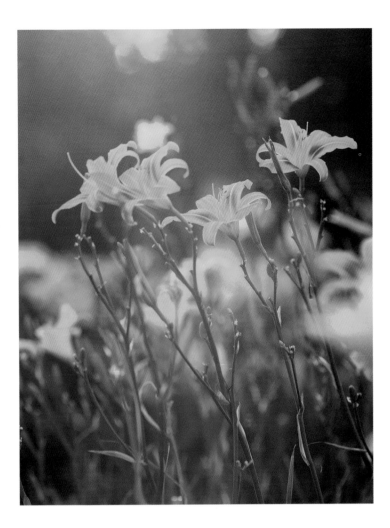

I always plan to be at a location at least an hour before sunset. That way I can work out the best place to set up my camera well before the sun starts to set.

Dusk

Like dawn, dusk can be a wonderful time to photograph outdoor floral subjects, especially on those days when the setting sun floods the garden with rich, golden light. The major difference is that moisture levels in the air are usually less at dusk than dawn, unless there has been an evening rainstorm. As with dawn sunshine, I like to shoot towards the sun for maximum atmosphere, taking care to shield the lens from any direct sunlight.

To avoid any flare in this autumnal sunset image of trees in the Harcourt Arboretum, near Oxford, opposite, I placed myself so that the trunk of the tree in the foreground obscured the sun, thus avoiding any possibility of flare. I used a zoom lens and Fujichrome Velvia film in order to record the rich colours in the sky and deliberately underexposed the frame by 1/2 stop in order to retain detail in the sky whilst turning the bare tree into a silhouette.

Above right, the last rays of the low evening sun adds a rich glow to the 'hot' oranges of *Hemerocallis* 'Rajah' growing in a bed at the 'Nursery Farther Afield' in Northamptonshire. Shooting towards the sunset, I used a macro lens to pick out the flower heads and set the aperture at f4 in order to blow the background nicely out of focus.

Overleaf, this remarkable field of poppies was just a short walk away from my house. The picture was taken seconds before sunset, just after 9p.m.. I used a wide-angle lens to capture the full sweep of the meadow and shot towards the setting sun, being careful to avoid any flare. To add a sense of scale, I made sure that a little bit of the barn appeared in the top lefthand corner of the composition.

The Nursery, Further Afield, Northamptonshire, England. Digital image. Canon 1Ds Mark II with 180mm macro lens. ISO 100 Raw, 2 seconds @ f4.

Overleaf: private garden, Northamptonshire, England. Nikon F90X with 28mm wide-angle lens. Fuji Velvia ISO 50, 2 seconds @ f22.

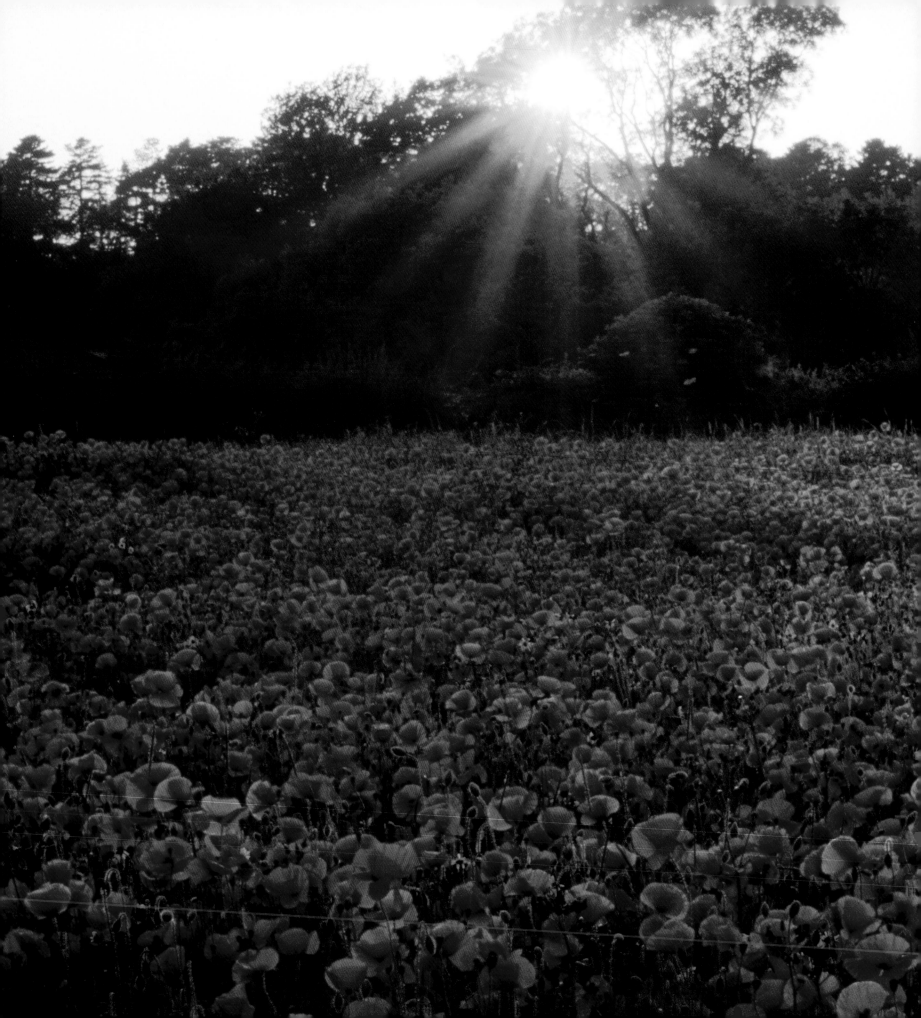

Colour

Colour is the dominant element in many of my pictures. Inspired by artists such as Howard Hodgkin, Mark Rothko, Georgia O'Keefe and David Hockney, I use strong colours, often juxtaposed with each other, to create floral images with maximum impact. In a well designed garden, where plants are artfully arranged in pleasing colour combinations, much of the work has already been done for me. But with plant portraits, I often have to work harder, moving around my chosen subject until I find a background colour to complement the main subject.

For many years I have been a huge fan of Fujichrome Velvia, a transparency film that is particularly good at capturing the greens present in many plants and gardens. The film is still loved by many magazine and book publishers too, because it delivers punchy, well saturated images that look great on the printed page. When I converted to digital capture, I initially struggled to replicate this 'Velvia look' in my digital images – until I came across a superb 'plug in' developed by the San Francisco based photographer Michael Soo (www.soophotography.com). Called Msoo Velvia v 3.0 the action perfectly replicates the look and feel of Velvia film, can be delivered by email and currently costs just $10 (£6).

This maple leaf had fallen onto a frond of a New Zealand tree fern below. Colour – the red of the leaf against the complimentary green of the fern – was my primary motivation for taking the picture. The 'hot' red autumnal leaf provides the dominant colour, pushed to the fore by the cooler, apple green of the fern.

Lakemount, Glanmire, Country Cork, Eire.
Nikon F90X with 200mm macro lens. Fuji
Velvia ISO 50, 1/25 second @ f8.

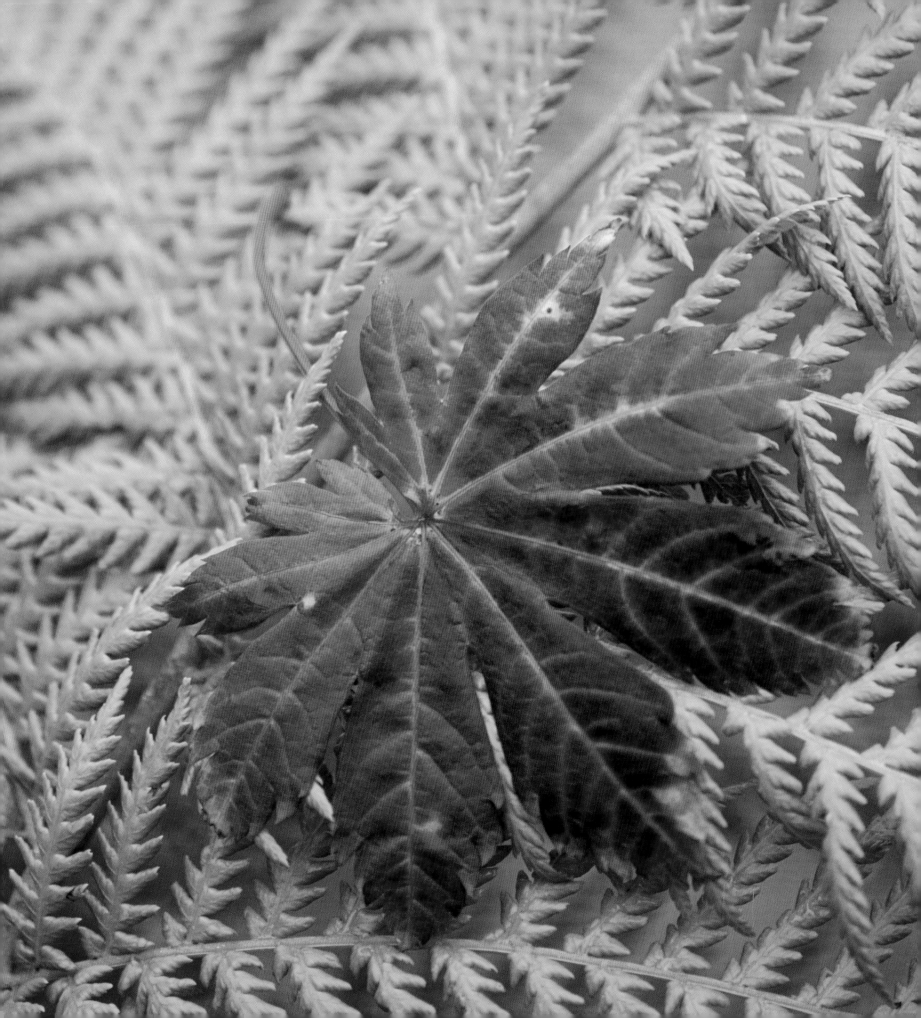

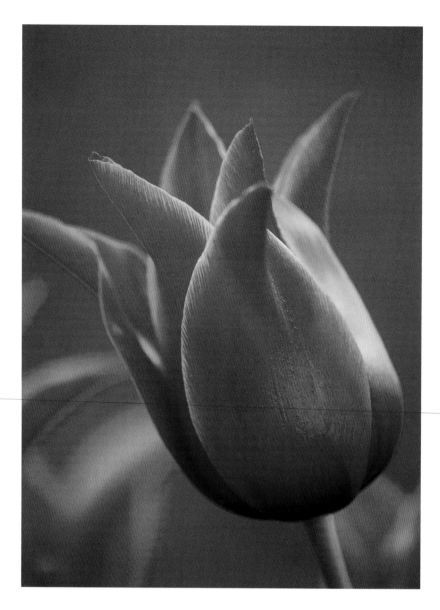

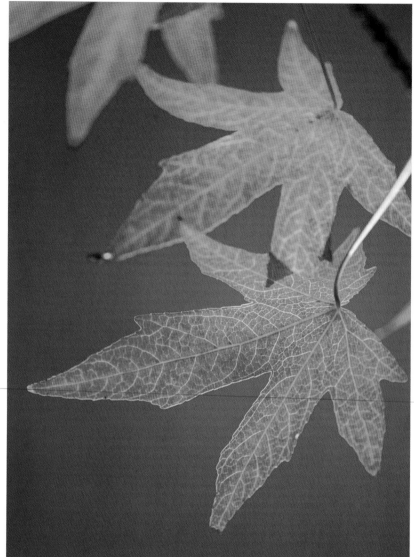

I often think of the colour wheel when I am out in the garden, using it to anticipate which colours will work well together in a picture to create a particular mood. The colours opposite each other on the wheel are complimentary and therefore contrast, whereas colours adjacent to each other on the wheel are in harmony.

Tulipa 'Queen of Sheba'. Pettifers Garden, Oxfordshire, England. Nikon F90X with 200mm macro lens. Fuji Velvia ISO 50, 1/125 second @ f4.

Liquidambar styraciflua leaf. Sir Harold Hillier Gardens and Arboretum, Hampshire, England. Nikon F90X with 80-400mm zoom lens. Fuji Velvia ISO 50, 1/60 second @ f4.

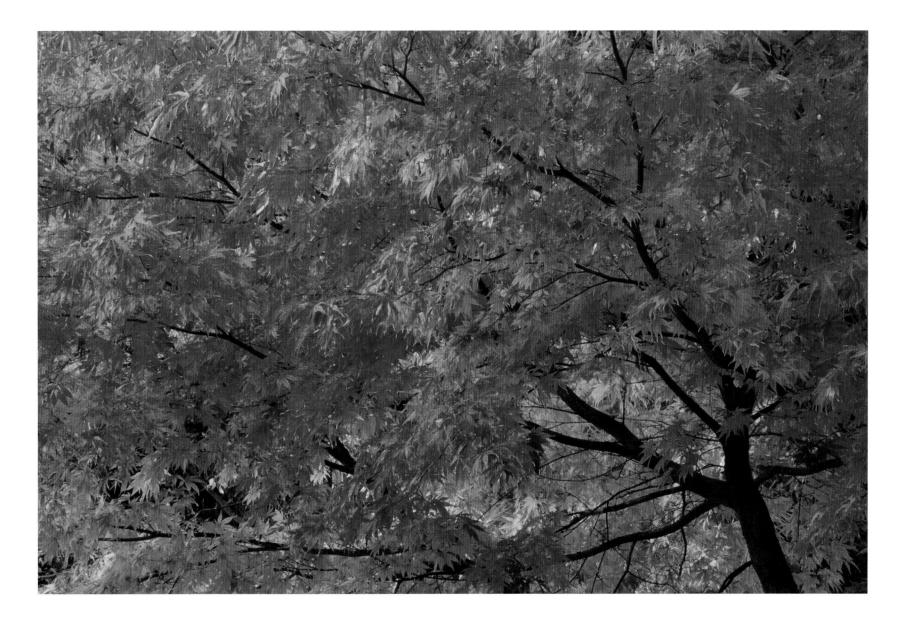

Complementary red and green

Red and green are on opposite sides of the colour wheel and therefore complement one another. Because red is a 'hot' colour and green is at the 'cool' end of the spectrum, red will appear more powerful, 'advancing' when the two colours are combined in a photograph.

Opposite left, I thought that this brilliant red 'Queen of Sheba' tulip would look fabulous against a blurred, bright green backdrop. The tulip was one of a number in the middle of a border, and the colour of the nearby foliage was a bit dull. I noticed that the lawn beside the border was a lush green, so I moved deep into the border and turned back to face the lawn, which gave me a superb complementary green backdrop for the scarlet tulip

Opposite right, like the tulip beside it, I made this dramatically backlit Japanese maple stand out from its surroundings by moving around and selecting a viewpoint where the lawn around the tree becomes an out-of-focus swathe of green.

Above, the impact of this fabulous red-leaved maple at Batsford Arboretum in Gloucestershire would be significantly diminished were it not for the bold splash of green captured in the bottom righthand third of the image. Here I have used a zoom lens for a tightly cropped, frame-filling shot.

Acer palmatum 'Elegans'. Batsford Arboretum, Gloucestershire, England. Nikon F90X with 80-400mm zoom lens. Fuji Velvia ISO 50, 1/30 second @ f11.

Complementary blue and yellow

Rudbeckia deamii and *Aster novae-angliae*
'Barr's Purple'. Old Court Nurseries, Colwall,
Worcestershire, England. Nikon F90X with 200mm
macro lens. Fuji Velvia ISO 50, 1/125 second @ f5.6.

Blue and yellow are complementary colours that occur frequently in gardens. Think, for example, of yellow narcissi and blue scillas, or bluebells and acid yellow azaleas. When I see these colours in combination, I will deliberately try and juxtapose one against the other in order to make one plant jump out from its background.

I moved around this bright yellow *Rudbeckia*, above, until I found a suitable background – in this instance a nearby group of purple asters.

The Keukenhof Garden in Holland, opposite, is the finest tulip garden in the world and a photographer's dream. Many areas of the garden have been sensitively planted with an eye for colour. Here I used a macro lens to isolate these yellow 'Westpoint' tulips against a blue, out-of focus-swathe of grape hyacinths (*Muscari armeniacum*).

Tulipa 'Westpoint' and *Muscari armeniacum*. Keukenhof Gardens, The Netherlands. Nikon F90X with 200mm macro lens. Fuji Velvia ISO 50, 1/30 second @ f8.

Bright sunlight should be avoided when shooting blue flowers on film, as the emulsion layers are sensitive to infra-red light, which is invisible to the naked eye. As a result their colour can turn out somewhat magenta.

Naturalized spring bulbs. Keukenhof Gardens, The Netherlands. Pentax 6x7 with 55mm wide-angle lens. Fuji Velvia ISO 50, 1/4 second @ f22.

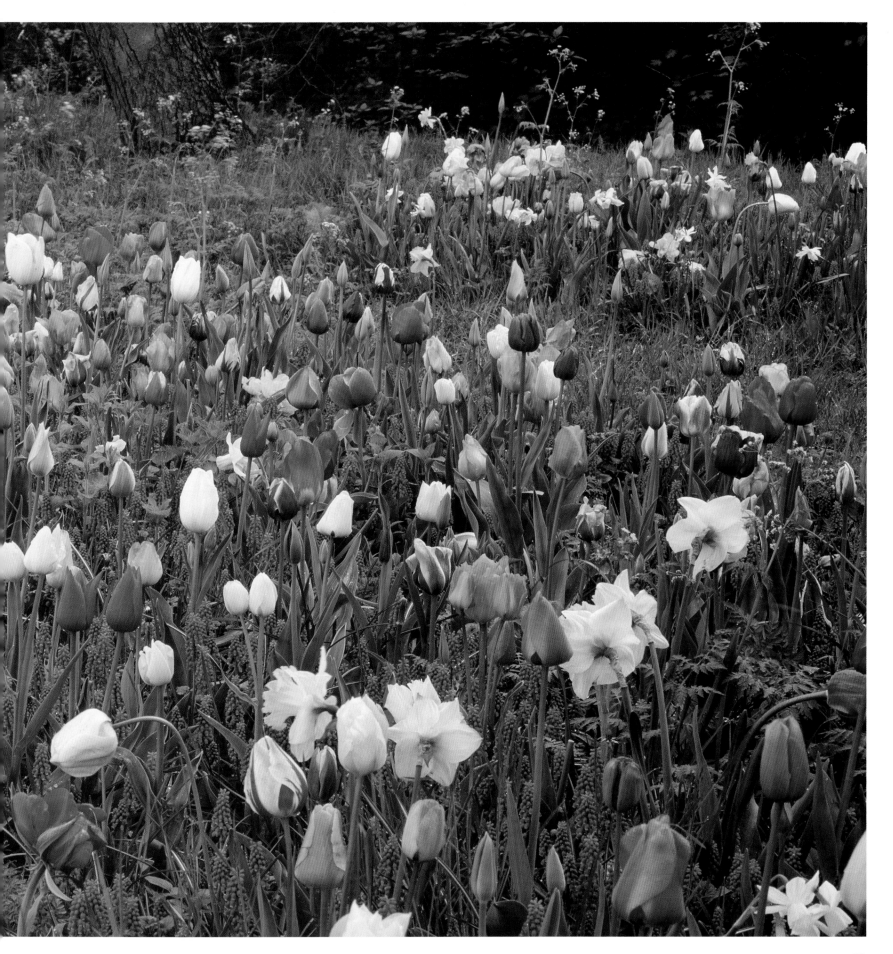

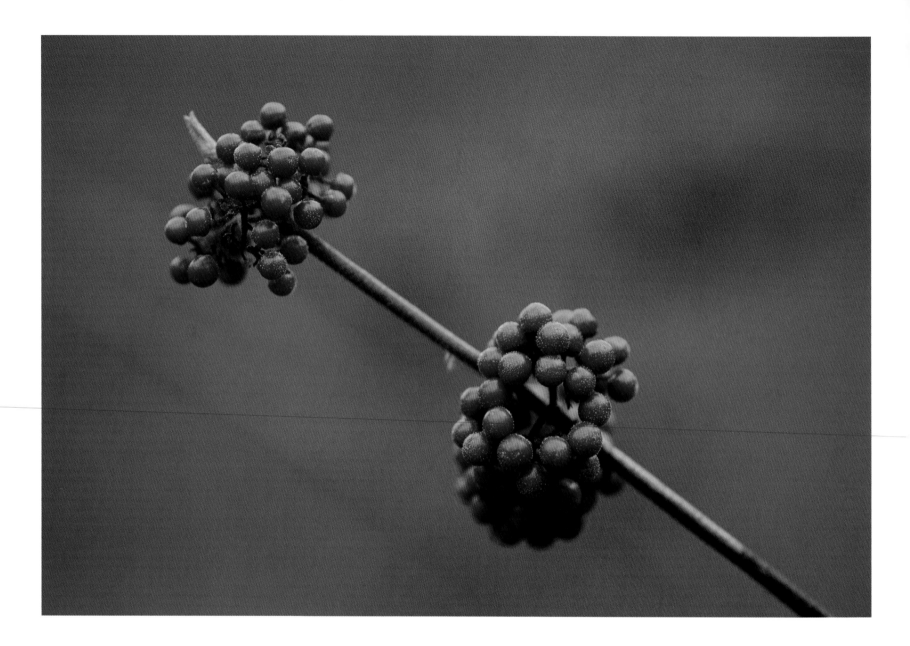

Vibrant contrasts

Callicarpa bodnieri var. *giraldi* 'Profusion'. Batsford Arboretum, Gloucestershire, England. Nikon F90X with 200mm macro lens. Fuji Velvia ISO 50, 1/250 second @ f4.

Some of my favourite photographs involve the juxtaposition of vibrant contrasting colours – oranges with purples, purples with lime greens, lime greens with pinks. For me these images are uplifting and invoke a feeling of real excitement. They are punchy, in-your-face images saturated with unorthodox colour combinations.

Above, smouldering, burnt oranges collide with strident purples to devastating photographic effect as globes of vibrant *Callicarpa* berries pierce a searing, out-of-focus backdrop of autumnal maple leaves stained with the rich tones of more distant berries.

Opposite left, using a 200mm macro lens I was able to create a striking image, full of energy, by juxtaposing this smoky, slate-plum coloured fritillary against some nearby orange tulips with their lime green foliage.

Opposite right, my kitchen has a wall painted a deep orange. I wanted to use the wall as a

background, so I started to think about what colours would look good in front of it. I decided that clashing colours – lime green and purple – would look best, so I bought a perfect specimen of *Scilla peruviana* from my local florist. I set the flower in a vase of water and placed it on a table a metre away from the orange wall. Lighting was from a large window to the left of the table. The result is a simple but visually powerful image.

Overleaf left, In this striking digital image a stunning lime green *Echinacea purpurea* 'Rubinstern' is set against an out-of-focus pink dahlia. I used a 180mm macro lens and a large aperture (f3.5) in order to blur the background.

Overleaf right, this portrait shot of *Anemone hupehensis* 'Splendens' reverses the colour combination on page 36 by setting a pink plant against a lime green background. Again I used a macro lens and a large aperture (f3.5) to blur the background.

Above left: *Fritillaria persica.* Keukenhof Gardens, The Netherlands. Nikon F90X with 200mm macro lens. Fuji Velvia ISO 50, 1/125 second @ f5.6.

Above right: *Scilla peruviana.* The kitchen. Nikon F90X with 200mm macro lens. Fuji Velvia ISO 50, 1/250 second @ f4.

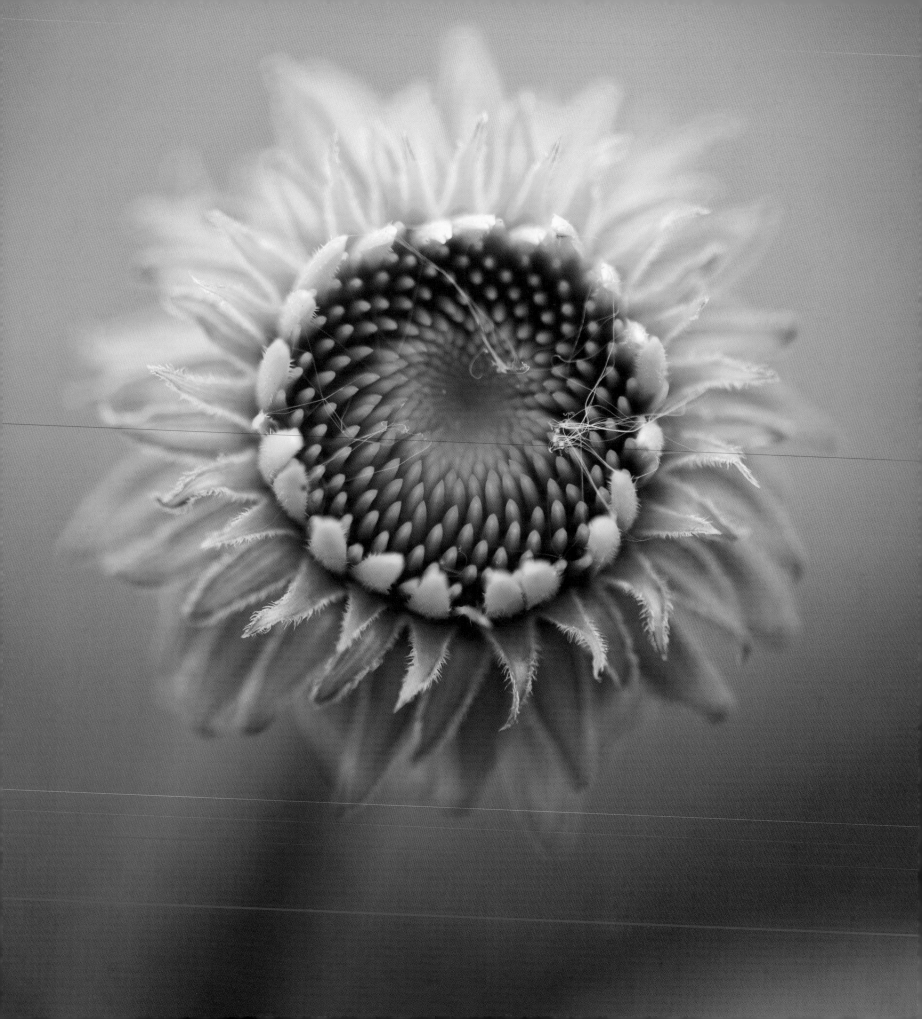

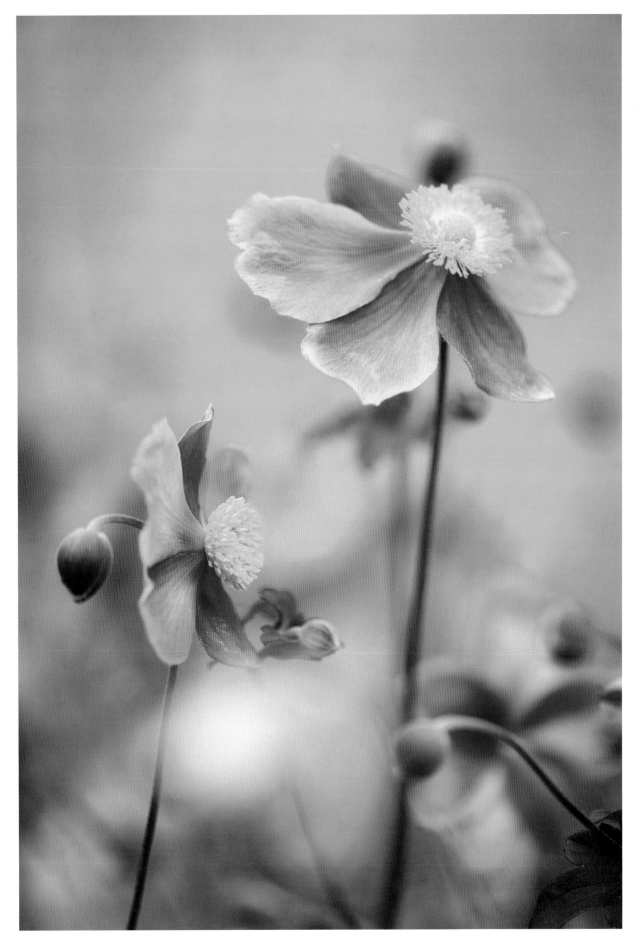

Opposite: *Echinacea purpurea* 'Rubinstern'. RHS Garden, Wisley, Surrey, England. Digital image. Canon IDs Mark II with 180mm macro lens. ISO 100 Raw, 1/250 second @ f3.5.

Right: *Anemone hupehensis* 'Splendens'. RHS Garden, Wisley, Surrey, England. Digital image. Canon IDs Mark II with 180mm macro lens. ISO 100 Raw, 1/500 second @ f3.5.

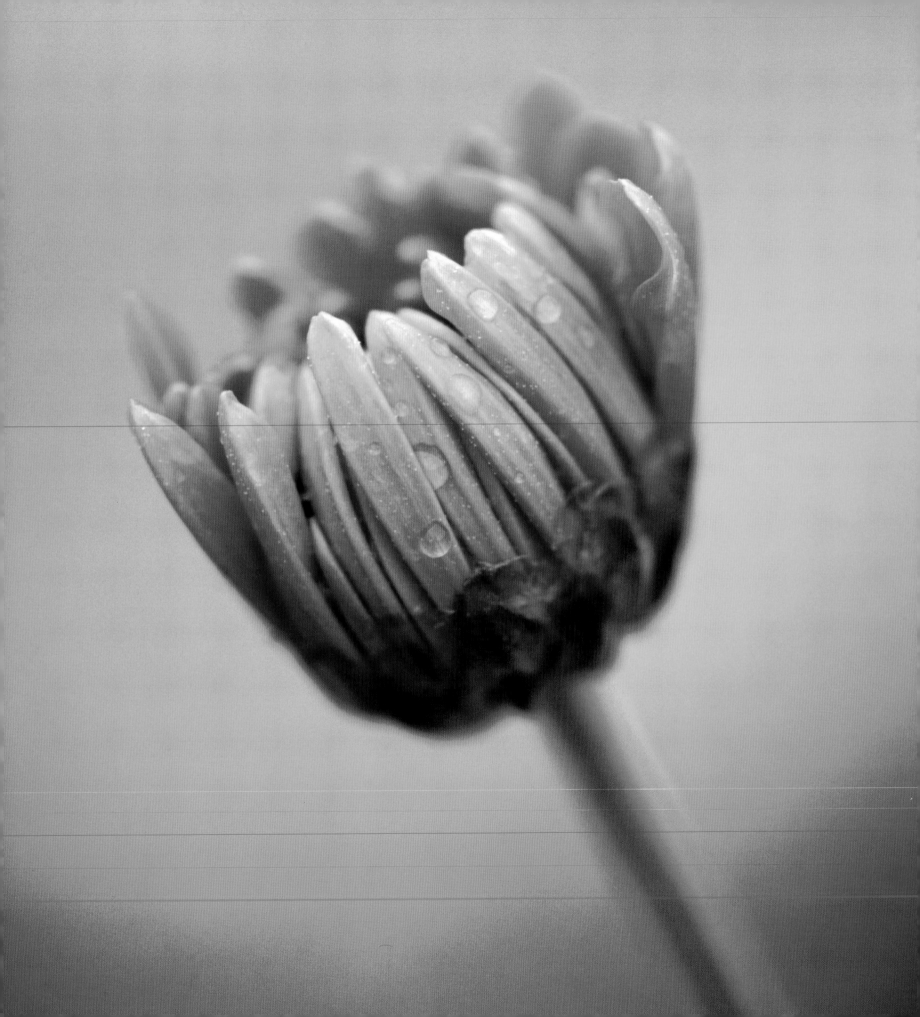

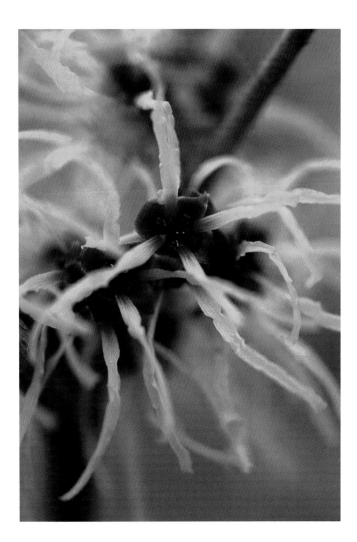

I like to move around my chosen subject, looking through the viewfinder until I find the angle that gives me the perfect background. Only then will I set up the camera and press the shutter.

Colour harmony

When I take a picture I am always hoping to evoke an emotional response from the viewer by looking for something a little bit special and out of the ordinary. Contrasting and clashing colours bring life and vitality to an image, but sometimes I like to use harmonious colour to induce a calmer, more restful emotional response.

Opposite, the burnt orange of the unfurling *Chrysanthemum* has a depth of colour which is emphasized when placed over a layer of softer orange tone, brought about by differential focus with a macro lens. It was raining heavily when I took the picture and I examined the flower from various angles before settling for an harmonious background – in this instance a group of orange dahlias.

Above right, similarly, the citrus-coloured ribbon petals of this sweetly scented witch hazel flower, photographed in the depth of winter, are suffused in an ethereal golden inner glow. A 200mm macro lens blurs the background flowers and branches beyond recognition, transforming them into a swathe of yellows and browns which harmonize with the sharply focused flower.

Overleaf, the flat, drooping seed heads of the inland sea oat (*Chasmanthium latifolium*) look fantastic in winter, golden and frost-rimmed, dangling from arching stems. Using a 200mm macro lens and differential focus, I was able to record the oats in sharp focus whilst at the same time throwing the rest of the image out of focus. I used other leaves and oats nearby to create an harmonious, smooth, buff-brown backdrop.

Opposite: *Chrysanthemum* 'Southway Spirit'. RHS Garden, Wisley, Surrey, England. Nikon F90X with 200mm macro lens. Fuji Velvia ISO 50, 1/500 second @ f4.

Above: *Hamamelis* x *intermedia* 'Barmstedt Gold'. Ashwood Nurseries, West Midlands, England. Nikon F90X with 200mm macro lens. Fuji Velvia ISO 50, 1/60 second @ f4.

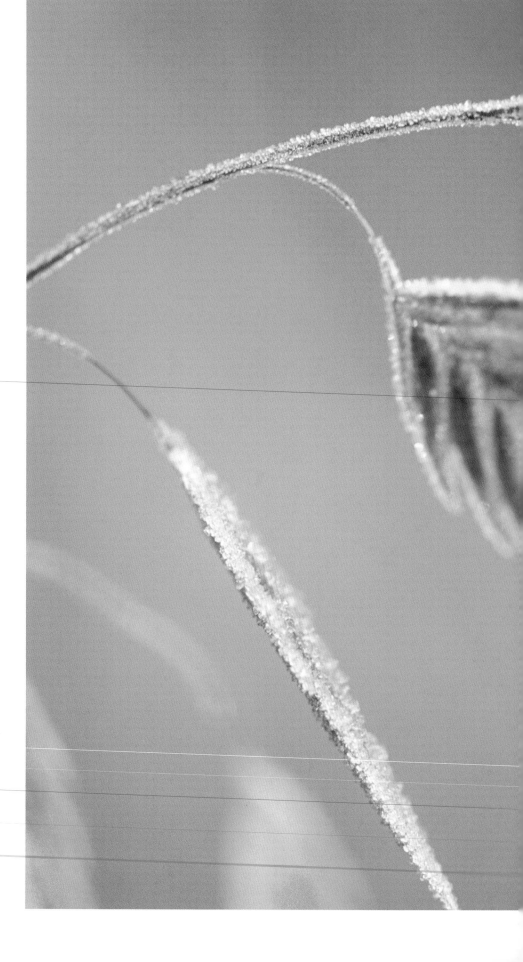

A shallow depth of field makes the main subject 'pop' out of the picture and throws the background completely of focus, adding a three-dimensional quality to the composition which is further emphasized by backlighting.

Chasmanthium latifolium. University of Oxford Botanic Garden, England. Nikon F90X with 200mm macro lens. Fuji Velvia ISO 50, 1/15 second @ f4.

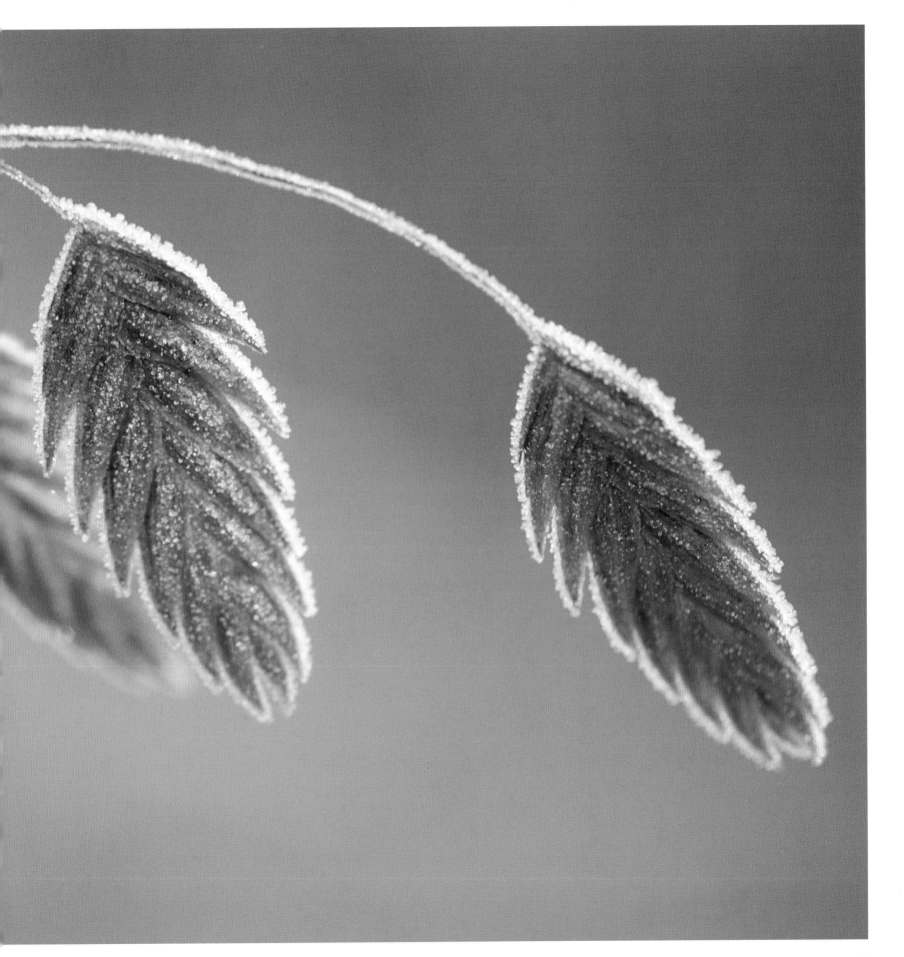

Abstracts

I am constantly seeking out new ways of portraying plants and gardens and creating abstract compositions is a pleasurable and creative way of pushing the limits of my floral photography. A good abstract image should act as a kind of visual puzzle, intriguing viewers and forcing them to look carefully at the image and question what the subject of the picture actually is. The key to a good abstract image is composition, as what I want to leave out of the composition can be as important as what I leave in. For example, if I have noticed a pattern on some tree bark, then that is what I want to emphasize in the picture, so I will ruthlessly crop anything that doesn't contribute to that pattern out of the composition. With the advent of digital photography and post-capture image manipulation, accurate cropping can be done later on the computer in the comfort of my office.

Opposite, at first sight this image looks like it could be a pink snail, but closer inspection reveals it to be a stunning *Phalaenopsis* orchid on show at Kew's annual Orchid Festival. I used a macro lens and focused on the very front of the flower. Setting the aperture to f4 has blown the rest of the flower completely out of focus, creating an abstract swirl of orange and pink in the background.

Phalaenopsis hybrid. Royal Botanic Gardens, Kew, England. Nikon F90X with 200mm macro lens. Fuji Velvia ISO 50, 1/250 second @ f4.

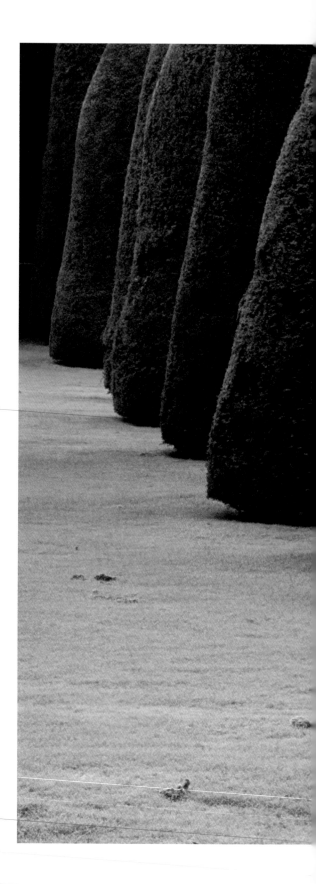

When it comes to taking abstract images, less is definitely more. What I leave out of a picture is as important as what I leave in.

Less is more

I create abstracts by shooting an image in such a way that it is removed from its context, with key identifying elements eliminated. I look for powerful abstract images in landscapes and gardens as well as flowers and leaves, finding them visually magnetic. This magnificent avenue of yews at Packwood House in Warwickshire seemed an obvious choice for an abstract image. The repeat pattern of the yews emerging from a frosted lawn cried out to be photographed with a zoom lens, so that all objects that might spoil the image – benches, walls and people – could be cropped out of the composition. The monochrome effect imparted to the yews and the lawn by the frost further adds to the power of the image by reducing the number of colours in the picture.

Packwood House, Warwickshire, England. Nikon F90X with 80-400mm zoom lens. Fuji Velvia ISO 50, 1 second @ f32.

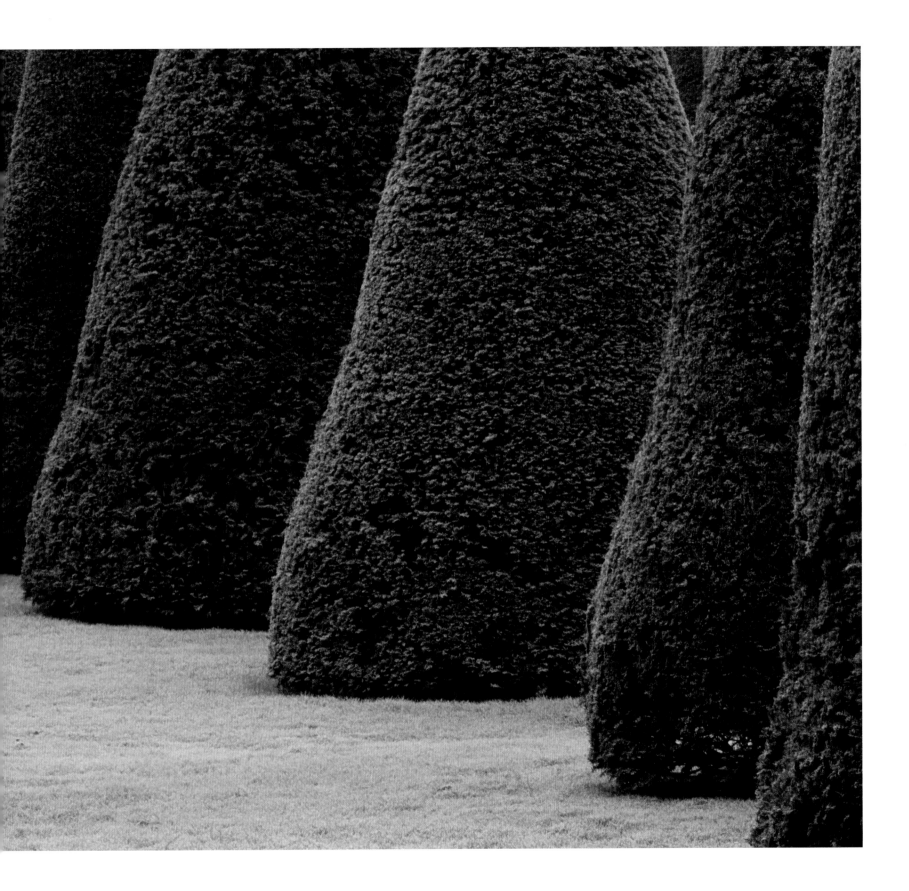

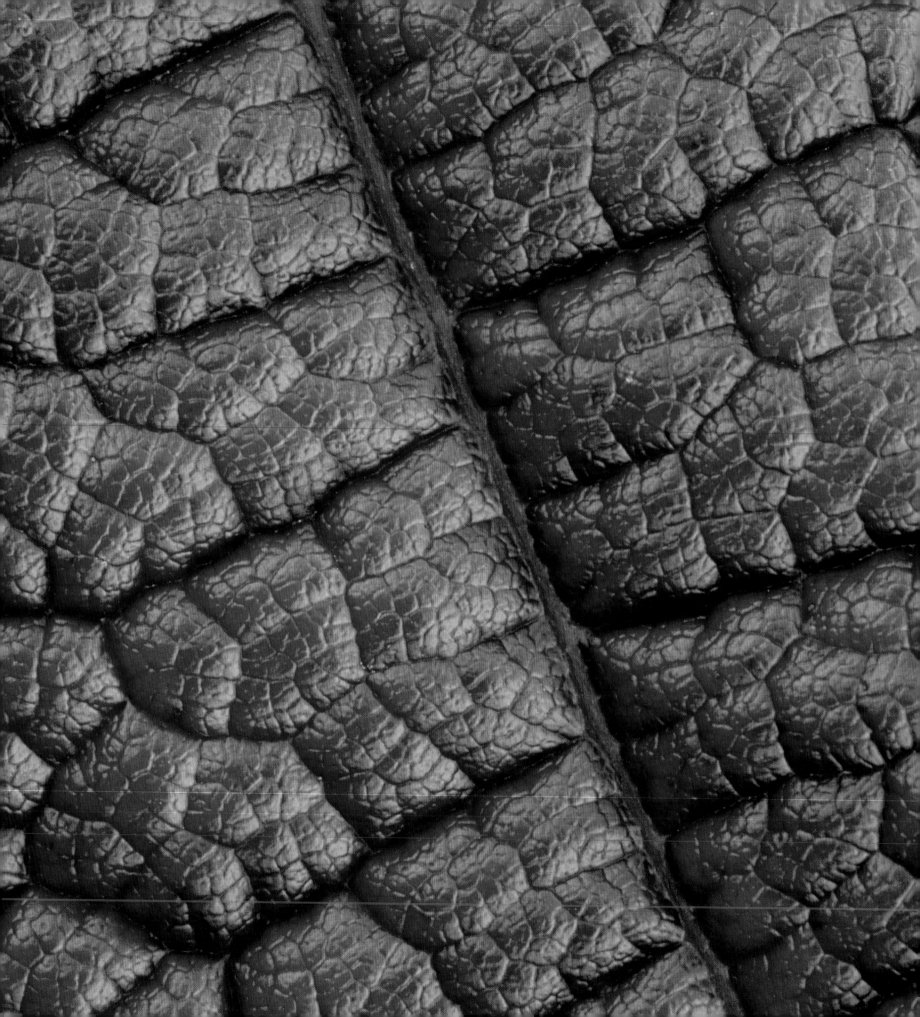

Bark and skin

Textured and peeling tree bark, bulbous and pockmarked fruit and vegetable skins and deeply veined and puckered leaves all make fantastic subjects for abstracts. I see them as 'found art', nature's own detailed, miniature landscapes, which I can bring to life, usually through the medium of a macro lens. To show these subjects to their best advantage and to emphasize surface texture, I usually try and show them pin-sharp, setting small apertures (like f16 or f22) and focusing carefully in order to ensure a good depth of field.

Opposite, you can almost feel the texture and relief on the surface of this rich and vibrant autumnal leaf, photographed in soft, overcast light on a still October morning. I closed down the aperture to f32 for maximum depth of field.

Above left, resembling a huddled group of naked bathers, the beautiful *eau-de-nil* skin of this squash 'Queensland Blue' makes an interesting abstract composition.

Above right, this image is ambiguous and open to interpretation; is it the scaly skin of a snake or some creeping fungal growth? In fact, it is the interlocking bark on the trunk of a massive Crimean pine at Arley Arboretum, in Worcestershire, captured with a macro lens.

Opposite: *Vitis coignetiae* leaf detail. Christopher Holliday's garden, Cumbria, England. Nikon F90X with 200mm macro lens. Fuji Velvia ISO 50, 1 second @ f32.

Above left: Winter squash 'Queensland Blue' – *Cucurbita maxima*. RHS Garden, Rosemoor, Devon, England. Nikon F90X with 200mm macro lens. Fuji Velvia ISO 50, 1/30 second @ f8.

Above: Bark of the Crimean pine – *Pinus nigra* subsp. *pallasiana*. The Arley Arboretum, Worcestershire, England. Nikon F90X with 200mm macro lens. Fuji Velvia ISO 50, 2 seconds @ f32.

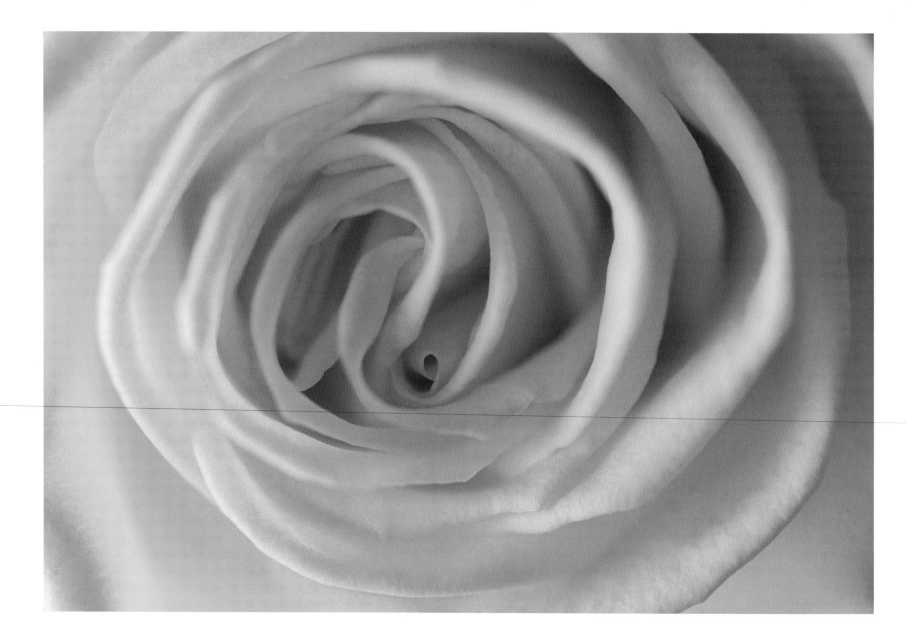

Flowers and petals

Yellow rose. Studio. Nikon F90X with 200mm macro lens. Fuji Velvia ISO 50, 1/30 second @ f11.

If you stop and look at almost any flower, you cannot fail to notice and admire the ingenuity of its form. Invariably, flowers contain a natural rhythm and symmetry, which I seek to exploit photographically. I find the best way to capture this geometry in order to create a piece of abstract art is to explore different compositions with a macro lens. If I am in a garden situation, I will be looking closely at each flower whilst simultaneously assessing the amount of wind and the quality of the light before making a decision on whether or not to start shooting. Sometimes, if the weather outdoors is not right, I will pop down to my local florist and spend time there just looking closely at various blooms that are in season, checking on their colour, form and quality before deciding which ones to buy, bring home and photograph.

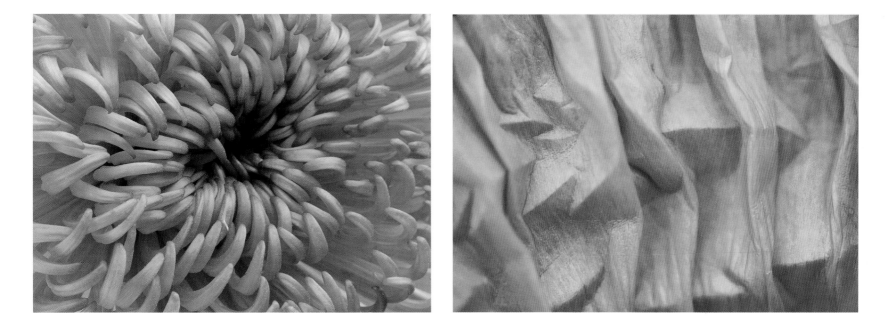

> Not all flowers are photogenic, even though they may at first appear so. I like to take my time, searching out natural pattern and rhythm, before selecting subjects that will make abstract images.

Above, soothing, soft and hypnotic, the natural swirling pattern of this yellow rose resembles churned butter. Soft, overcast light brings out the subtle hues of yellow and the radiating petals draw your eye outwards from the centre of the image to the very edges of the frame

Above left, the zesty, saturated and vivacious lime green centre of this shamrock chrysanthemum, purchased from my local florist, is captured in this close-up study. Several people who have seen this image have mistaken the flower for a sea anemone on the seabed – an easy mistake to make given the abstract nature of the image.

Above right, crumpled and pleated shot taffeta? No, this is in fact a small section of a freshly opened leaf of an oriental poppy, aptly named 'Saffron'.

Above left: Shamrock chrysanthemum. Studio. Nikon F90X with 200mm macro lens. Fuji Velvia ISO 50, 1/2 second @ f32.

Above: *Papaver orientale* 'Saffron'. Hadspen Garden, Somerset, England. Nikon F90X with 200mm macro lens. Fuji Velvia ISO 50, 1/4 second @ f16.

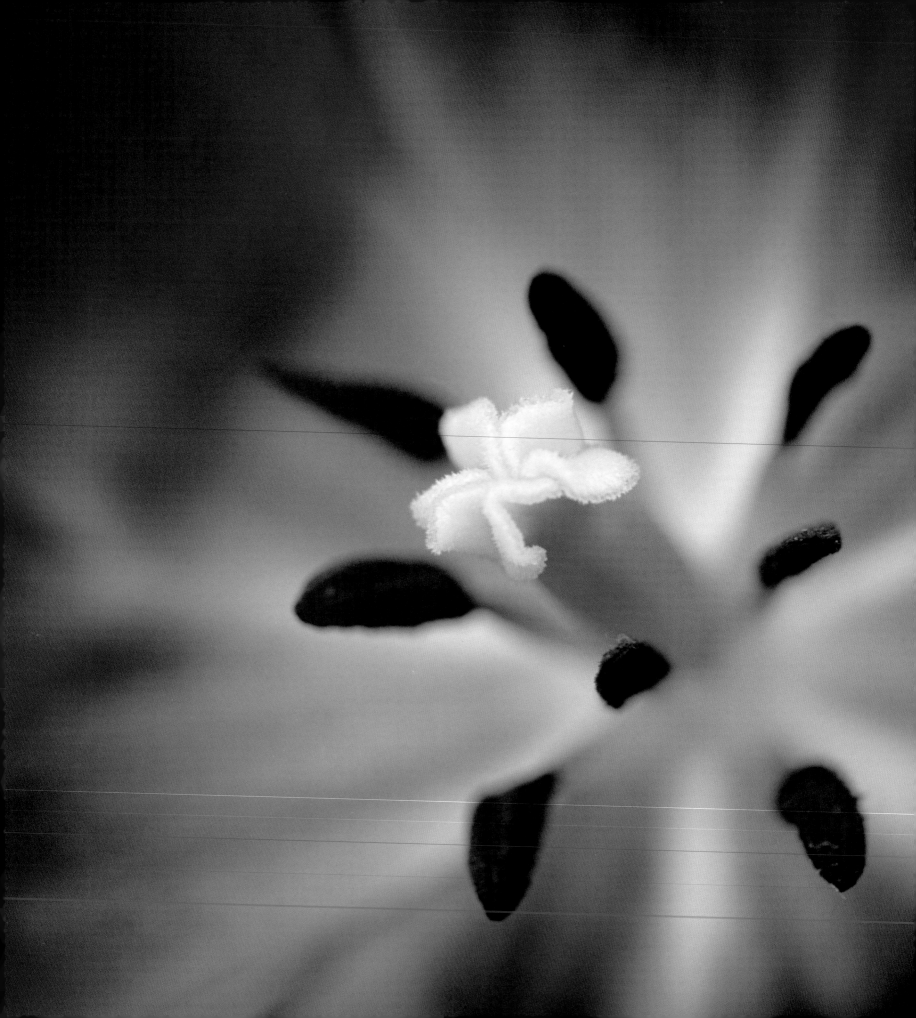

> *Using a tripod and a cable release to fire the cameras shutter is absolutely essential to avoid camera shake, especially when taking extreme close-ups such as the pollen dusted anthers in a flower's interior.*

Innermost secrets

To capture the internal structures of flowers requires the use of a quality macro lens and a good deal of patience and time to set up a shot. The use of a tripod and cable release is obligatory as the slightest movement of the camera will render the subject unsharp. Accurate focusing becomes more critical and depth of field is reduced. Light levels inside a flowerhead can also sometimes do with a boost. This is where I find reflectors absolutely invaluable. I use either white or gold lastolite reflectors to bounce light back into the throat of a flower, depending on the effect that I want to achieve. White reflectors give a very natural light, whereas gold reflectors throw a warmer light onto the subject, useful if I am photographing flowers on the warmer side of the colour spectrum (such as red, orange or yellow).

Opposite, tulips are amongst the most photogenic of plants and *Tulipa* 'Queen of Night' is one of the most beautiful. This particular specimen was fully opened inside a glasshouse in the Keukenhof Gardens in Holland. Having no wind to contend with, I was able to take the abstract easily with a macro lens, focusing on the stamens and blowing the rich, dark purple petals behind completely out of focus.

Above right, I used a gold reflector, held close to the front of the flower, to bounce some light back into the throat of this red *Hemerocallis*. I prefer using reflectors rather than flash to add light to flowers because I can see the results with my own eyes, whereas flash is slightly less predictable.

Overleaf, I had admired this tulip as it grew in a container in my own garden. Realizing its abstract potential, I waited until it was at its peak before cutting the flower and bringing it inside. Once in the house, I put flower and stem in a water-filled vase and left it on a windowsill. With no wind to contend with, I was able to spend half an hour or so trying out different compositions with a macro lens and finally settled on this one. I used the smallest aperture I could (f32) to achieve maximum depth of field and shot it on my 17 megapixel Canon digital camera. I later printed it on a sheet of A4 Hahnemule Fine Art Photo Rag paper to bring out the surface texture of the tulip.

Opposite: *Tulipa* 'Queen of Night'. Keukenhof Gardens, The Netherlands. Nikon F90X with 200mm macro lens. Fuji Velvia ISO 50, 1/500 second @ f4.

Above: *Hemerocallis*. Studio. Nikon F90X with 200mm macro lens. Fuji Velvia ISO 50, 1/1000 second @ f4.

As well as looking for the natural rhythm and symmetry in a plant, I love to reveal the surface texture of petals, using a macro lens and a small aperture to maximize depth of field.

Tulipa 'Purple Rain'. Studio. Digital image. Canon IDs Mark II with 180mm macro lens. ISO 100 Raw, I second @ f32.

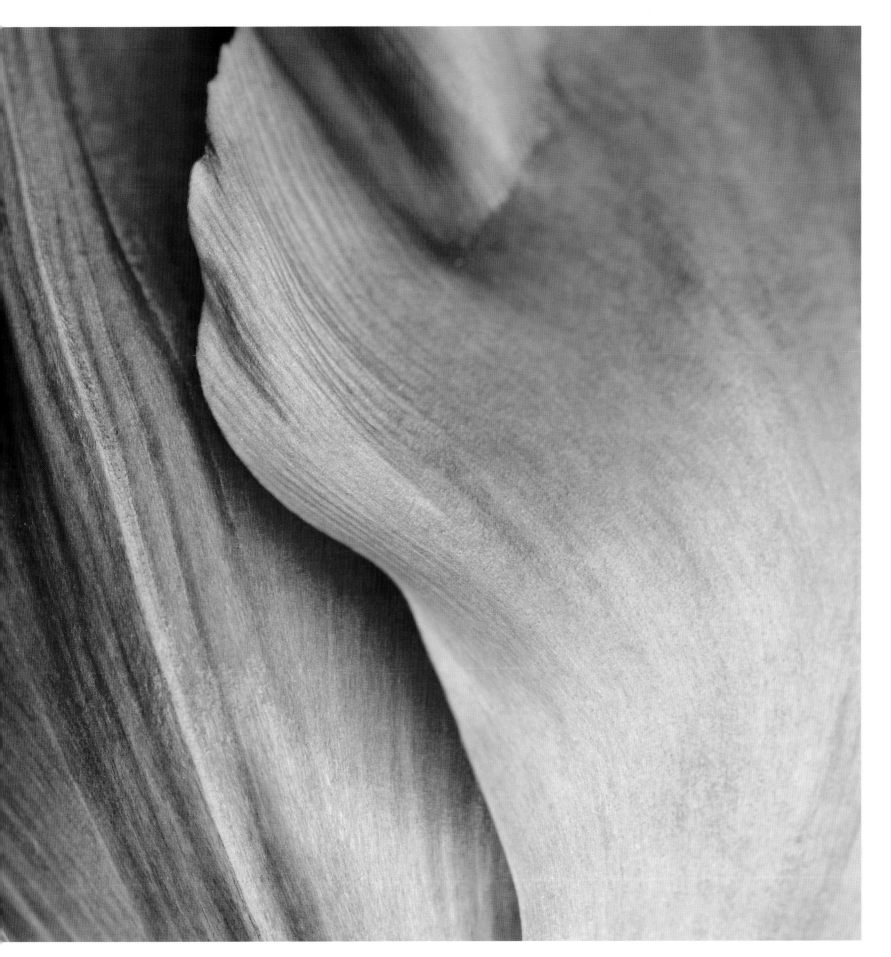

Plant portraits

People chuckle sometimes when I tell them I have spent the day shooting plant portraits. They seem unaware that taking great images of plants requires quite as much skill, passion and commitment as taking portraits of people. Plants are fragile, ephemeral and often not as photogenic as they first appear. How many times have I looked at an apparently gorgeous flower from a distance and rushed up to photograph it, only to discover that, when inspected at close range, its petals are blemished and not nearly as perfect as I first imagined?

Another major problem I face when taking plant portraits is wind, which can turn close-up photography into a nightmare. It is not surprising then that most of my finest, pin-sharp images of plants are taken on still days or indoors, where there is no wind to contend with.

I caught the aquilegia, opposite, absolutely at its prime early one damp, summer morning in June. I was immediately attracted to its strong design and beautiful colour. The petals, dripping with droplets of dew and stained purple, were in perfect condition and looked amazing when set off by a complementary green backdrop.

Aquilegia. Pettifers Garden, Oxfordshire, England.
Nikon F90X with 200mm macro lens. Fuji Velvia ISO 50, 1/500 second @ f4.

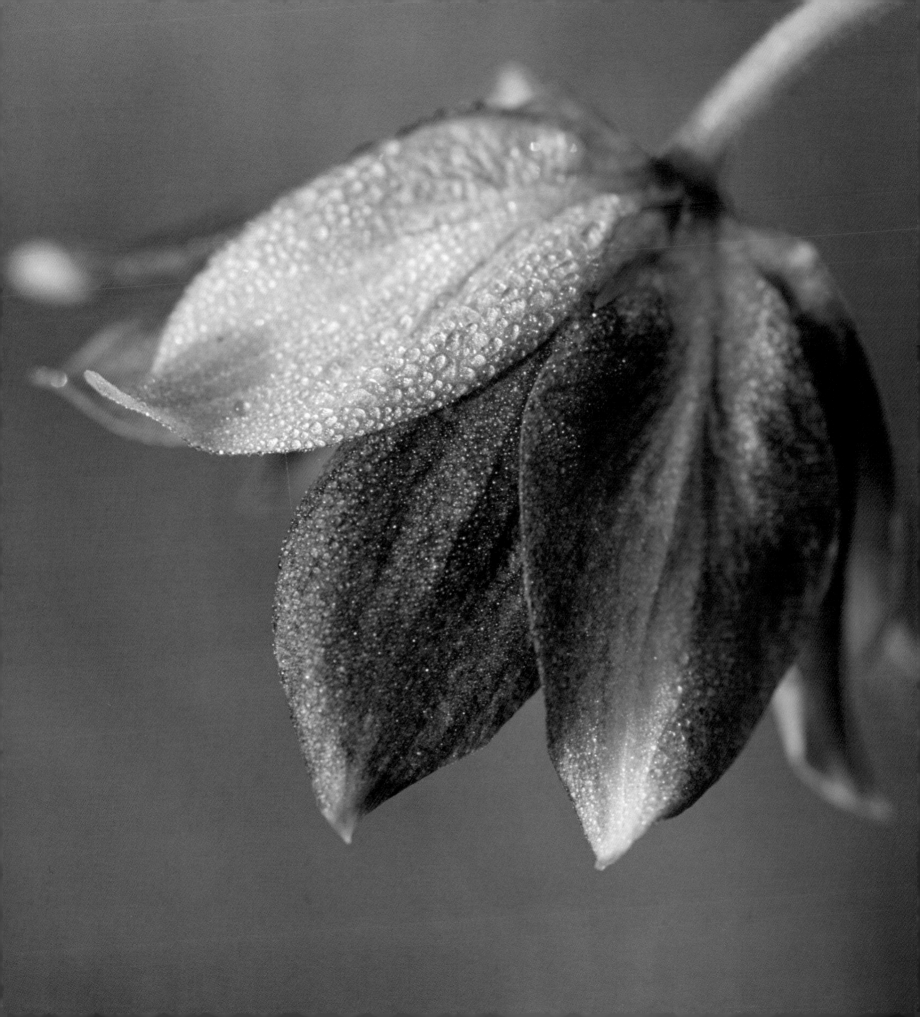

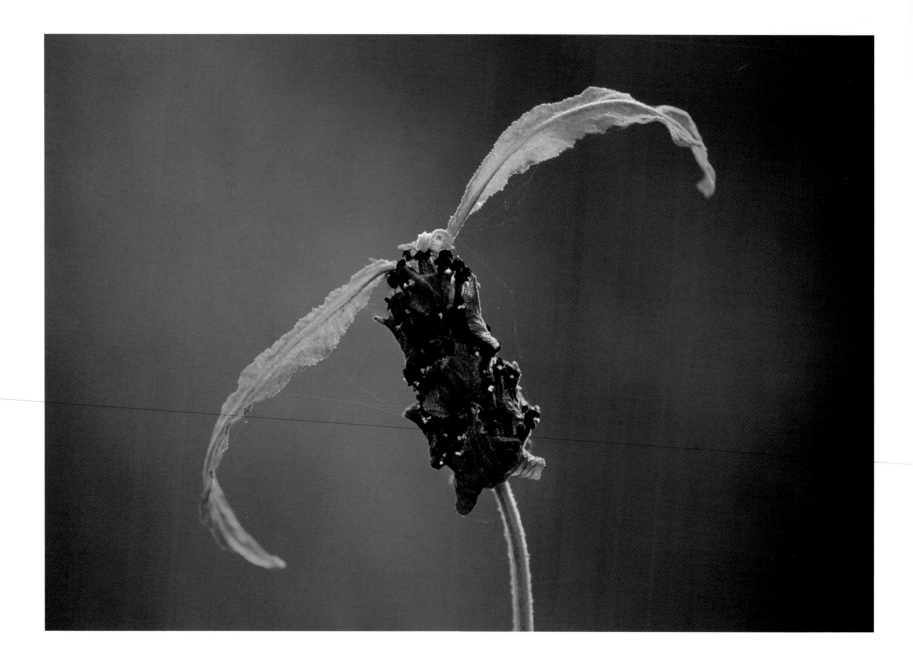

Landscape or portrait

Lavandula pendunculata subsp. *pedunculata.*
Downderry Nursery, Kent, England. Nikon F90X
with 200mm macro lens. Fuji Velvia ISO 50, 1/1000
second @ f4.

When composing a plant image, one of the first decisions that I make while looking at the subject through the viewfinder is how best to frame the shot – in other words, will it look better in portrait or landscape format ? Usually I find that the character and personality of the plant will dictate the format of the picture and nine times out of ten I will instinctively frame the shot. Sometimes, however, I will make a rectangular frame with my hands so that I can pre-visualize how best to frame a subject.

Above, this lavender appears to be 'flying' like an insect on the wing. But what set it apart from other flowers nearby was the quirky, almost humorous angle at which it was poised. The form of the flower cried out for a landscape rather than a portrait format.

Opposite, in contrast to the lavender, the serene, clasped petals of these crocus flowers assume a more upright posture and therefore work well as a portrait-shaped image. To simulate an insect's eye view of the crocus, I chose a ground-level viewpoint, lying flat on my stomach and placing the camera on the grass in front of me.

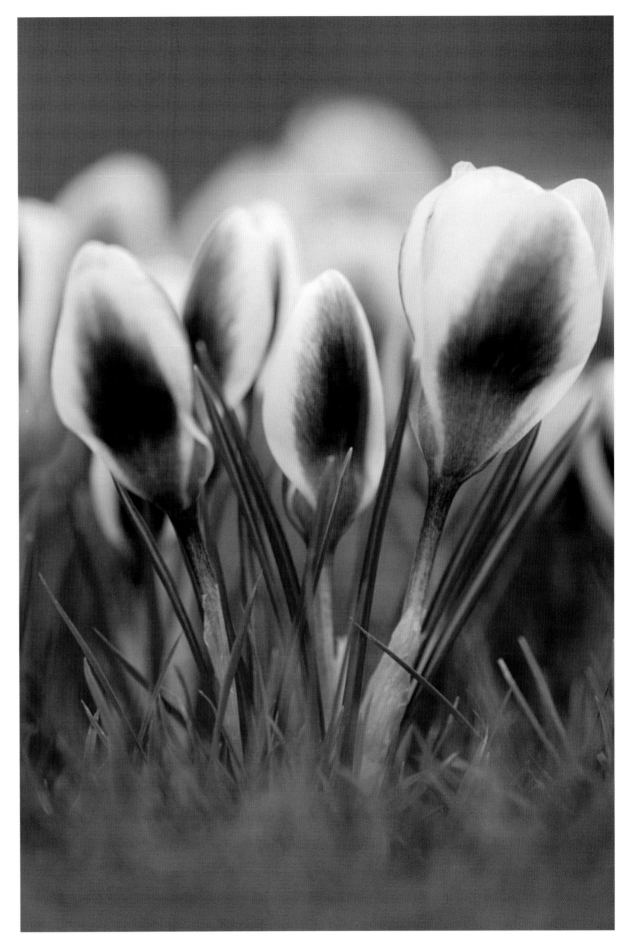

Photographing plants is really no different to photographing people. Each one is an individual with its own personality.

Crocus chrysanthus 'Prins Claus'. Pettifers Garden, Oxfordshire, England. Nikon F90X 200mm macro lens. Fuji Velvia ISO 50, 1/500 second @ f4.

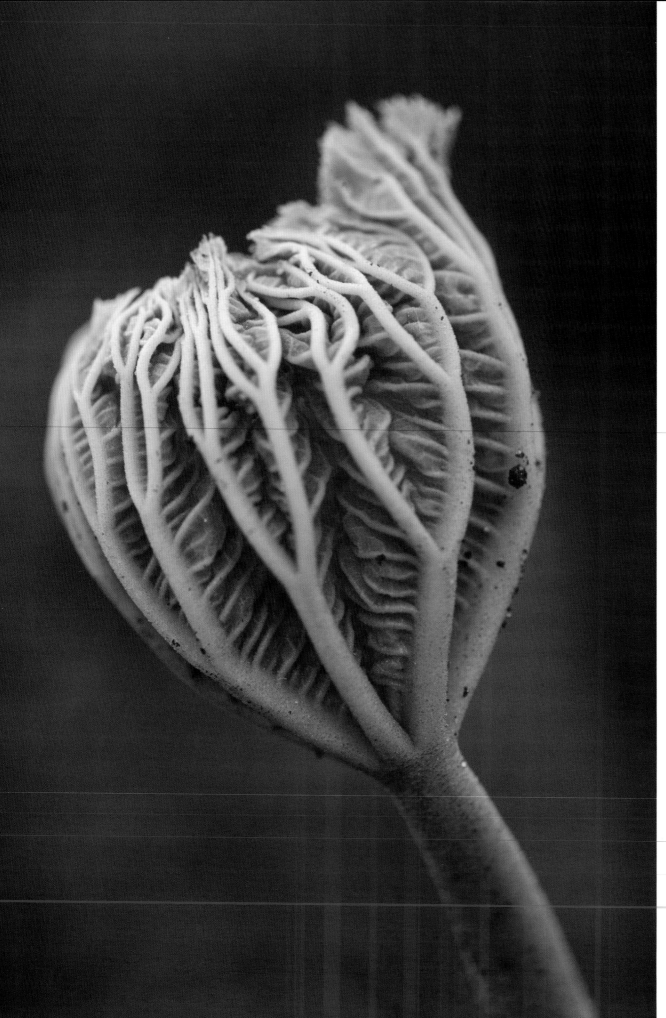

Astilboides tabularis (syn. *Rodgersia tabularis*). Royal Botanic Gardens, Kew, England. Nikon F90X with 200mm macro lens. Fuji Velvia ISO 50, 1/60 second @ f5.6.

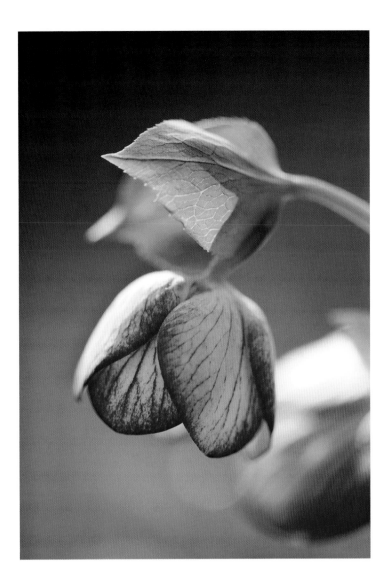

> *I find that building up a set of images based on a specific theme is a great way to improve my photography. Spring is the time for capturing new plants as they emerge into the world.*

Emerging buds

I enjoy trying to capture unusual portraits of plants at various stages of their life-cycle. Recently, I set myself the task of building up a collection of images on the theme of emerging buds. Having a specific goal in mind focuses my work and this in turn helps me to photograph plants in new and exciting ways. Having built up a body of work on a specific theme, I will then think about producing an article or maybe even a book on the subject.

Opposite, this dramatic and unusual image of a rodgersia bud, apparently resembling a clawed dinosaur emerging from its egg, demands attention. The combination of a macro lens, shallow depth of field to create a smooth out-of-focus background and Velvia film really brings out the surface texture of the bud as it unfurls in early spring.

Above right, the delicate, shyly nodding head of this hellebore bud denotes its fragility and femininity. The image captures the beautifully painted underside of the petal, often neglected in photographs for the more showy inner petals. Delicate backlighting inside a glasshouse enhances the bud, bringing it to life

Overleaf, the pendulous emerging buds of this bleeding heart flower were easily captured with a macro lens, inside a glasshouse. The soft, diffused light present inside the glasshouse was ideal for recording the delicate pinks and whites in the flowers and I was able to use the foliage from other nearby plants to create a smooth, brown, out-of-focus backdrop.

Hellebore – *Helleborus* x *hybridus* 'Pink picotee'. Hertfordshire, England. Digital image. Canon IDs Mark II with 180mm macro lens. ISO 100 Raw, 1/60 second @ f8.

Overleaf: *Dicentra spectabilis*. Orchard Dene Nurseries, Oxfordshire, England.. Digital image. Canon IDs Mark II with 180mm macro lens. ISO 100 Raw, 1/250 second @ f5.6.

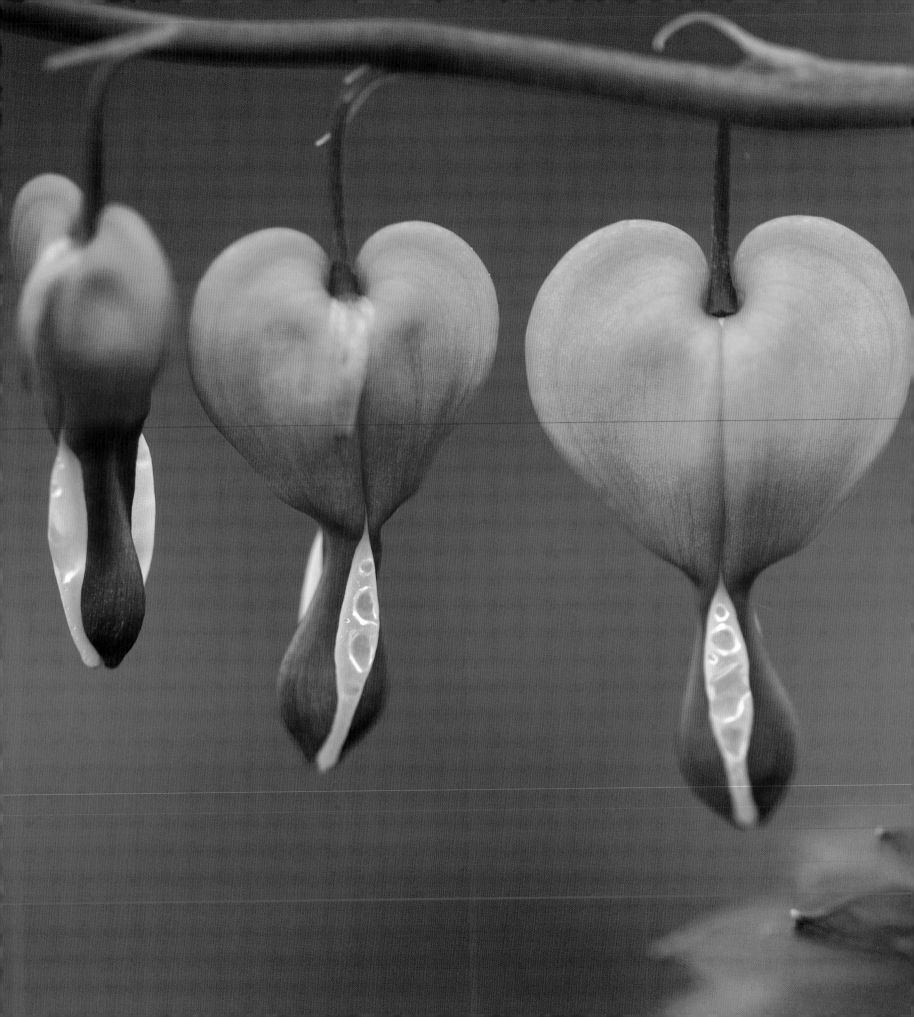

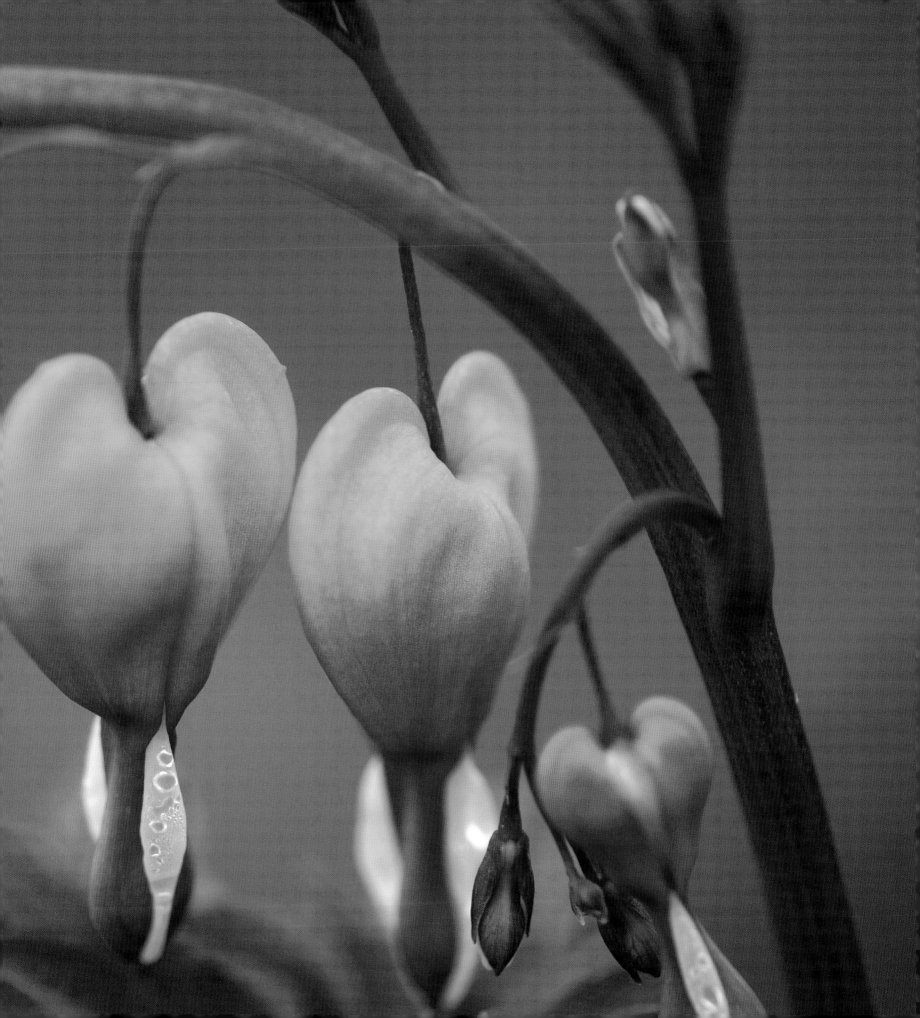

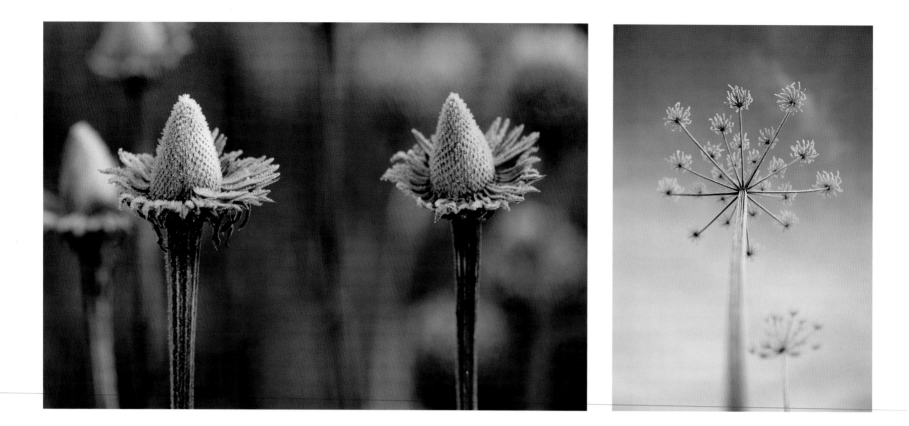

Seasonal portraits

Above: *Echinacea purpurea*. Pettifers Garden Oxfordshire, England. Nikon F90X with 200mm macro lens. Fuji Velvia ISO 50, 1/30 second @ f8.

Above right: Umbellifer. Digital image. Canon IDs Mark II with 16-35mm wide-angle lens. ISO 100 Raw, 1/60 second @ f11.

There is something incredibly photogenic about plants that are coated in a thick dusting of frost. I find them totally irresistible. If I wake up to a frost, I will abandon my plans for the day and rush outside to capture some new subject on film. I work quickly, the adrenalin pumping, as the sun can melt the frost in an instant.

Above left, I tried to give a slightly whimsical feel to this image of two frost-coated *Echinacea* seed heads, seemingly in conversation. The frost delicately picks out the subtle form of the flowers' cones, which are set against a bronze background of dead perennials in a border.

Above right, the hedgerows surrounding my barn in Northamptonshire are packed with umbellifers which dry to a crisp brown in winter. When they are dusted in frost, however, they turn a beautiful creamy white. I set out early one morning in November with the specific intention of capturing these plants from a slightly unusual viewpoint and eventually I decided to shoot from a low angle, up into the plant, using the blue winter sky as a backdrop. I shot the image with a wide-angle lens, which exaggerates perspective, making the flower appear more imposing.

Opposite, for me, plant portraiture is all about capturing the very essence, or character, of a plant. The whole *raison d'etre* of the contorted hazel, *Corylus avellana* 'Contorta' is its twisting, tortured form, so that is what I set out to portray in this frosted winter portrait. A 200mm macro lens has allowed me to isolate the end of this corkscrew-like branch against a dramatic, inky blue backdrop.

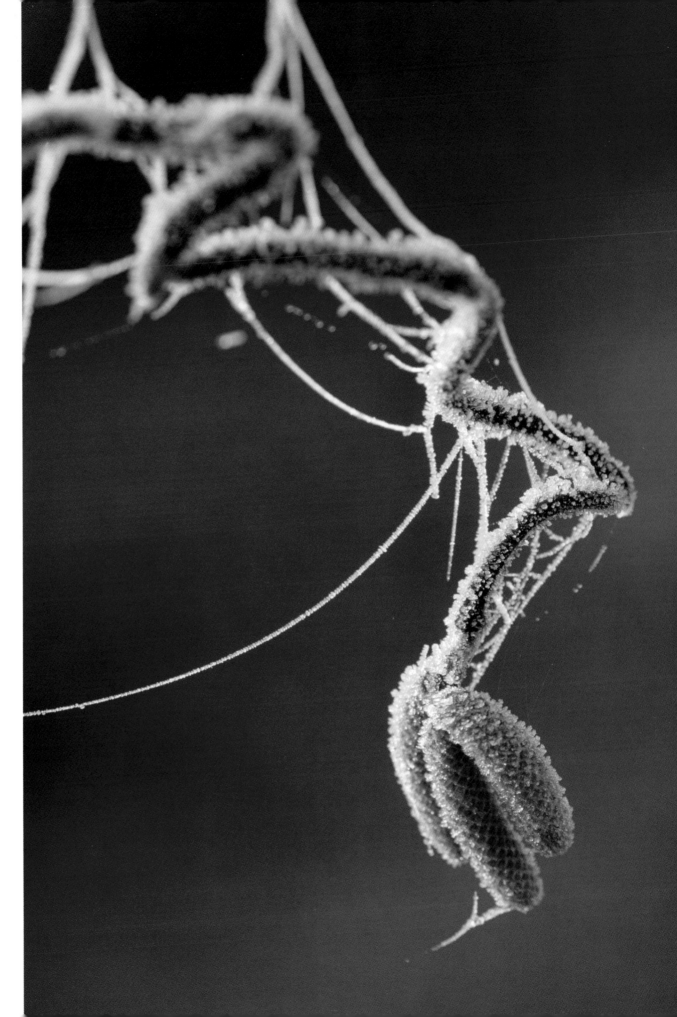

The changing seasons continually provide new and ever-changing photographic possibilities and winter can be one of the best times for making plant portraits – offering subjects such as the skeletal remains of shrubs and flowers.

Corylus avellena 'Contorta'. Pettifers Garden, Oxfordshire, England. Nikon F90X with 200mm macro lens. Fuji Velvia ISO 50, 1/2 second @ f5.6.

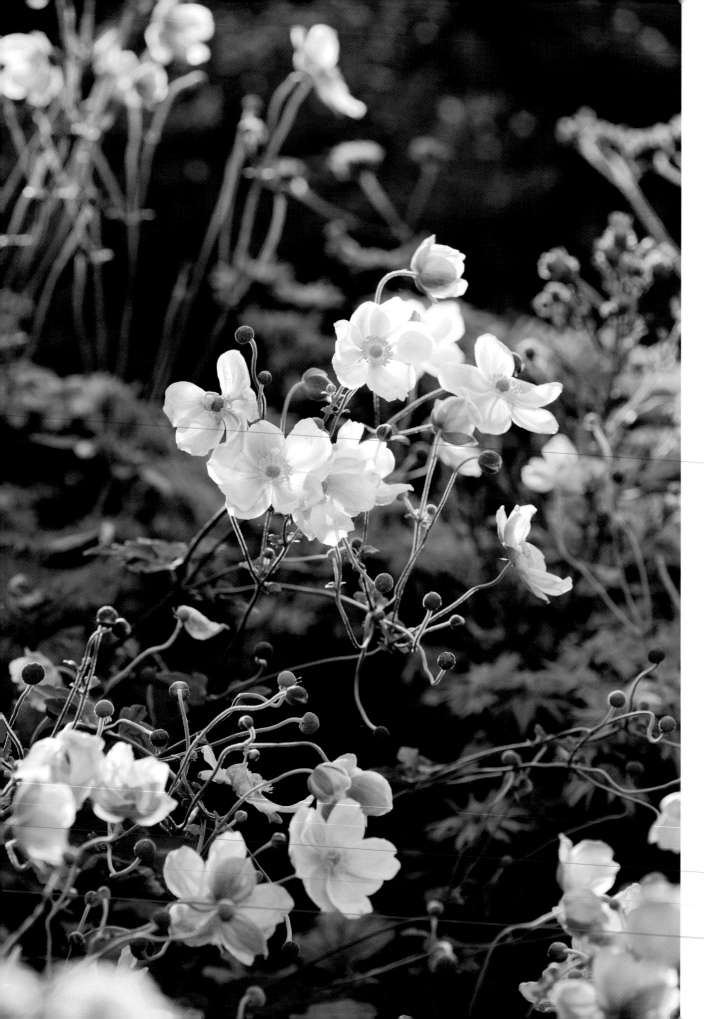

I find the best way to make a plant or group of plants stand out from their surroundings is by selective focusing and the use of a large aperture with either a macro or telephoto lens.

Anemone × hybrida 'Königin Charlotte'. RHS Garden, Wisley, Surrey, England. Nikon F90X with 80-400mm zoom lens. Fuji Velvia ISO 50, 1/4 second @ f8.

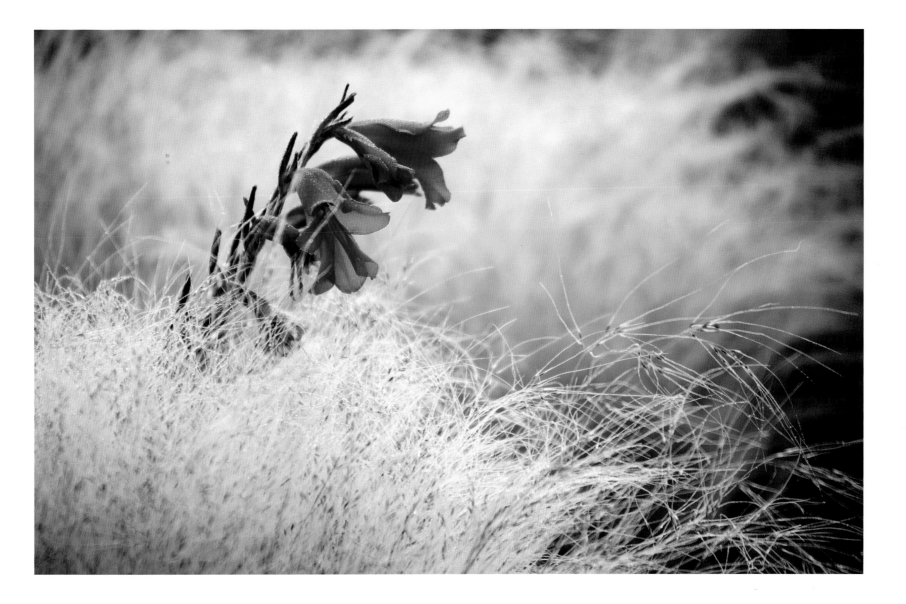

Out of the crowd

Few garden plants are naturally isolated in beds and borders. Most are jostling for space with other plants and it is often difficult to make a plant or group of plants stand out from the crowd. One tried and tested method that I adopt is to wait until the light is dappled, falling on some subjects, but not on others.

Opposite, *contre-jour* light is the key to this shot of Japanese anemones in an autumn border in the RHS Garden at Wisley in Surrey. The rich, evening backlight highlights the soft pink, tissue paper-like flowers, making them stand out from their shadowy background.

Above, a solitary magenta flower stalk of *Gladiolus communis* subsp. *byzantinus* emerges from a delicate froth of *Stipa tenuissima* in Gina Price's garden at Pettifers in Oxfordshire. I used a macro lens and shallow depth of field in order to make the subject jump out from its surroundings.

Overleaf, I wanted to photograph these amazing lupins in panoramic format like skyscrapers in a cityscape. I shot the picture on my Canon digital camera and then cropped the image later in Photoshop, being careful not to include any of the greenhouse in which they were growing, as this would have reduced the impact of the shot. I stopped down to f22 with a wide-angle to get everything sharp from front to back.

Gladiolus communis subsp. *byzantinus*. Pettifers Garden, Oxfordshire, England. Digital image. Canon IDs Mark II with 70-300mm zoom lens. ISO 100 Raw, 1/15 second @ f8.

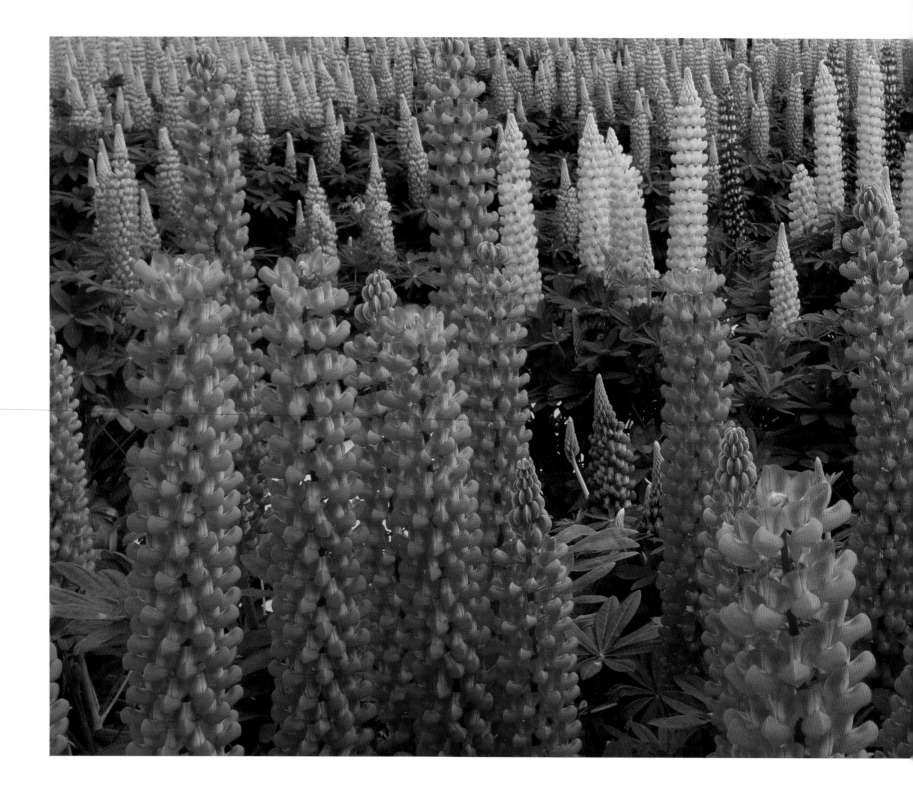

Lupin Nursery, Devon, England. Digital image. Canon
1Ds Mark II with 16-35mm wide-angle lens. ISO 100
Raw, 1/60 second @ f22.

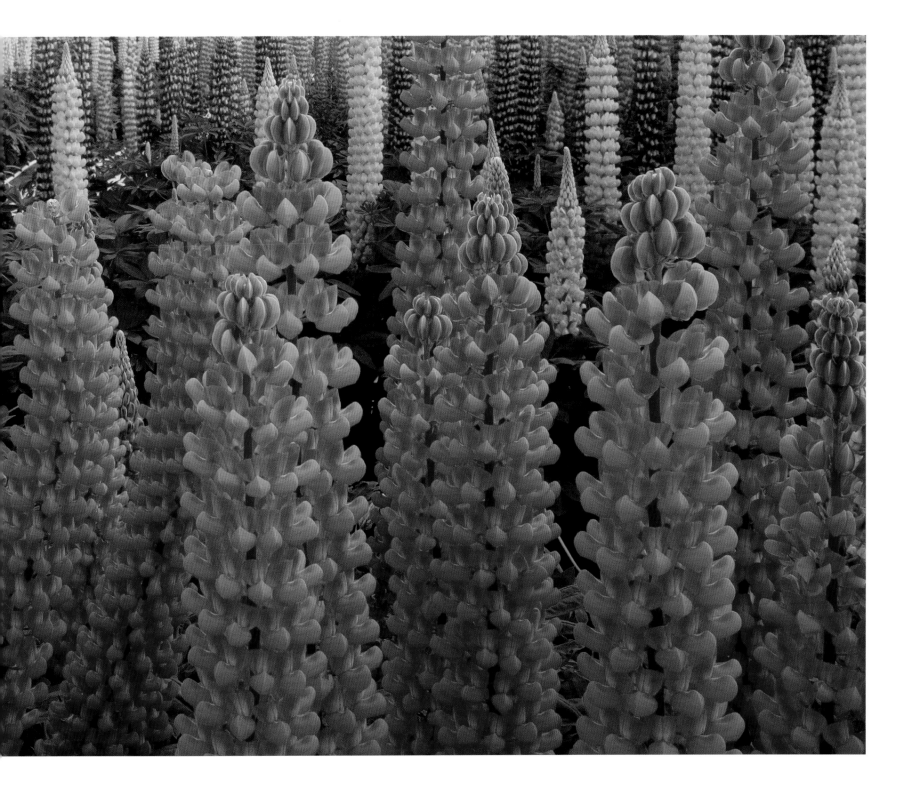

Cropping an image, either through the viewfinder or on the computer screen post-capture, makes it easy to remove unwanted elements from a composition.

Gardens

Great garden photographs are the holy grail of garden photography. Quite simply, they are extremely difficult to take. Not only has the light got to be right, but the garden itself must be at its absolute best. Being in the right place at the right time is essential. I have found, not surprisingly, that most of my best garden shots have been taken in gardens that are very close to where I live, because I have been able to pick and chose the days when I want to photograph.

It is almost impossible to photograph a whole garden in just one visit, especially a large garden which is likely to have different areas that may 'peak' at different times of year. For this reason I like to photograph a garden over a long period, returning frequently to capture it in different seasons, moods and light. Building a good relationship with garden owners and designers is essential for me as I often need to access the gardens at unsociable hours – this can be as early as 4.30a.m. in the morning and as late as 9.30 p.m. in the evening. Without their support, I would have few subjects to photograph. Many have become great friends, phoning me on a regular basis with updates of how their gardens are looking and informing me of the latest seasonal 'highlights'.

Opposite, I had been monitoring the condition of this magnolia tree for several days, The garden owner, Gina Price, had called me the previous afternoon to say that the magnolia was at its best and knowing that this area of meadow would get early morning sunlight, I made sure my camera was set up at dawn the following day. The picture was taken with a wide-angle lens on a medium-format camera.

Pettifers Garden, Oxfordshire, England. Pentax 6x7 with 55mm wide-angle lens. Fuji Velvia ISO 50, 1/8 second @ f22.

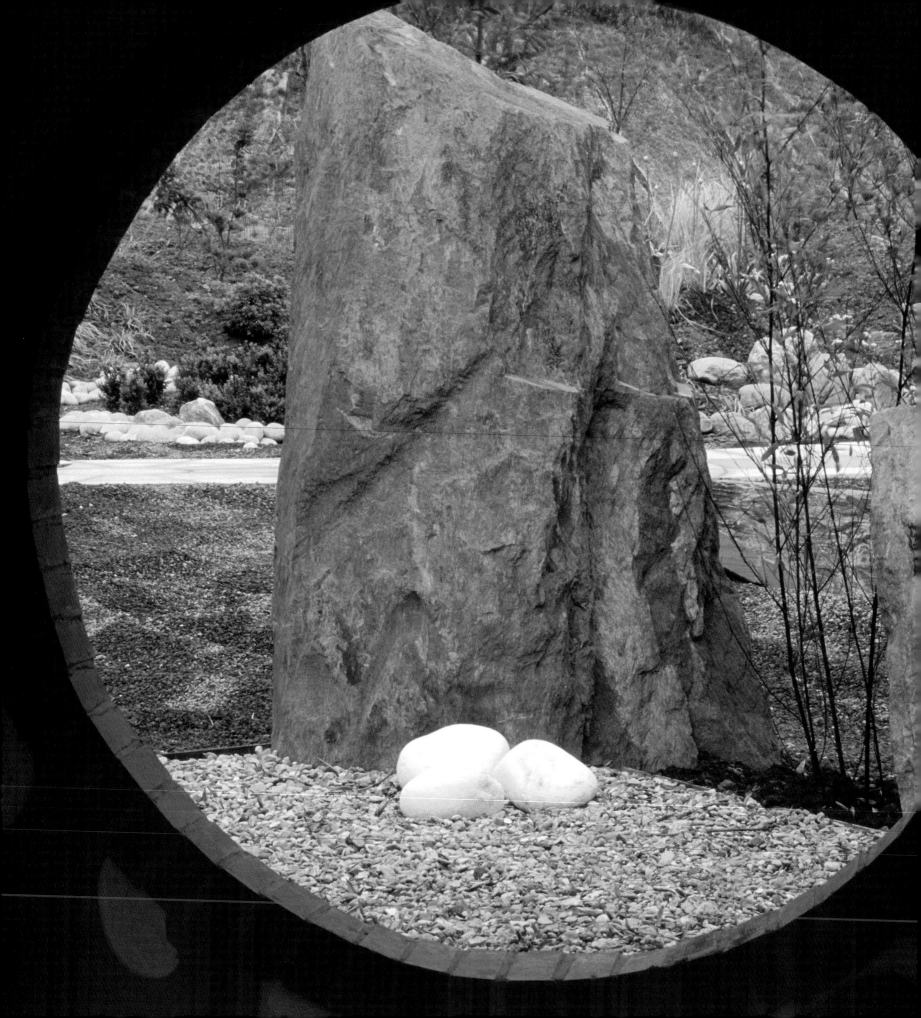

Framing the view

Like a picture on a wall, many garden vistas can be improved if they are given a 'frame'. Archways, pergolas, doorways, gates, openings in hedges – all can be used to frame the view of a scene beyond, drawing your eye into or out of a garden. When I am first scouting a garden, I am constantly on the look out for scenes that are framed in this way. If the light is right, I will try to shoot them straight away; if not, I will make a mental note to return another time.

Opposite, a moon gate perfectly frames this Japanese garden. Here the designer has done the work for me, creating a wonderful 'through the keyhole' view. The sharp contrast, dark to light, from frame to scene draws your eye inevitably to the focal point of the rock.

Above, the garden at Fovant Hut, in Hampshire, relies heavily on the 'borrowed landscape' surrounding it for its design and atmosphere. Here I have used a mature oak tree to frame the landscape beyond. I arrived at the garden shortly after dawn and stopped down to f32 on my medium-format Pentax 6x7 in order to render the whole scene sharp from front to back.

Opposite: Garden designed by Robert Ketchell and Jacquie Blakeley, England. Nikon F90X with 80-400mm zoom lens. Fuji Velvia ISO 50, 1/15 second @ f22.

Above: Fovant Hut, Wiltshire, England. Pentax 6x7 with 135mm macro lens. Fuji Velvia ISO 50, 3 seconds @ f32.

Designers use paths to
take visitors on a journey
through a garden. As
photographers, we can
take pictures which lead
the viewer on the same
visual journey.

Woodchippings, Oxfordshire, England.
Nikon F90X with 80-400mm zoom lens.
Fuji Velvia ISO 50, 1/4 second @ f22.

Up the garden path

Pictures taken along a garden path are often successful because they lead your eye from the front to the back of the composition, thereby increasing the sense of depth in the photograph.

Opposite, an early morning view along this path in the cottage garden at Woodchippings, in Northamptonshire, was captured with an 80-400mm zoom lens. The zoom has allowed me to make a fairly tight crop, with two focal points – the stone sundial and the piper statue – drawing the viewer through the picture and adding a sense of depth to the composition.

Above, the main focal point at the end of this path in Tony Ridler's garden in Swansea, Wales, is a modern sculpture by Helen Sinclair. A zoom lens has enabled me to make a tight crop and shooting towards the light backlights the hedging and clipped box pyramids in a pleasing way. I took the picture from the top of a garage, which has given a slightly elevated perspective to the shot

Overleaf, being in the right place at the right time was the key to this photograph of the allium walk at Lady Farm, Somerset. I woke at 2.30a.m. and drove over 100 miles to the garden so that I could catch the dawn light. The picture was taken at 4.45a.m. using a wide-angle lens on my Pentax 6x7. Shooting towards the light, I made sure the path enters the photograph at the bottom left and leaves through the top right, thus drawing your eye through the picture.

Ridler's Garden, Swansea, Wales. Nikon F90X with 80-400mm zoom lens. Fuji Velvia ISO 50, 1/15 second @ f22.

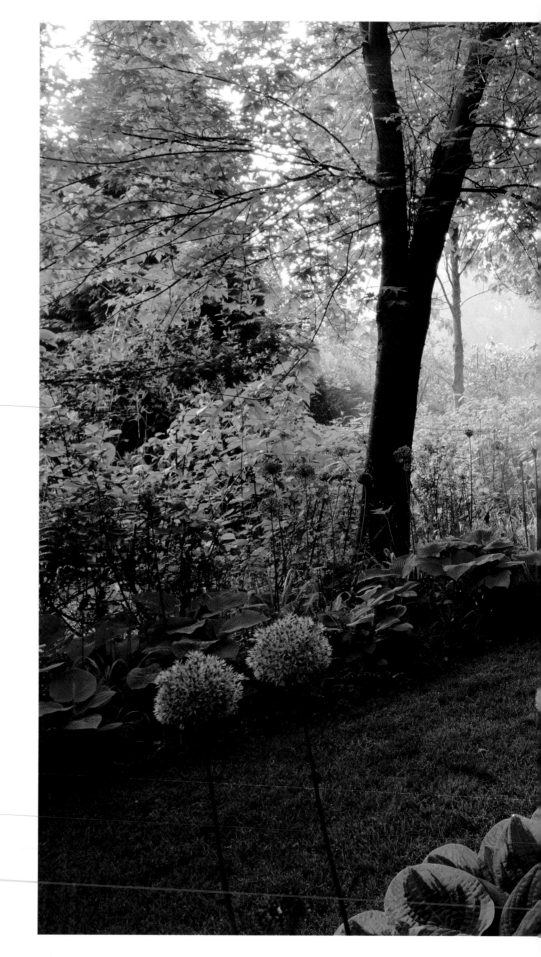

To get the right light I always try to be in the right place at the right time and that can often mean a very early, pre-dawn start to the day.

Lady Farm, Somerset, England. Pentax 6x7 with 55mm wide-angle lens. Fuji Velvia ISO 50, 4 seconds @ f22.

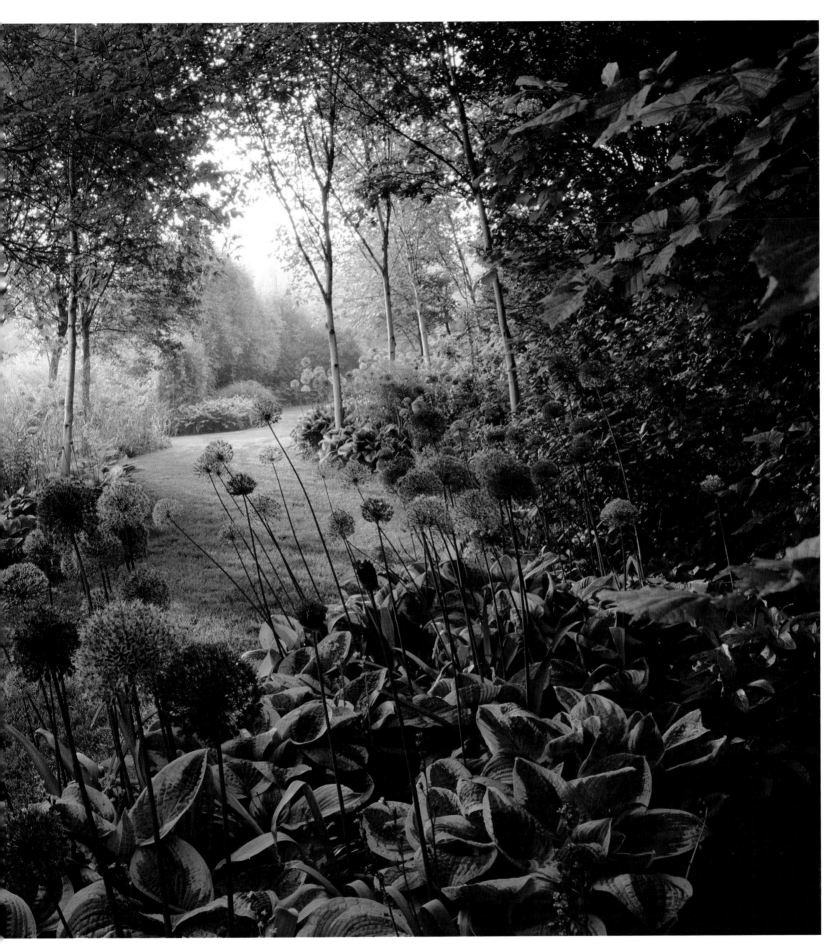

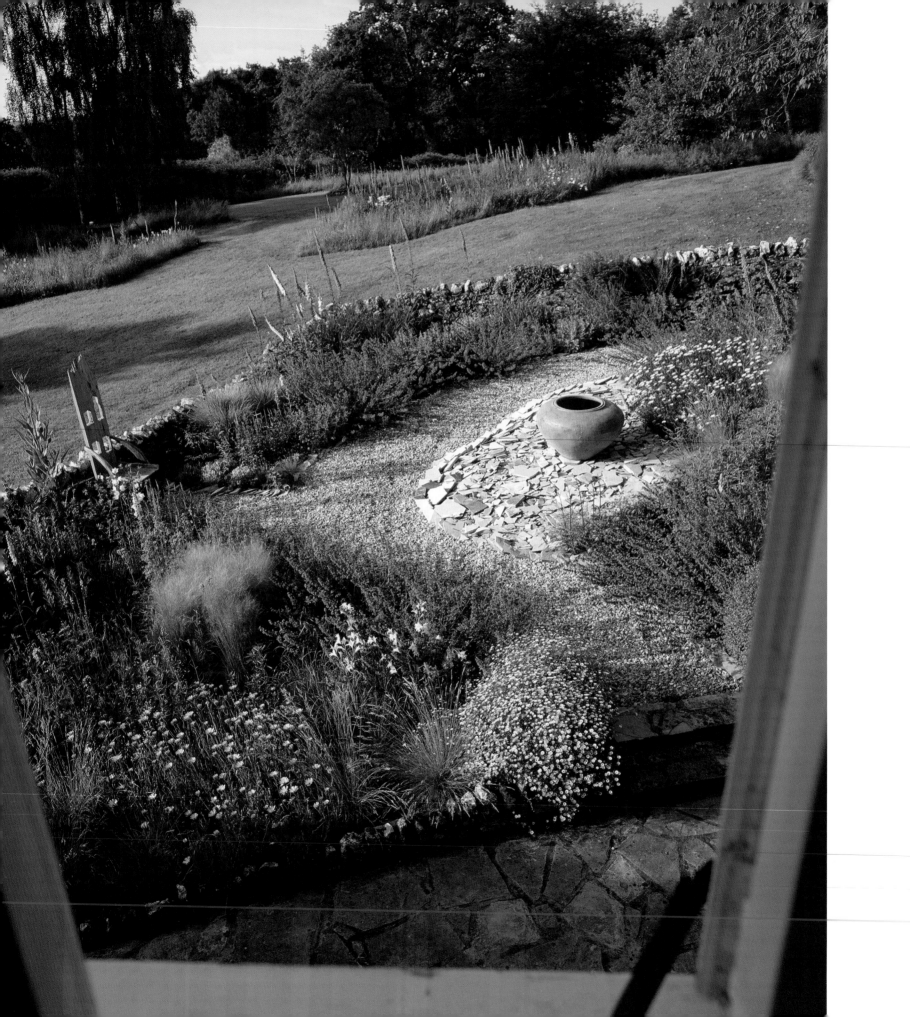

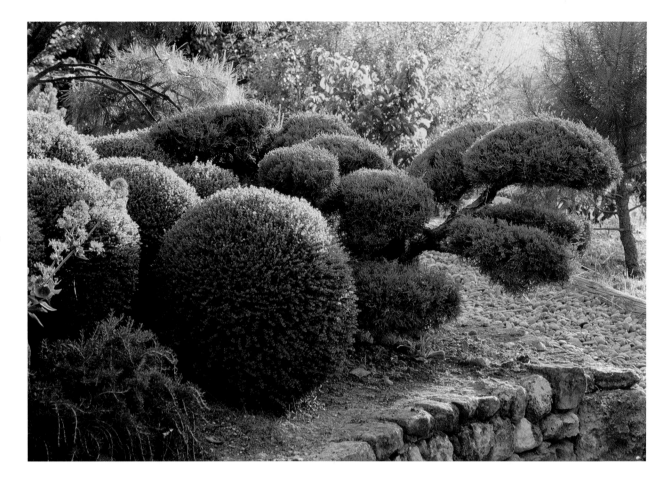

I usually find that country gardens offer more shooting possibilities than their more restricted urban counterparts; although, being more open, they are often more exposed and windy.

Country gardens

I love shooting country gardens. Unlike urban gardens, where the only way into the garden may be through the front door of a property, many country gardens are easy to access, making early morning shoots much easier and avoiding any disturbance to the gardens' owners. In addition, many country gardens receive amazing early morning or late evening sunlight, so as long as I am prepared to rise early and hang around late into the evening, I can usually guarantee shooting some really atmospheric images. A major problem can be the amount of wind in some exposed country locations. My previous garden faced west and was almost always windy, so I had to be patient and wait for the rare moments, usually in the evening, when the wind dropped.

Opposite, this bird's-eye view of Clare Matthews' walled gravel garden in Devon was taken from a bedroom window. A high viewpoint combined with a wide-angle lens gives a pleasing early morning vista. I took great care not to drop any of my camera equipment out of the window.

Above, I used a zoom lens to isolate this beautiful piece of topiary in a private garden in the Luberon, France. Shooting directly towards the evening sunshine has bathed the whole scene in a golden glow. I used a lens hood on my zoom to ensure that there was no direct sunlight hitting the front of the lens, as this would have resulted in flare.

Opposite: Clare Matthews' garden, Devon, England. Pentax 6x7 with 55mm wide-angle lens. Fuji Velvia ISO 50, 1/8 second @ f22.

Above: Private garden, the Luberon, France. Nikon F90X with 80-400mm zoom lens. Fuji Velvia ISO 50, 1 second @ f22.

Overleaf: Garden designed by Stephen Woodhams, London, England. Pentax 6x7 with 55mm wide-angle lens. Fuji Velvia ISO 50, 1/60 second @ f22.

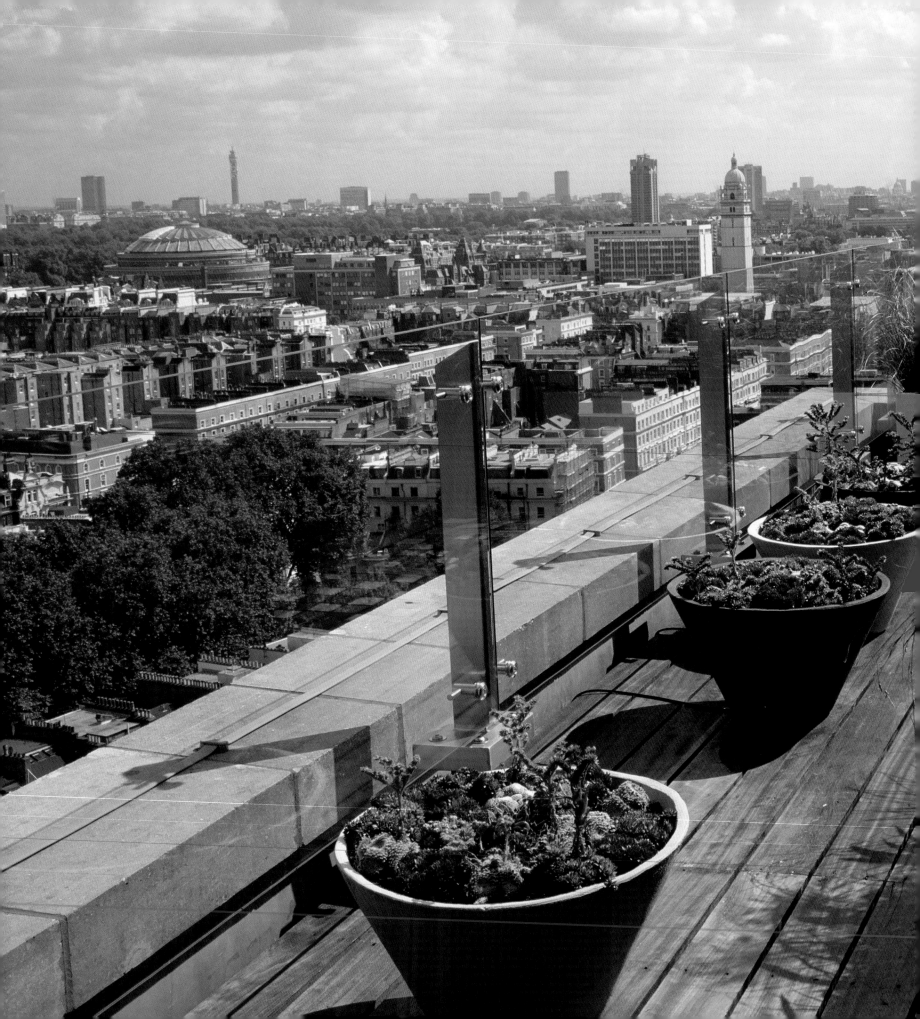

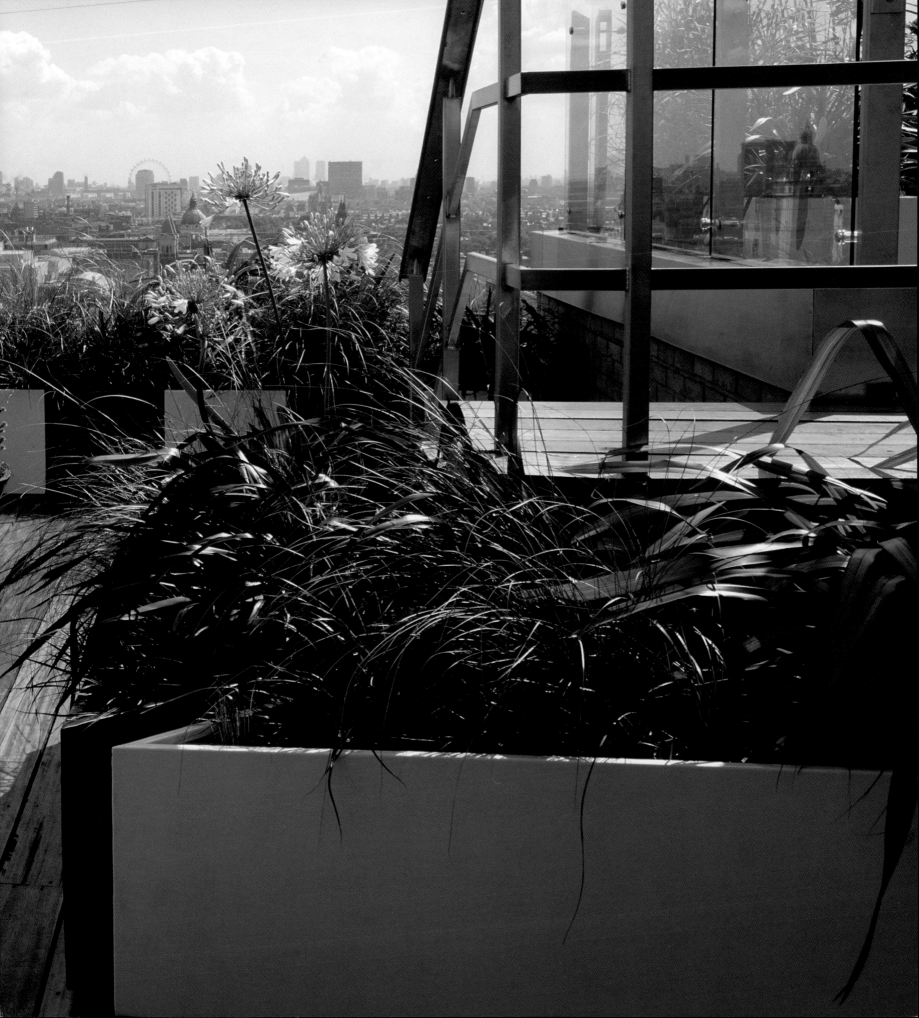

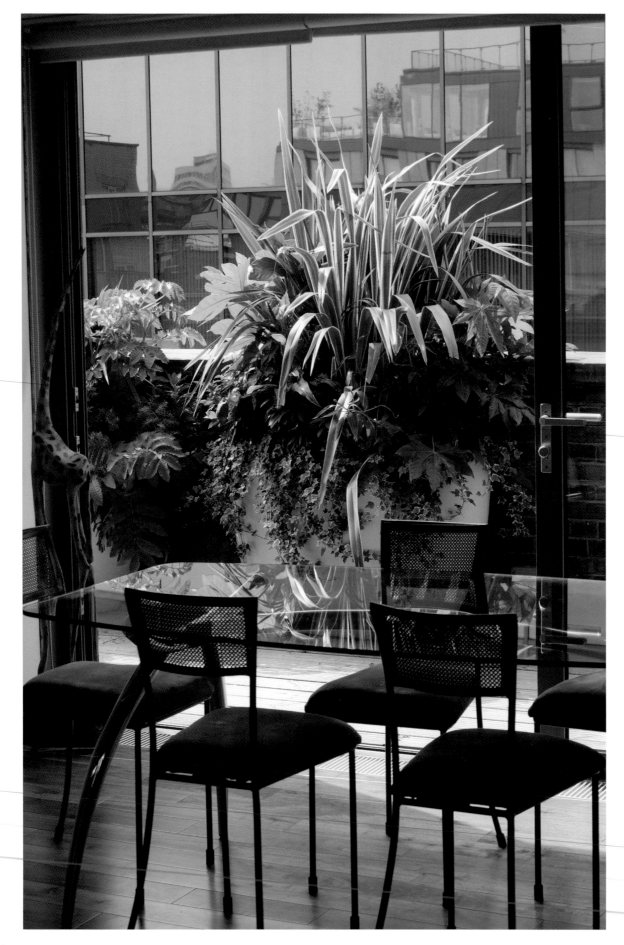

Urban gardens, with their confined spaces, tend to be easier to shoot in bright, overcast light than under clear blue skies.

Garden designed by Suzi Watson, London, England. Nikon F90X with 80-400mm zoom lens. Fuji Velvia ISO 50, 1/2 second @ f22.

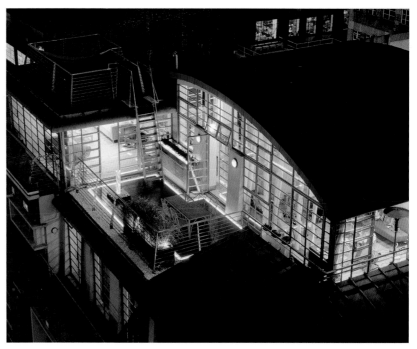

Urban gardens

Urban gardens present a different kind of challenge to those in the country. For a start, they are usually quite small and are often hemmed in by other buildings, so often I find myself working in quite confined spaces. Unlike most country gardens, access can be a real problem. I find that few houses in central London, for example, have side entrances and that the only way into the back garden is through the house or flat itself. I work quite closely with garden designers, so that I can keep up with trends and gain access to new projects before a flat or apartment is sold, which makes access much easier. Urban gardens, with their emphasis on design and hardscaping, are usually best photographed shortly after completion, when the hard materials – paths, walls and fences – are looking pristine.

The sensational roof garden by Stephen Woodhams, shown on the previous spread, has panoramic views over central London that I was keen to include in the photograph. For this reason I opted for a wide-angle lens and chose a viewpoint where half the image covers the garden and the other half consists of the surrounding cityscape. I took the picture on a sunny morning so that there was colour and interest in the sky.

Above left, because many city gardens are hemmed in by surrounding buildings, they can often be in deep shade for much of the day. For this reason I prefer to shoot on cloudy, overcast days when the light is much softer. This shot of a garden in central London was taken on just such a day. I used a wide-angle lens on my medium-format Pentx 6x7 in order to show the garden in its urban context.

Above right, increasingly, city dwellers are asking for their gardens to be lit at night so that they can be enjoyed after dark. I took this picture of a garden in central London designed by Stephen Woodhams from the top of a twenty-storey apartment block nearby. I took the picture at dusk, when there was a nice balance between the artificial lighting and the ambient natural light.

Opposite, for this 'inside out' shot of a roof terrace I used a zoom lens to narrow the angle of view, juxtaposing the simple glass table and chairs inside the flat with the lushly planted containers on the terrace and the modern glass offices beyond. The containers were planted by Suzi Watson.

Above left :Garden designed by Alison Wear Associates, London, England. Pentax 6x7 with 55mm wide-angle lens. Fuji Velvia ISO 50, 1/60 second @ f22.

Above right: Garden designed by Stephen Woodhams, London, England. Pentax 6x7 with 135mm macro lens. Fuji Velvia ISO 50, 10 seconds @ f22.

Weather

Whilst I can decide on subject matter and target a certain location, I can do little to influence the weather. Forecasts make it easier to plan the best day if I have the luxury of choosing from a selection of shoot days, but often I have to just work with what nature throws at me. This year for example, the Chelsea Flower Show, normally a reliable source of fresh garden imagery, was wet and windy every single day. Weeks later the Hampton Court Flower Show brought a searing heat wave, brutal sunlight and cloudless skies. Learning to get the best out of such adverse conditions has pushed my technique into new and exciting areas. I am constantly checking the weather on the internet and on television, trying to work out which days in the week ahead will be best for outdoor photography. The key thing that I look out for is wind speed. I find it much easier to work on days when the wind speed is five miles per hour or less. Thankfully many sites on the internet now include this information and a decision on which days to shoot and in which part of the country is now just a mouse click away.

Phormium 'Evening Glow', Pettifers Garden,
Oxfordshire, England. Nikon F90X with 200mm
macro lens. Fuji Velvia ISO 50. 1/8 second @ f4.

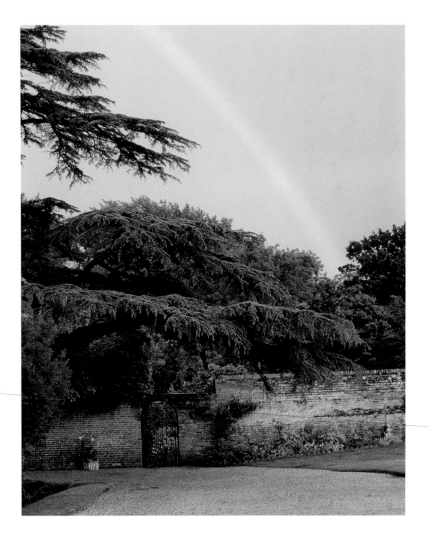

I find that some of the most dramatic lighting conditions often occur just before a big storm, when the sun is still shining but the clouds are dark and ominous.

Rain

Private garden, Berkshire, England. Nikon F90X with 80-400mm zoom lens. Fuji Velvia ISO 50, 1/2 second @ f22.

Although I find it frustrating and almost impossible to take pictures in very heavy rain, I often venture outside in light showers, especially on those days when light levels are good and there is little or no wind. On such occasions I am often rewarded with dramatic images of raindrops clinging to leaves, petals and buds. Colour, too, takes on a different, more saturated quality in such conditions. Rain splashed leaves and berries seem to shine out, especially in soft light or when backlit. Some photographers use a fine water spray to replicate raindrops but somehow the resulting images always look slightly staged and unnatural.

Previous page, the phormium leaf appears rich and vibrant just after a downpour, its waxy coating holding tight to a snakeskin of water droplets. I used a 200mm macro and Fujichrome Velvia film and set an aperture of f4 to obtain a very shallow depth of field.

Opposite, these chrysanthemums were shot on a soaking wet day in October at the RHS garden at Wisley in Surrey. Whilst the raindrop on the central flower is the focus of attention, the crystal clear, yet diffused light lends an almost watercolour-like freshness to the scene.

Above, rainbows are rare, elusive and transient so you need to be alert to capture them. Being in the right place at the right time is crucial. Here I dodged several storms before I was eventually rewarded with this memorable rainbow that appeared for just a few seconds above an old yew tree and garden wall.

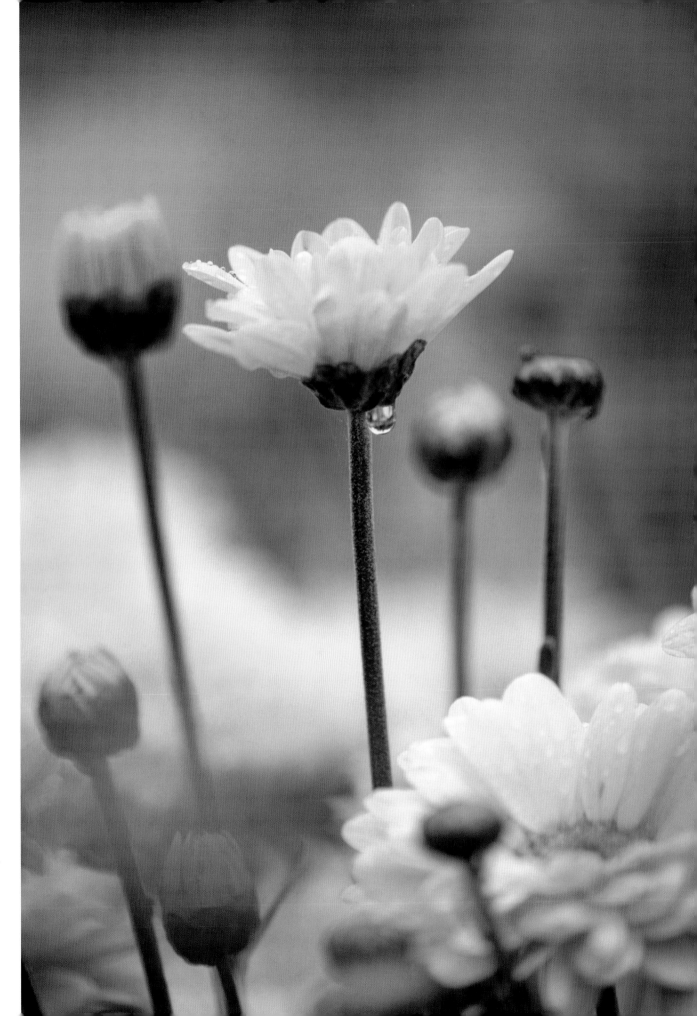

Chrysanthemum 'Caukeel Candy'.
RHS Garden, Wisley, Surrey, England.
Nikon F90X with 200mm macro lens.
Fuji Velvia ISO 50, 1/15 second @ f4.

Overleaf: Birtsmorton Court,
Worcestershire, England. Digital
image. Canon 1Ds Mark II with 16-
35mm wide-angle lens. ISO 100 Raw,
1/30second @ f11.

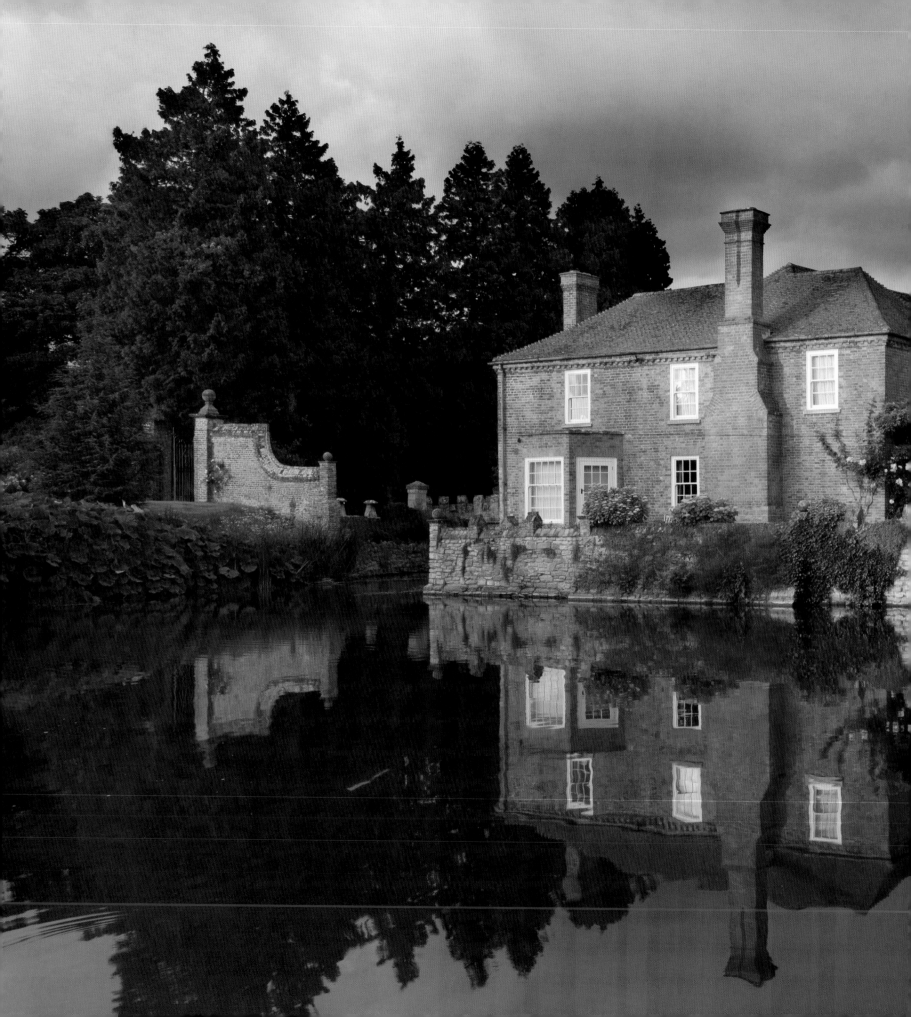

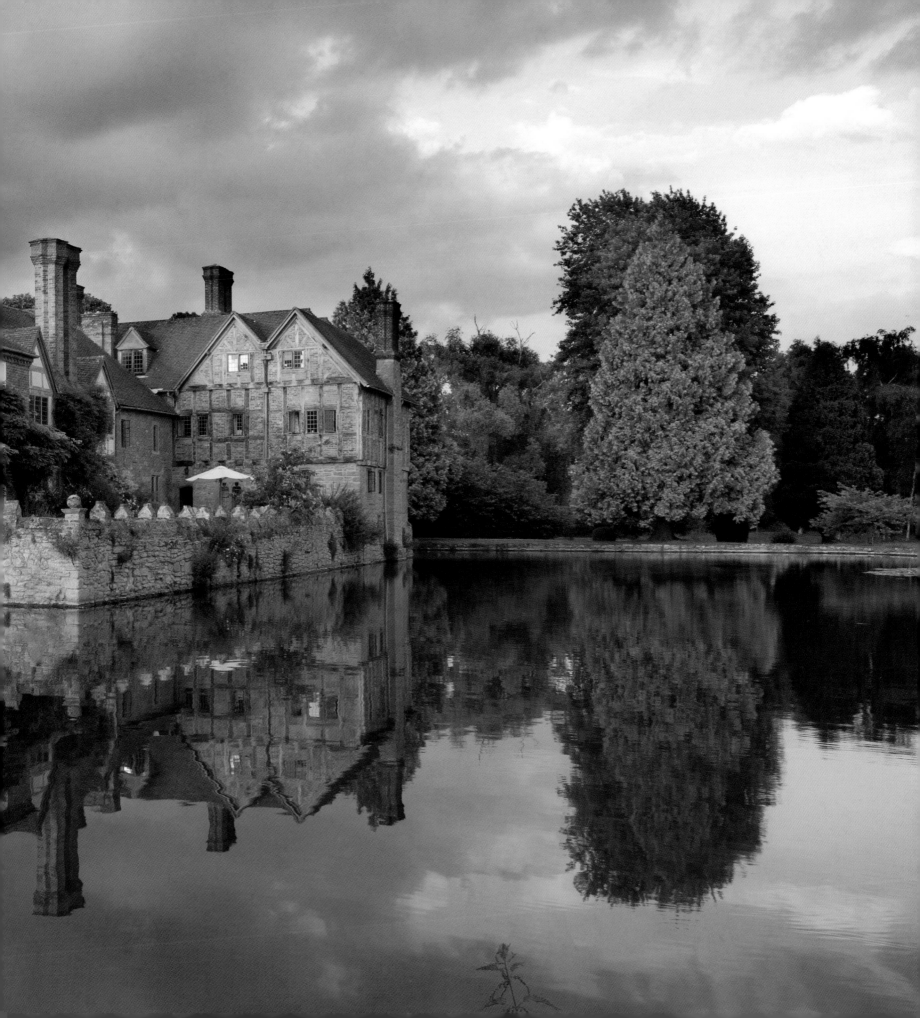

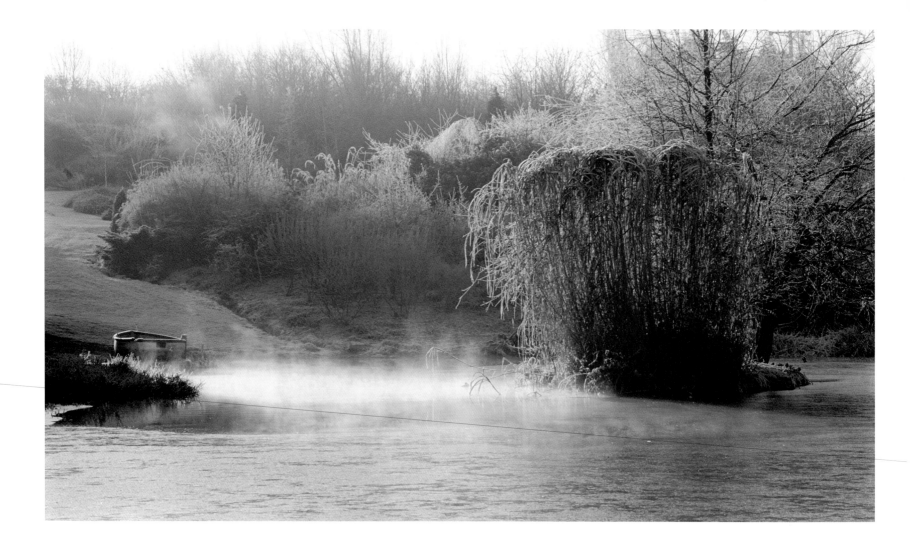

Mist and fog

Lady Farm, Somerset, England. Nikon F90X with 80-400mm zoom lens. Fuji Velvia ISO 50, 2 seconds @ f22.

I love mist and fog because of the unusual, ethereal atmosphere that they give to gardens. Because mist and fog almost always occur first thing in the morning and tend to evaporate quickly, I find it essential to arrive at my chosen location by dawn. Mist and fog tend to desaturate colours, giving them more of a monochromatic appearance when photographed. For this reason I usually look for subjects which have strong form and that work well as silhouettes, like the grass and metal sculpture opposite. Gardens which have large expanses of water, such as the lake at Lady Farm, in Somerset, above, tend to photograph well as mist often rises from the water's surface, adding a feeling of serenity to the scene. Here I used a zoom lens to isolate a section of the lake. The rowing boat to the left of the shot gives scale to the composition.

The *Molinia,* opposite left, was photographed on a misty morning in November at Marchants Hardy Plants Nursery in Sussex, using a macro lens. Mist has helped to diffuse the background and soft backlight makes the grass stems appear quite brittle, as if they could be snapped off with just the slightest touch.

Opposite right, a delicate metal sculpture rising from a pool of swirling mist at Lady Farm in Somerset. The form of the sculpture, rimed with frost, is accentuated by the strong dawn backlighting and was captured with a zoom lens.

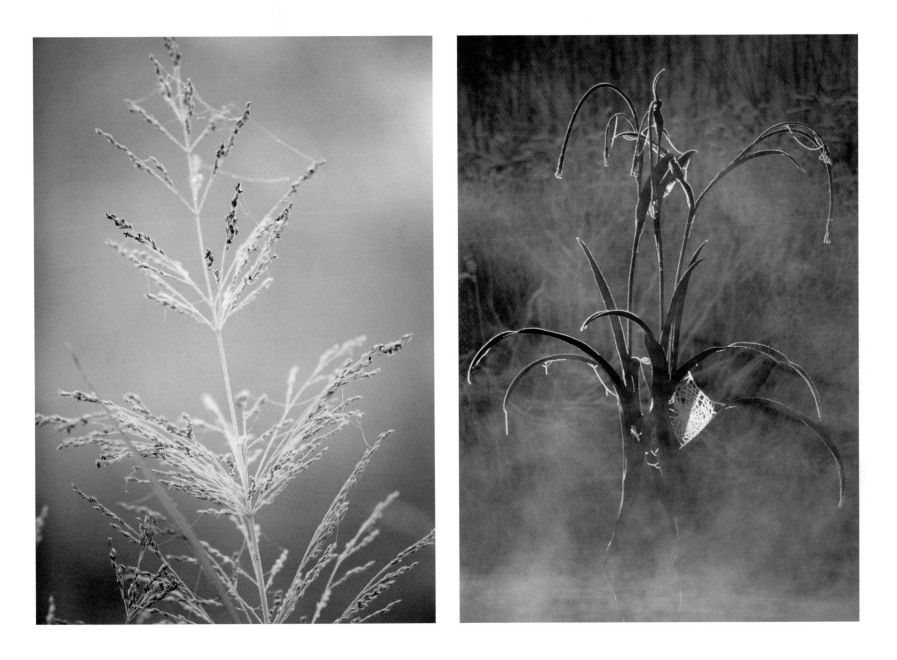

> Rising mist, caught in the first rays of the morning sunshine, has an extraordinary ability to bring a scene dramatically to life.

Above: *Molinia* 'Transparent'. Marchants Hardy Plants, Sussex, England. Digital image. Canon IDs Mark II with 180mm macro lens. ISO 100 Raw, 1/15 second @ f5.

Above right: Lady Farm, Somerset, England. Nikon F90X with 80-400mm zoom lens. Fuji Velvia ISO 50, 1/4 second @ f8.

Overleaf: Great Fosters, Surrey, England. Pentax 6x7 with 55mm wide-angle lens. Fuji Velvia ISO 50, 1/30 second @ f22.

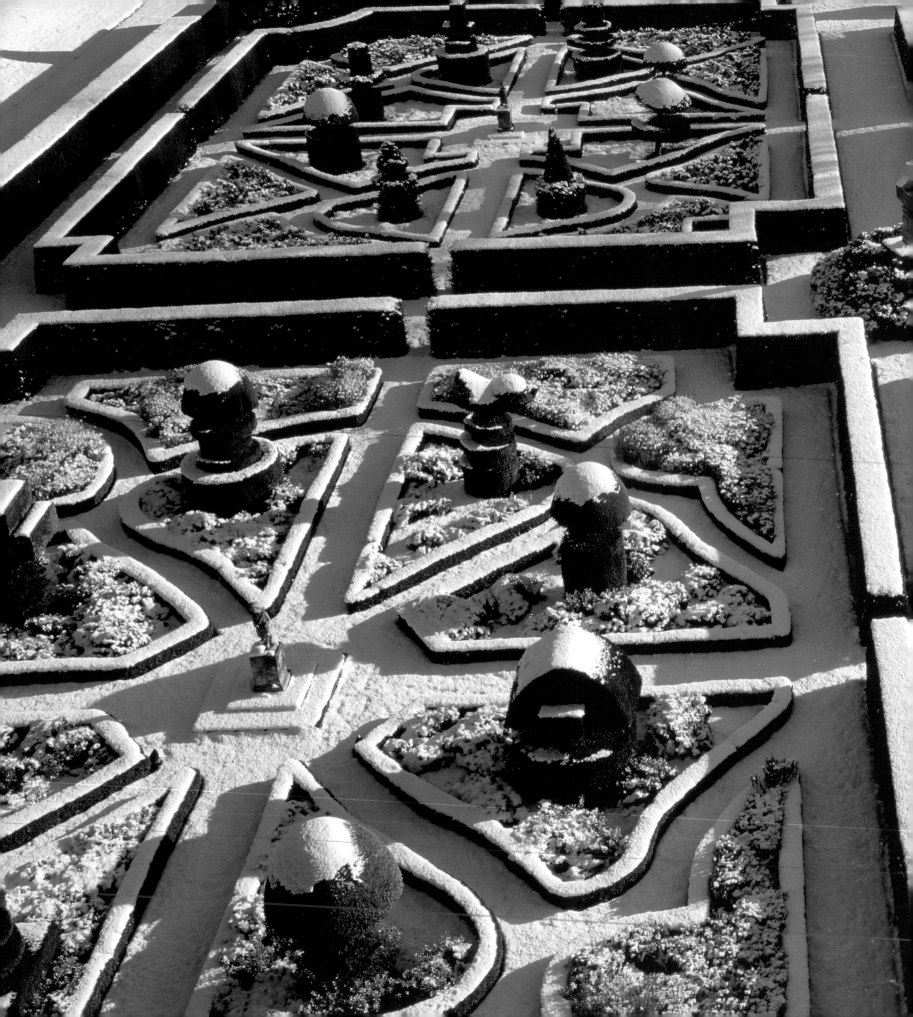

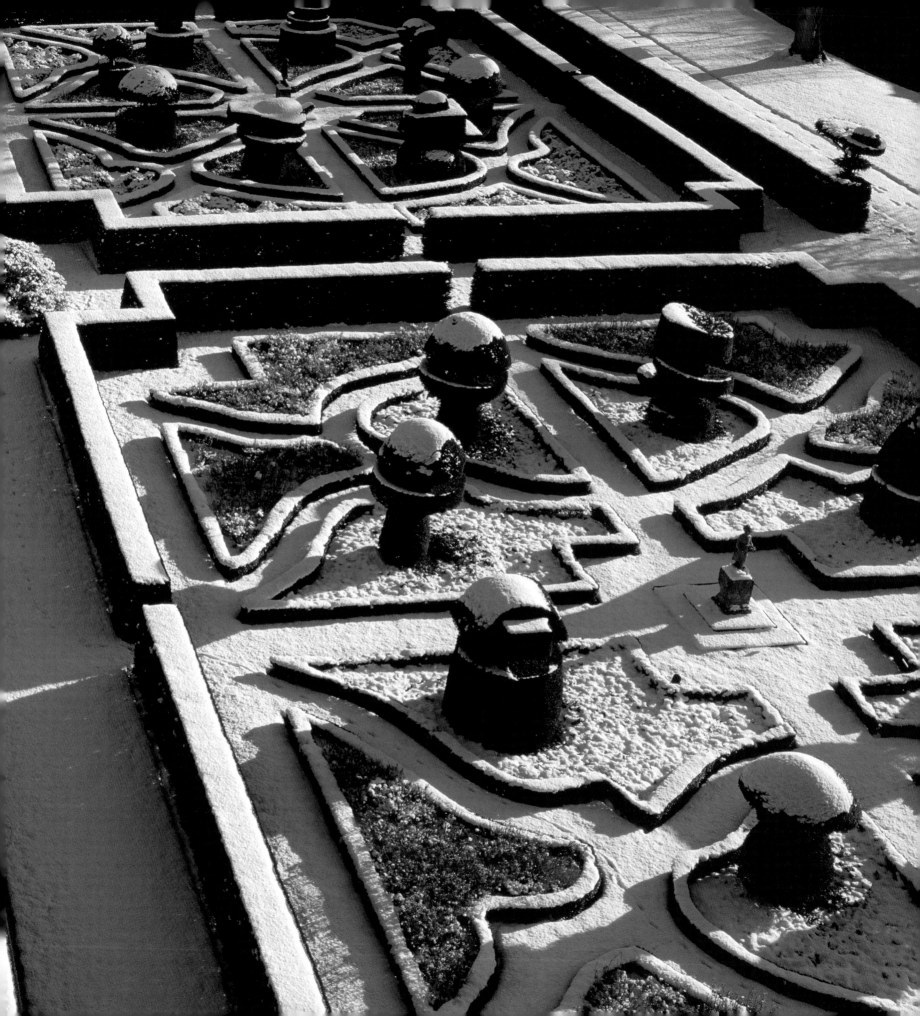

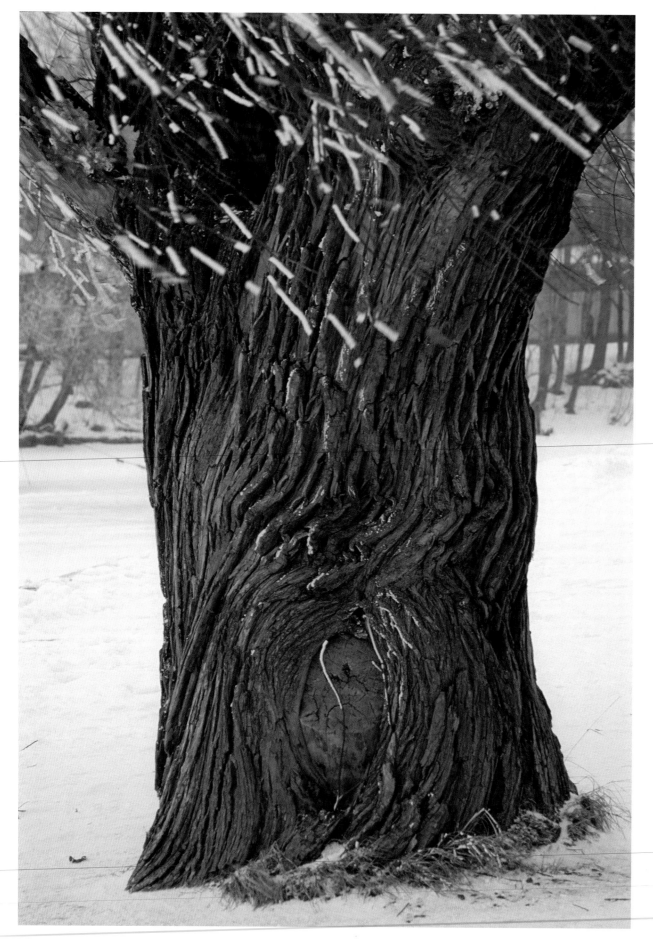

Shooting digitally means that I no longer have to worry too much about exposure when shooting snow scenes. A quick glance at the histogram will tell me if I have underexposed the scene.

Yelagin Island, St Petersburg, Russia.
Nikon F90X 80-400mm zoom lens.
Fuji Velvia ISO 50. 1 second @ f11.

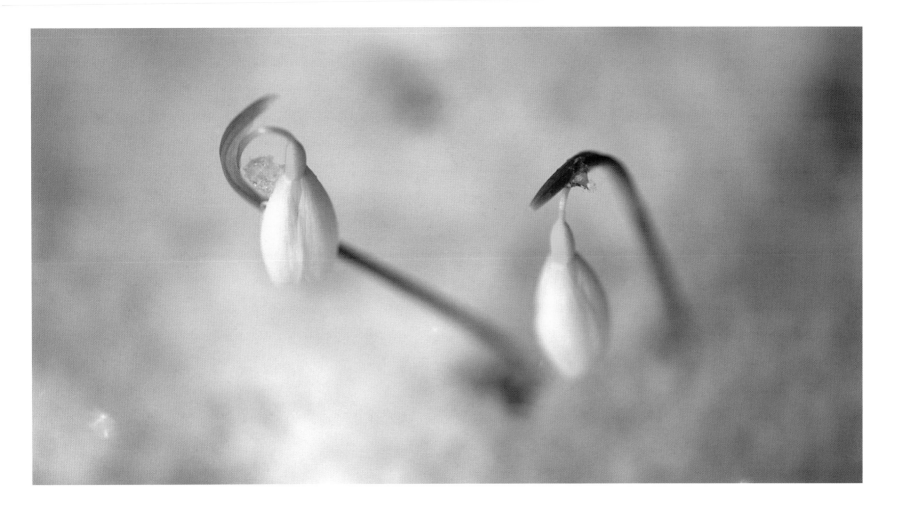

Snow

In the winter I am usually prepared to drop whatever I am doing at the slightest hint of snow. I keep in touch with garden owners and head gardeners and hope that they will call me the moment there is a decent covering. I have to be flexible and prepared to travel long distances at short notice if need be. Snowfall can be very localized and, like mist and fog, can disappear almost as soon as it arrives, so speed is of the essence. When I arrive at a location, I always try to shoot overviews of the whole garden before homing in on design details and planting. This way I can avoid distracting and ugly footprints from appearing in my wider shots.

Opposite, this picture of a tree in a park in St Petersburg, Russia, appears to have been taken during a snowstorm. Closer inspection, however, reveals that the flurry of snowflakes at the top of the picture are in fact the tree's fine branches, covered with a dusting of snow and blowing in the wind. Notice how the snow picks out and emphasizes the snaking curves of the bark.

Above, simplicity is the key to this photograph of *Galanthus plicatus* 'Bill Clarke' emerging from a blanket of freshly fallen snow. The two brave flower heads appear to be conversing with each other. I used a shallow depth of field to blur the background and got as low as I could to the ground to gain an insect's eye view.

The *parterre* at Great Fosters in Surrey, previous spread, shows how beautifully snow can delineate a formal garden, simplifying shapes and lines. As I like the cold, slightly blue bias that Fujichrome Velvia film brings to snow scenes, I decided not to filter this out in Photoshop once I had scanned the image ready for reproduction. The picture was taken from the roof of the hotel, after obtaining the management's permission to shoot from this vantage point.

Pettifers, Oxfordshire, England. *Galanthus plicatus* 'Bill Clarke'. Nikon F90X 200mm macro lens. Fuji Velvia ISO 50, 1/8 second @ f4.

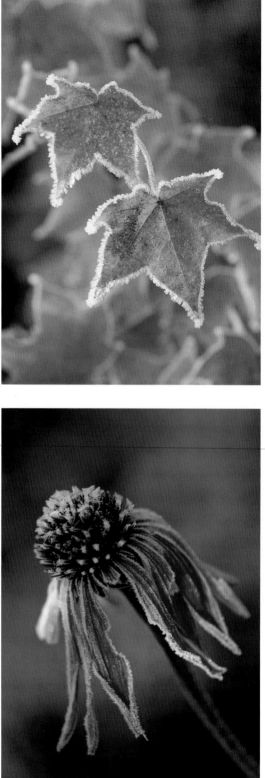

Frost

In Britain, as a general rule, we get more frosty days in a year than we do snowy ones. Also, I find that frost is more reliable than snow, so it is possible to plan a shoot a couple of days in advance. Britain seems to get a lot of frosts in November, so this is the month that I plan most of my frosty shoots. Often when the temperature drops below zero there is little or no wind, so I can shoot with small apertures for greater depth of field without the risk of subject movement. Frost adds an exciting dimension to my photography, etching and highlighting planting and structures in the wider garden context and adding sugar-coated fragility to close-ups.

There is no question in my mind that the best gardens to photograph in frost are those that have a lot of structure, or 'bones'. I am talking about formal gardens like Hatfield House in Hertfordshire or Wollerton Old Hall in Shropshire, gardens that have an abundance of topiary, hedging, paths, gates and statuary. I spend hours every autumn thumbing through books, magazines and the internet to find these kinds of locations.

Opposite, this private garden in Oxfordshire was designed by Duncan Heather and was photographed in November. I arrived at dawn so that I had a few minutes to walk around the garden before the sun came up. I was wearing a ski suit, as the temperature had dropped to − 8c. Here I have used the rule of thirds, placing the summerhouse at one of the intersections. Bands of planting and finally sky add rhythm and repetition to the composition.

Above left, delicate backlighting emphasizes the frost-rimmed edges of these maple leaves, photographed shortly after dawn with a macro lens.

Top: *Acer cappadocicum* 'Aureum'. The Parsonage, Worcestershire, England. Nikon F90X with 200mm macro lens. Fuji Velvia ISO 50, 1/30 second @ f5.6.

Above: *Echinacea purpurea*. Pettifers Garden, Oxfordshire, England. Nikon F90X with 200mm macro lens. Fuji Velvia ISO 50, 1/30 second @ f5.6.

Opposite: Private garden designed by Duncan Heather, Oxfordshire, England. Pentax 6x7 with 105mm lens. Fuji Velvia ISO 50, 1 second @ f22.

Wind

I hate wind. It is the enemy of plant and garden photographers. Mostly I try to avoid it, choosing instead to shoot on calm days or first thing in the morning, before the wind has picked up. However, there are occasions when I have no choice in the matter – shoot in the wind or come back with nothing. It forces me out of my comfort zone and I become more inventive. Now that I have switched completely from film to digital capture, I can try out different angles and shutter speeds, checking the results immediately on the screen.

As a general rule, if I want to freeze the movement of a wind-blown flower, I try to get the shutter speed up around 1/500th of a second. Alternatively, with subjects such as grasses or trees, I sometimes set small apertures like f22 or f32 in order to slow the shutter speed down, so that the subject's movement is recorded as a blur. The secret is to experiment a lot and just see what the results look like.

Opposite, Tom Stuart-Smith won Best of Show at last year's Chelsea Flower Show with this stunning planting. Heavy rain the previous night combined with strong blustery winds meant that it was impossible to record the garden in sharp focus and many photographers had already abandoned any hope of taking pictures. I decided to try and get a few shots using slow shutter speeds by setting small apertures. I took twenty or thirty shots from different angles, but this one stood out from the rest.

Above, the leaves on this maple tree, at the Chelsea Physic Garden in London, were blowing around in a light breeze yet the trunk was not moving at all, so I stopped down to f16 which gave me a shutter speed of 1/15 second, slow enough to record the movement of the leaves.

Opposite: *Daily Telegraph* Garden designed by Tom Stuart-Smith. Chelsea Flower Show, London, England. Digital image. Canon 1Ds Mark II with 75-300mm zoom lens. ISO 100 Raw, 4 seconds @ f32.

Above: Chelsea Physic Garden, London, England. Nikon F90X with 80-400mm zoom lens. Fuji Velvia ISO 50, 1/15 second @ f16.

Travel

Traveling to far-flung destinations provides new and exciting photo opportunities, a chance to capture plants and gardens unique to foreign shores. The secret of making a success of such trips is undoubtedly forward planning. Once I have decided on a destination, I use books, magazines, the internet and word of mouth to find good locations. I then contact the custodians of these gardens by phone or email to obtain permission to photograph, asking at the same time for early and late access. Often I will fix accommodation in advance and hire a car at my destination. I take out comprehensive travel and camera insurance.

In light of recent terrorist threats to international airlines around the globe there is currently a restriction on the amount of hand luggage that you can carry on board. You can risk putting expensive equipment into the hold of the aircraft, but I find it better to pare down my equipment, carrying one camera body and a couple of lenses in my hand luggage. When putting less costly equipment such as a tripod into the hold of the aircraft I always ensure that it is well packed and label it as fragile. Despite the myths, I have never come across any problems putting film through airport security x-ray machines.

I used a zoom lens from my bedroom window to photograph this beautiful infinity swimming pool and olive tree on the Greek Island of Corfu.

Gina Price's garden, Corfu, Greece.. Digital image.
Canon 1Ds Mark II with 75-300mm zoom lens. ISO
100 Raw, 1/15 second @ f32.

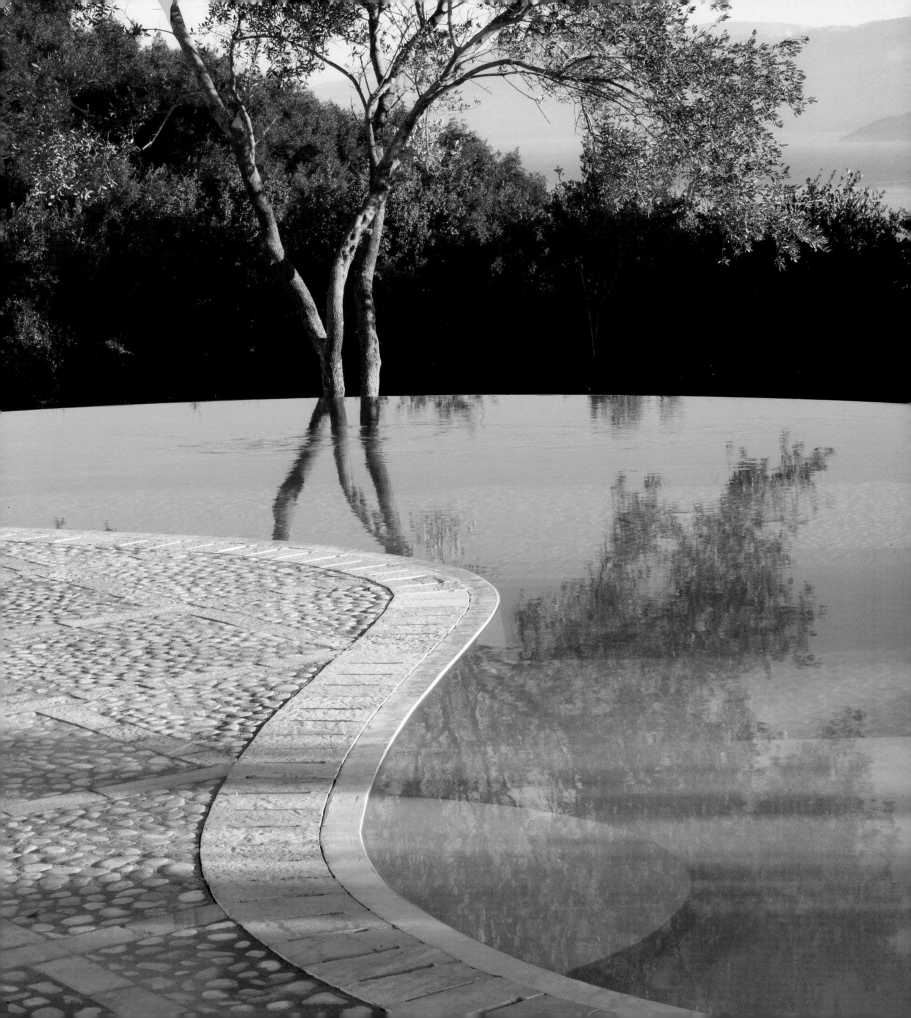

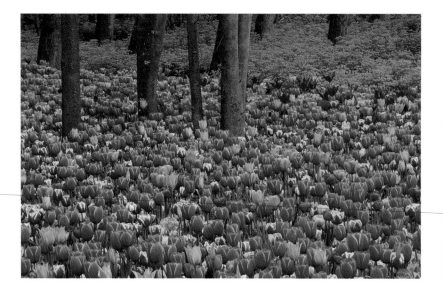 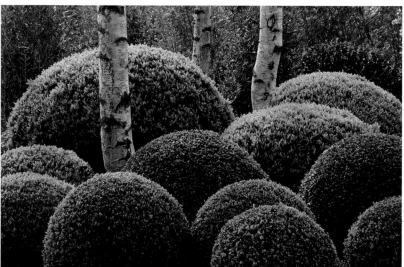

Seasonal spectaculars

Above left: Floriade, The Netherlands. Nikon F90X with 80-400mm zoom lens. Fuji Velvia ISO 50, 1/4 second @ f32.

Above right: Floriade, The Netherlands. Nikon F90X with 80-400mm zoom lens. Fuji Velvia ISO 50, 1/15 second @ f16.

Opposite: Mainau Island, Lake Constance, Germany. Pentax 6x7 with 55mm wide-angle lens. Fuji Velvia ISO 50, 1/2 second @f22.

Visiting a location at the right moment is the key to getting great garden photographs abroad. Holland, for example, is famous for its tulips which peak around the last week in April, whereas to capture Fall gardens in the USA I would travel in October. Sometimes I have discovered hidden treasures by word of mouth. I once asked my French agent (who is also a garden photographer) what his favourite garden was: 'Mainau in Germany – fantastic tulips', was his immediate reply. I looked up this little-known garden, was impressed by some of the images I saw on the internet and planned to pay a visit the following spring. I was not disappointed. The garden was stunning and I returned home with some of the best tulip photographs I had ever taken.

Above, these two images were taken at Floriade, an event that occurs every ten years in Holland. I used a zoom lens to fill the frame, first with tulips growing in woodland, and then box balls and birch trees.

A wide-angle lens on my Pentax 6x7 medium-format camera was used to capture these drifts of tulips growing in a meadow on the island of Mainau, Lake Constance, Germany. The whole scene was bathed in early morning backlight filtering through the trees.

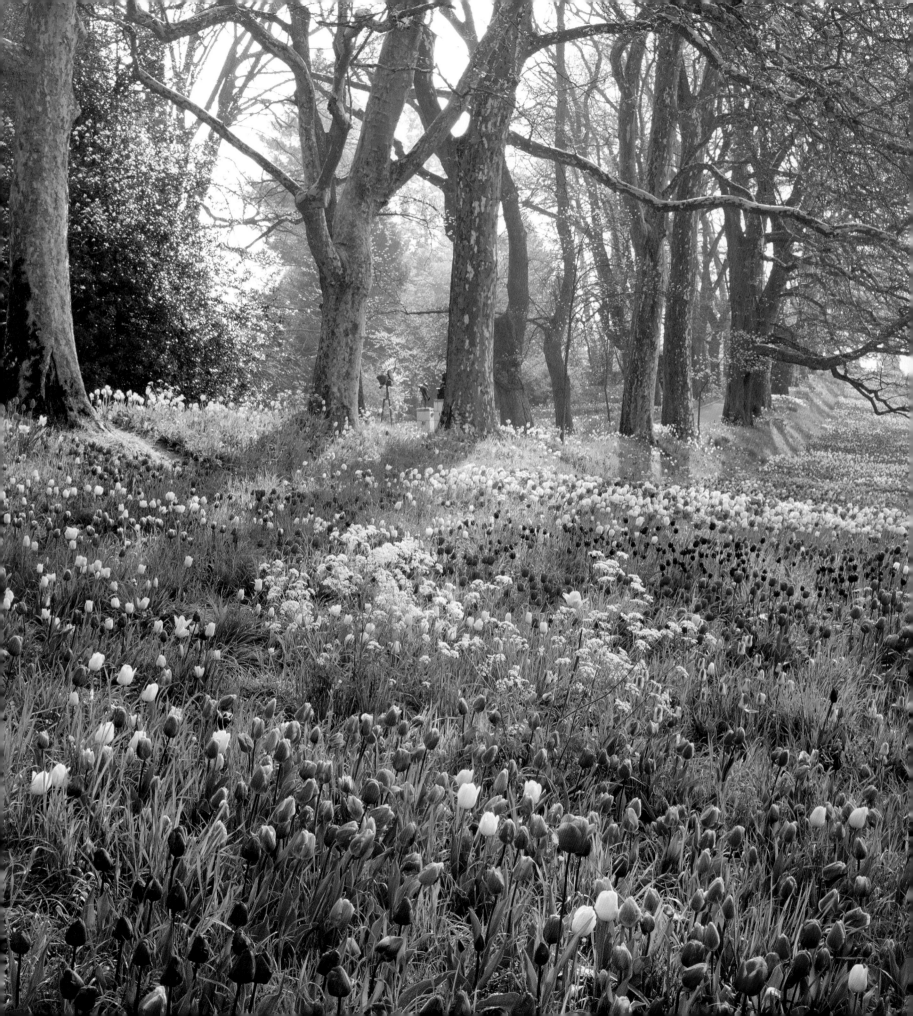

Earth tones often photograph best in warm sunlight – especially in the rich orange light of early morning or late evening – reminding us of their Mediterranean origins.

Sochi Arboretum, Russia. Nikon F90X with 80-400mm zoom lens. Fuji Velvia ISO 50, 1/4 second @ f32.

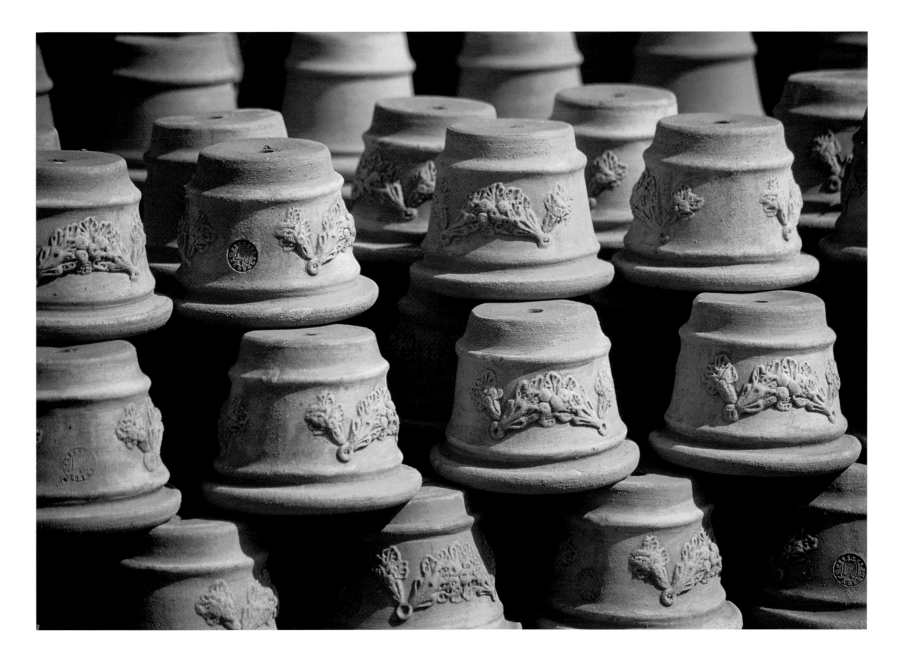

Earth tones

Whilst I enjoy shooting wide vistas of gardens when travelling, I often try to capture images which are more intimate but which still make a strong statement about a place. The terracotta pots above, basking and baking in the sun, are synonymous with Impruneta in Tuscany, where skilled craftsmen have made them for generations. Here I have detailed the geometry of the pots, row after row representing generation after generation, with the crafted detail to the fore, using a zoom lens. Strong sunlight floods in from the right, creating deep shadows. Repetition gives the composition structure and the pots' colours are redolent of the rich, earthy tones of the Tuscan landscape.

Opposite, the fabulous twisting bark of these *Metasequoia sempervirens* immediately brings to mind the great redwoods of the Pacific Northwest of America. It may surprise you then to learn that they were in fact photographed at the Sochi Arboretum in Russia. For me, the trees displayed the same hue and stature as buildings I had seen in St Petersburg – decayed, aged bare, yet still standing strong.

Above: Impruneta, Tuscany, Italy. Nikon F90X with 80-400mm zoom lens. Fuji Velvia ISO 50, 1/250 second @ f8.

Overleaf: Gina Price's garden, Corfu, Greece. Digital image. Canon IDs Mark II with 75-300mm zoom lens. ISO 100 Raw, 1/30 second @ f25.

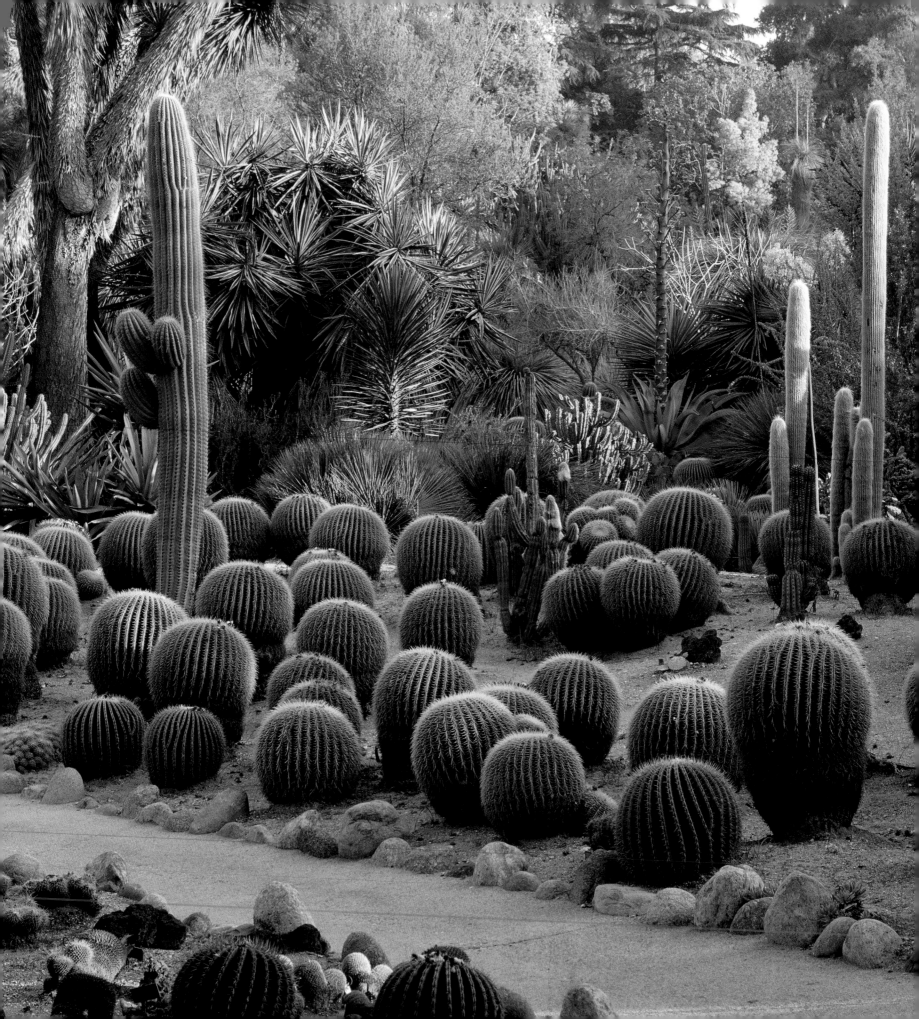

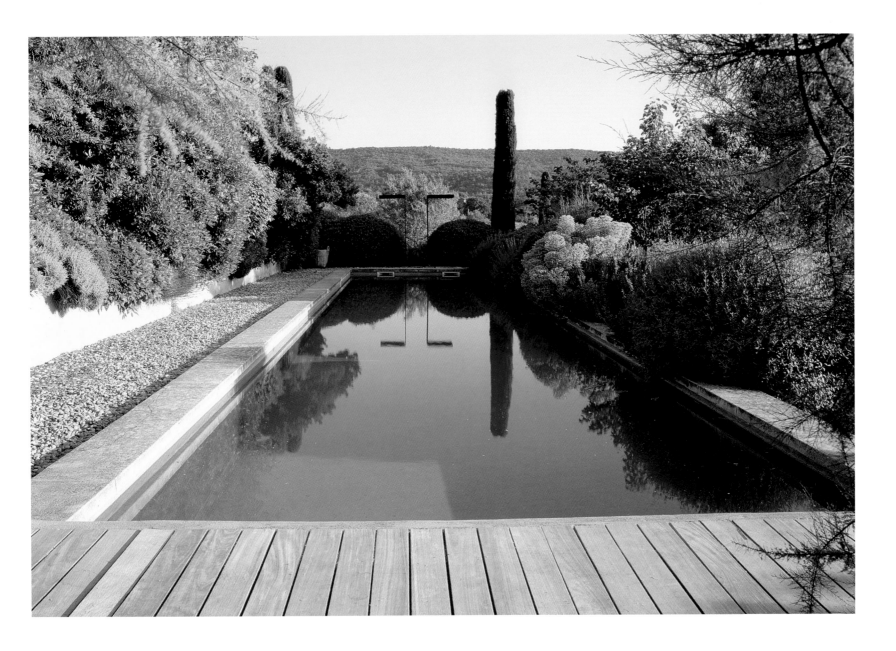

Hot climates

In hot climates, it is easy to make the mistake of thinking that the best time to photograph plants and gardens is in the middle of the day, when the sun is at it most intense. This rarely produces satisfying images, as shadows lose details and highlights become burnt out. The problem is that while your own eyes can cope with these extremes of contrast, film cannot. With digital photography, the problem is reduced, but I still prefer to work at the beginning and end of the day, when the light is less intense and more flattering to garden subjects.

I avoided the intense midday heat and returned instead in the early evening to shoot these magnificent *Echinocactus grusonii* growing in the cactus garden in the Huntington Botanic Garden in Los Angeles, opposite. I deliberately showed a section of the path in front of this border to give scale and took the picture with a standard lens on my medium-format Pentax 6x7 camera.

Strong evening light illuminates this swimming pool at a private garden in the Luberon, France, above. When shooting in hot climates I tend to work early and late, relaxing and sleeping during the hottest parts of the day.

Above: Private garden, the Luberon, France. Pentax 6x7 with 55mm wide-angle lens. Fuji Velvia ISO 50, 1/250 second @ f22.

Opposite : Huntington Botanical Gardens, Los Angeles, USA. Pentax 6x7 with 105mm lens. Fuji Velvia ISO 50, 1/2 second @ f22.

Cold climates

Yelagin Island, St Petersburg, Russia. Nikon F90X with 80-400mm zoom lens. Fuji Velvia ISO 50. 2 seconds @ f22.

What could be more romantic than a park in St Petersburg, Russia, in the depth of winter? In both these images, the soft, muffled light lends a slightly eerie sense of quiet and calm to the scene and a feeling of being weighed down by a cold blanket of snow. The simple image of railings on a bridge was taking when the temperature was – 20 c. Using Fujichrome Velvia film has emphasized the cool blues in the scene, adding to the mood. Notice how simple this image is, with the railings disappearing out of the lefthand side of the frame so that the viewer gets the feeling of walking over the bridge and hence 'through' the picture. The image on the right was taken on the same day. I was careful to 'frame' the garden building with a curtain of winter trees. The flagpole on the roof balances the whole scene and continues the lines of the pillars up into the sky. Shooting in extreme cold can be problematic. There have been occasions when my eyes have literally stuck to the camera viewfinder and I have had to return indoors to warm up. Batteries can run out extremely quickly and your hands can get so cold, even with gloves on, that it becomes impossible to operate the cameras controls properly.

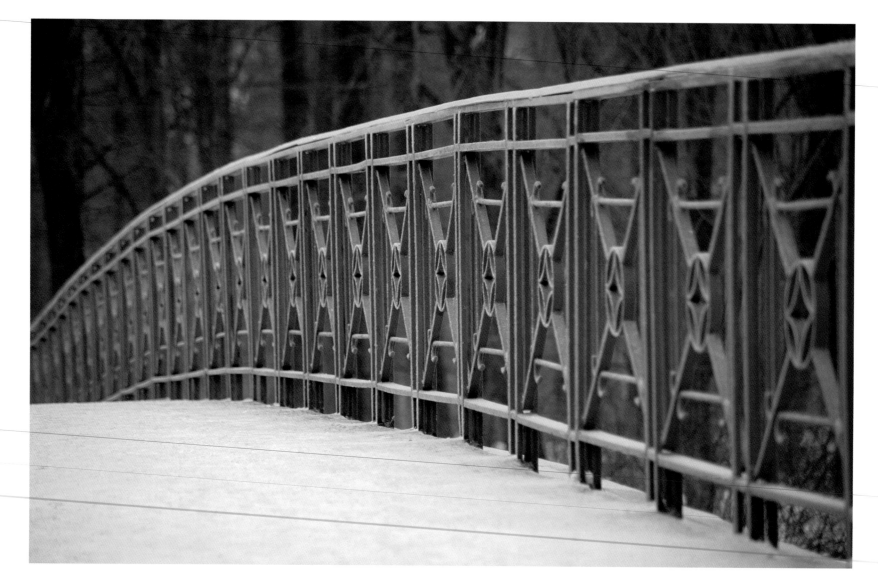

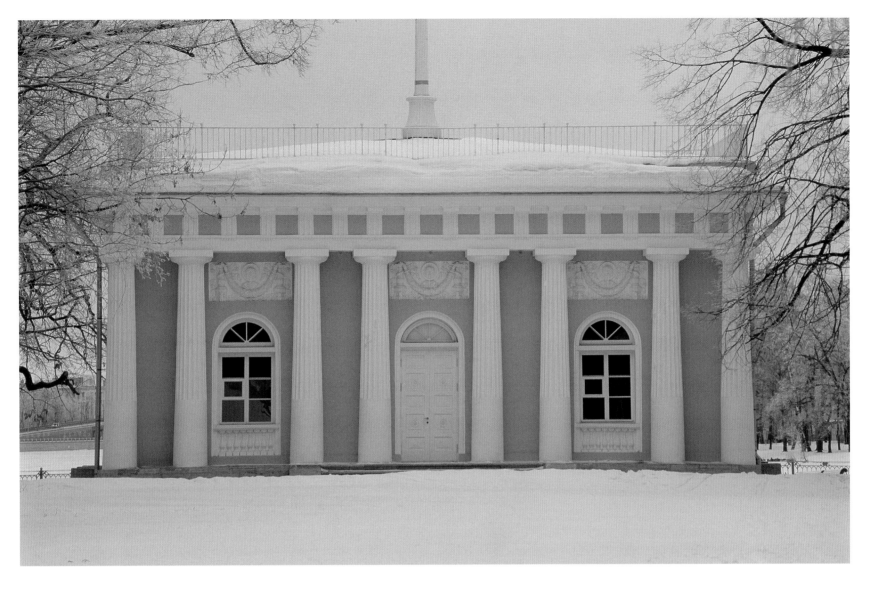

Yelagin Island, St Petersburg, Russia. Nikon F90X with 80-400mm zoom lens. Fuji Velvia ISO 50, 1 second @ f11.

Freshly fallen snow is the best to photograph – before its pristine surface is ruined by dirt and footprints. It can melt within minutes of falling so it is important to work quickly – in England, it could be a year before it snows again!

Photographic art

There are many days when photographing plants *in situ* outside can be fraught with difficulty. Heavy rain, very bright sunlight and strong winds can often put a stop to outdoor photography and on days like these, I often resort to bringing plants indoors. Here, with no wind or rain to contend with, I am able to control conditions – selecting the ideal lighting for a subject, trying out different coloured backdrops and experimenting with depth of field. The resulting images, though contrived or 'manufactured', can be true to life or composed to achieve a more abstract effect.

I bought a bunch of purple calla lilies from my local florist and examined each flower head carefully before selecting this one as the subject of a graphic close-up. I put the flower in a vase of water, placed it on a windowsill in my living room and hung a sheet of black velvet off a chair a metre away from the subject. Lighting was natural window light from the left and I used a 180mm macro lens to fill the frame with the subject.

Calla lily. Studio. Digital image. Canon 1Ds Mark II with 180mm macro lens. ISO 100 Raw, 1/8 second @ f3.5.

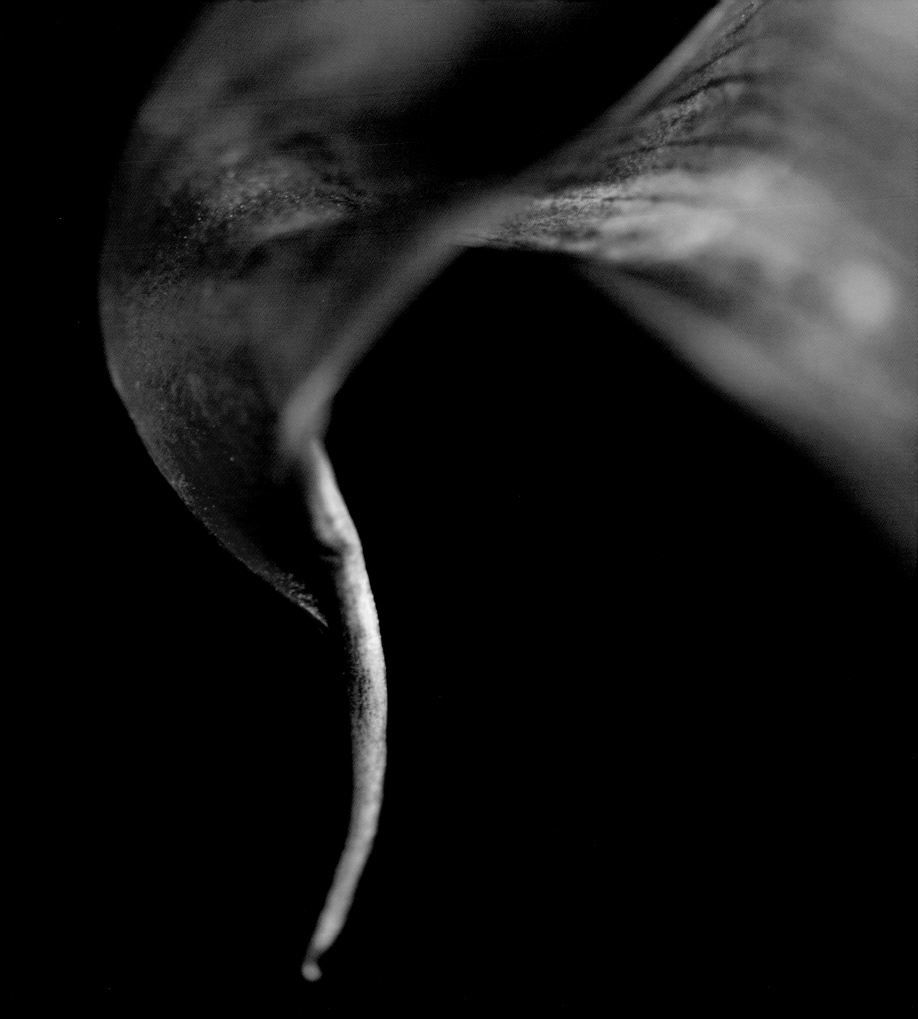

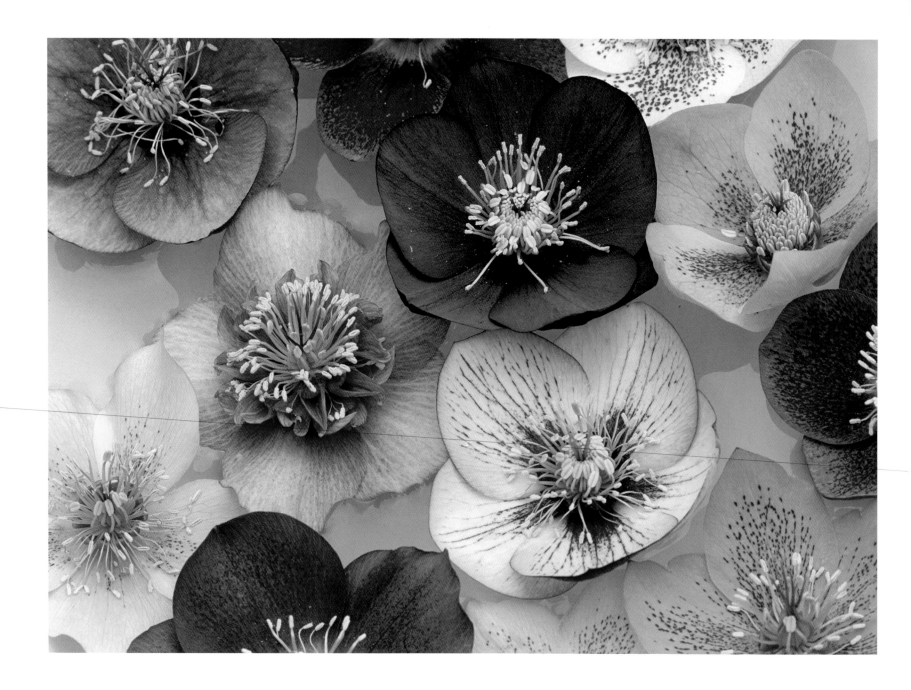

Suspended animation

Woodchippings, Oxfordshire, England. Nikon F90X with 200mm macro lens. Fuji Velvia ISO 50, 1/8 second @ f16.

Sometimes, in order to capture the true beauty of an individual flower or group of flowers, I simply remove them from nature's clutter and suspend them, as if frozen in time, in a bowl of water or against a simple coloured background. The photograph of hellebores, above, gathered by a gardener and displayed very simply floating in a white bowl filled with water, captures the breadth of a genus in a single, simple image. The repeating heads add strength to the composition, whilst the soft, diffused light brings out all the subtle markings and colours in the petals.

The portrait of a purple calla lily, opposite, accentuates the voluptuous, feminine form of the flower. Shot from a different angle it might have appeared far less curvaceous and thus less interesting. I focused on the striped snaking edge, which is sharpened by a glint of natural light. The bold silhouette, blurred by a shallow depth of field, almost quivers into the soft background – a sheet of coloured card bought from a local art shop.

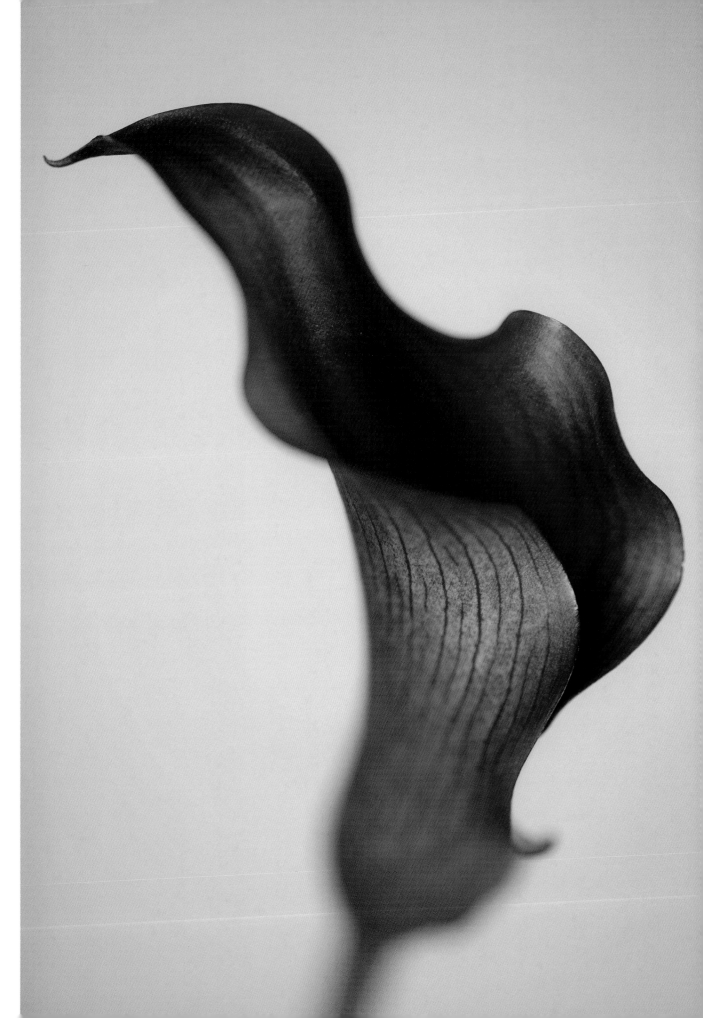

With still-life subjects I always prefer to work with natural lighting rather than flash. If I need to boost the light, I will use white, silver or gold reflectors.

Calla lily, Studio. Digital image.
Canon IDs Mark II with 180mm
macro lens. ISO 100 Raw, I
second @ f4.5.

I set the largest aperture possible (f3.5) on my macro lens so that the background of Pulsatilla *foliage* would be thrown completely out of focus. The result is a delicate digital image that reveals the fine, silky hairs of the flower, which appears to float in mid air. The picture was taken in my living room and was lit by soft light from a large window.

Pulsatilla vulgaris 'Heiler Hybrids'. Studio. Digital image. Canon IDs Mark II with 180mm macro lens. ISO 100 Raw, 1/2 second @ f3.5.

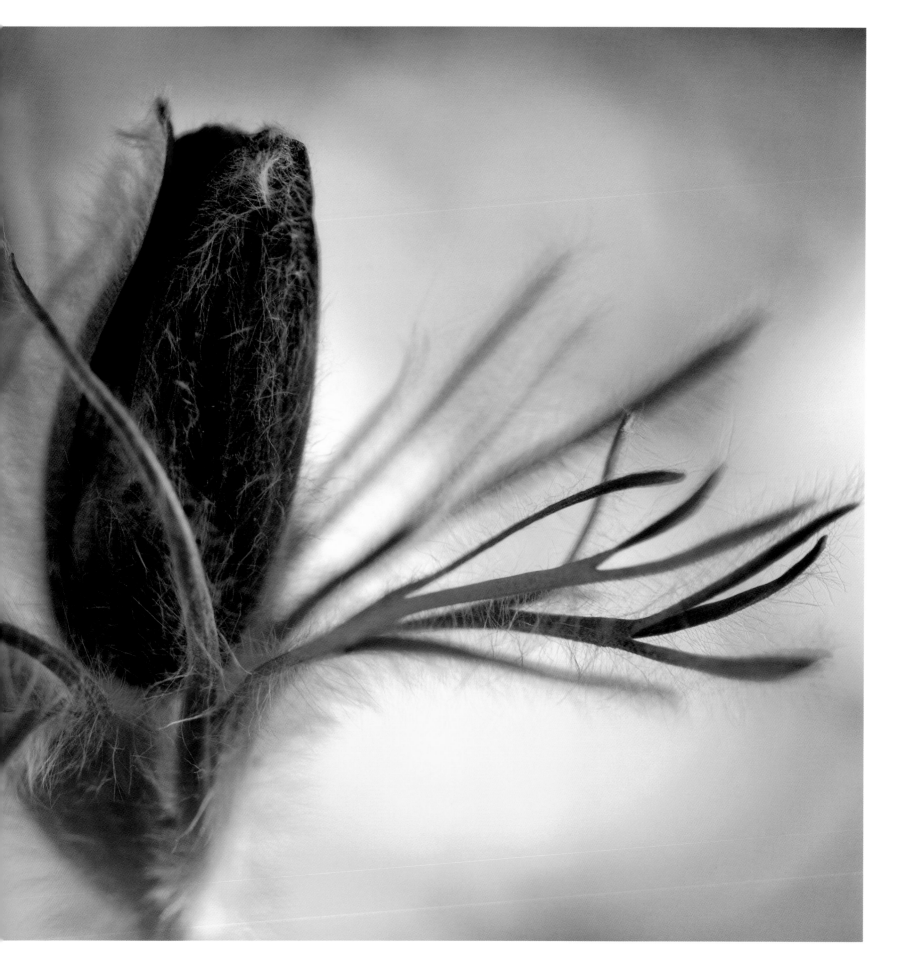

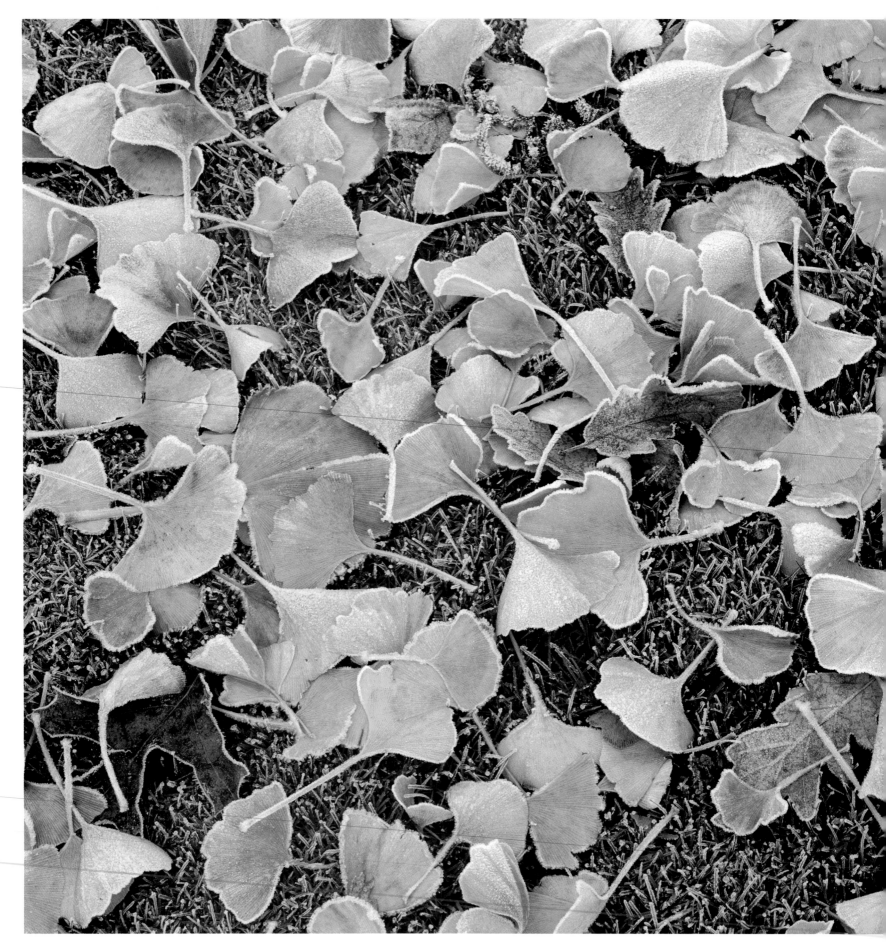

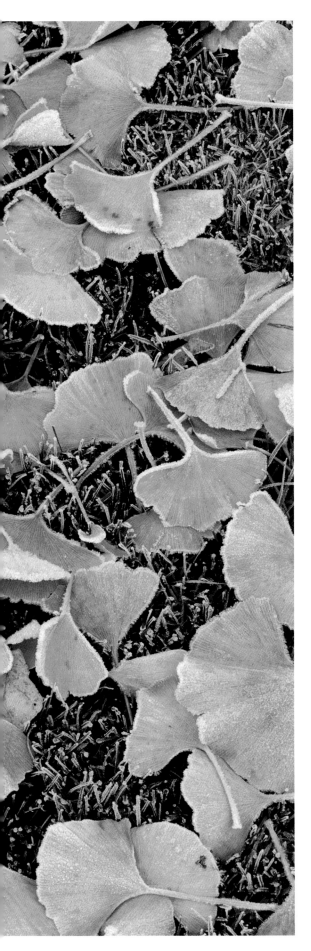

Still life has traditionally been the domain of medium- or large-format studio-based photography, but today's 35mm digital SLRs now offer comparable quality. I now use a 17 megapixel Canon IDS MK II 35mmm SLR camera for most of my still-life work.

Natural 'found' still life

Natural, 'found' still lives are often better left alone. They are nature's gems, arrangements that are sacrosanct and not to be tampered with. When I come upon such a scene – ripe apples strewn across the ground in an orchard, fallen rose petals or, as here, a scattering of autumnal leaves – I move around with my camera, checking out different angles until I am satisfied that I have the most pleasing composition in the viewfinder. Only then will I press the shutter button and make the photograph. Sometimes I am tempted to move components of the scene around or physically take something out, but this rarely leads to an improved picture. What is important is to edit the photograph to include only those elements that are important to the scene. Often, less is more – the tighter the composition, the more powerful the image. One advantage with digital photography is that you can always crop an image in Photoshop to improve the composition after the event.

 This picture of fallen gingko leaves dusted with frost one November morning at Englefield House Garden in Berkshire was inspired by the large-format close-up images of the American Midwest taken by photographers such as Ansel Adams, Elliot Porter, David Muench and Tom Till.

Englefield House, Berkshire, England. Pentax 6x7 with 135mm macro lens. Fuji Velvia ISO 50, 3 seconds @ f32.

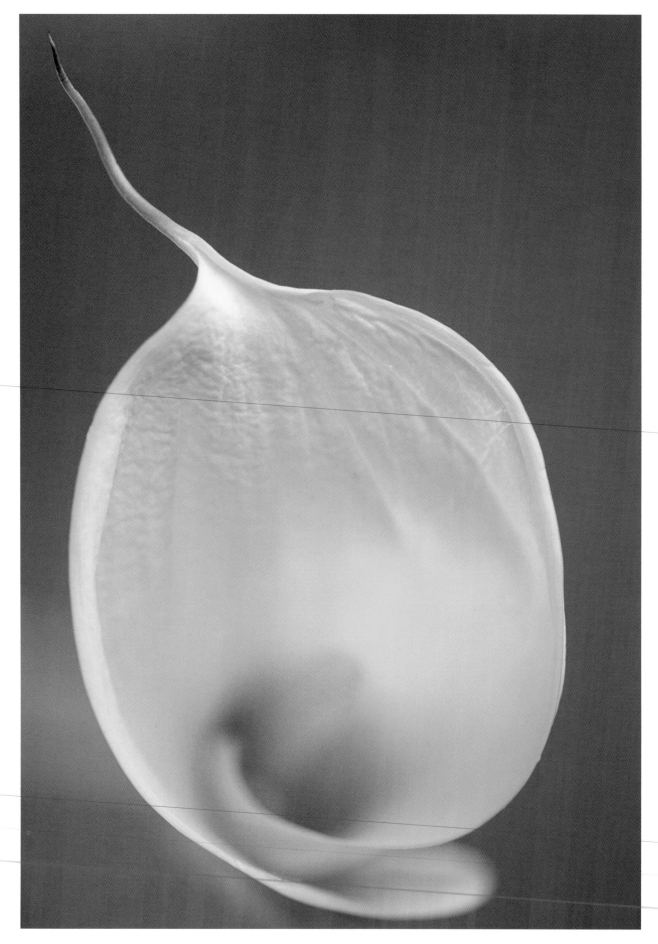

Keep it simple when lighting on location. Soft, diffused light combined with a plain, uncluttered backdrop makes for a strong composition.

Calla lily. Studio. Nikon F90X with 200mm macro lens. Fuji Velvia ISO 50, 1/4 second @ f5.6.

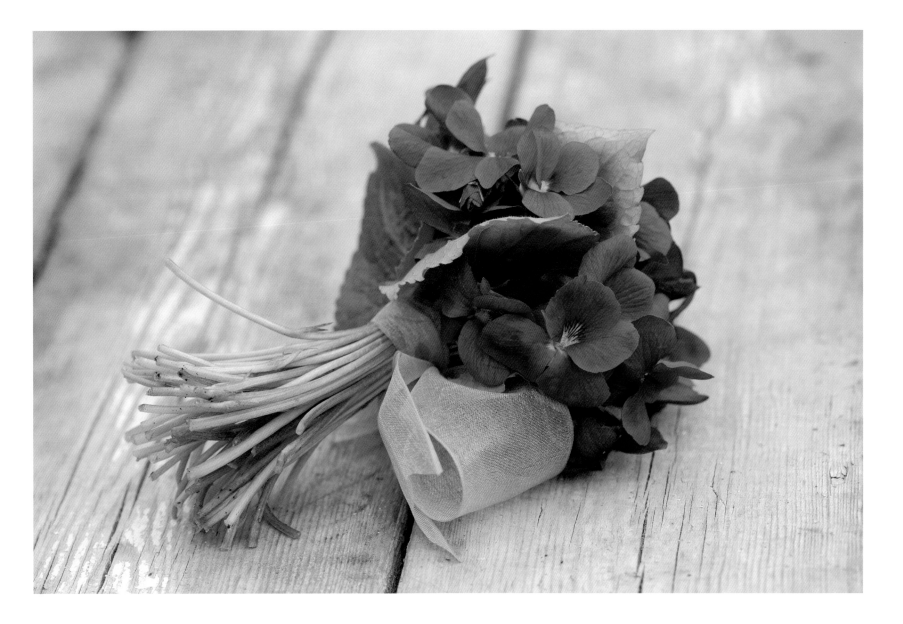

Lighting on location

When I am shooting still-life subjects on location I often choose soft, diffused light combined with simple, uncluttered backdrops to bring out the best in a composition. This image of a hand-tied bouquet of violets at Devon Violet Nursery illustrates perfectly my philosophy of keeping things simple. I placed the diminutive bouquet on a wooden bench in the greenhouse which had been cleared of pots and brushed clean. A cloudy, overcast day meant natural soft lighting, which, in turn, has brought out the true blues and purples of the flowers. The simplicity of the wooden boards and a shallow dept of field allows the arrangement to stand out.

For the white calla lily (*Zantedeschia aethiopica*) on the left I used soft, natural backlighting to enhance the flower's beauty, placing the cut stem in a vase on a windowsill, using some green box that was planted outside as a backdrop. The white flower is thrown into relief, fine details illuminated and the delicate and feminine personality revealed – its lifeless waxy, matt attire transformed into a semi-transparent veil by the softest touch of backlighting.

Violets. Devon Violet Nursery, Devon, England. Digital image. Canon 1Ds Mark II with 180mm macro lens. ISO 100 Raw, 1/10 second @ f6.3.

Petal art

Above: *Hyacinthus* 'Purple Passion'. Studio. Digital image. Canon 1Ds Mark II with 180mm macro lens. ISO 100 Raw, 1/60 second @ f4.

Opposite: *Hyacinthus* 'Purple Passion'. Studio. Digital image. Canon 1Ds Mark II with 180mm macro lens. ISO 100 Raw, 1/125 second @ f3.5.

These two images of hyacinth petals were inspired by the work of the Victorian photographer and architect Karl Blossfeldt, whose incredible graphic images of plants are difficult to differentiate from architectural or textile designs. Captivated by a hyacinth I had grown in a container, I set about creating my own work of petal art. Carefully plucking each waxen floret, I arranged them on a piece of cartridge paper similar in colour to the pinky blue hyacinth. The result was a floral pattern with pleasing repetitions of shape, the florets assuming, to me, the attire of swirling dancers. Then, by experimenting with different depths of field, I brought my 'dancers' to life, shallow depth of field lending apparent movement to the lead couple focused in the centre of the 'dance floor'. Lighting was from a large window just to the left of the arrangement.

Opposite, I used a 180mm macro lens to fill the frame with a single flowerhead. The shot was taken on a window ledge using just natural light from the right.

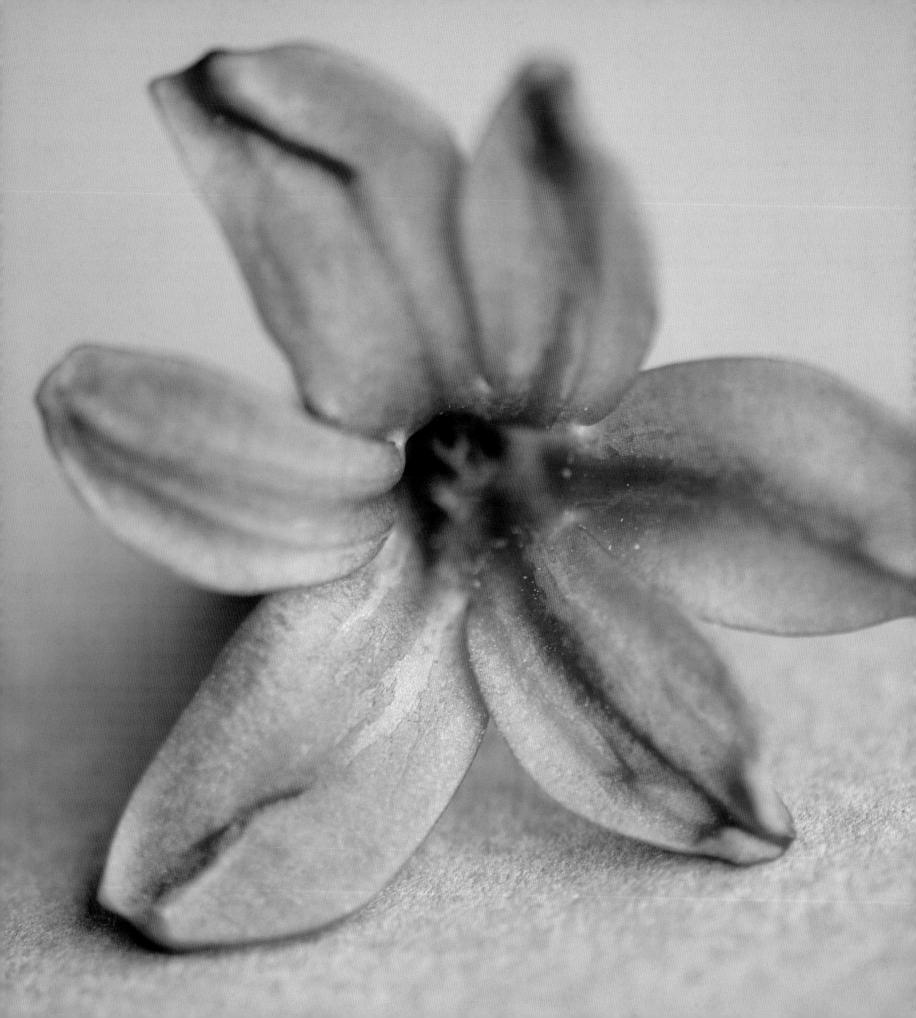

People

Gardens are a reflection of the passion and spirit of the people who make and maintain them. Because of this, I feel that when I am shooting gardens I need to include pictures of the people who have made and cared for them.

For me, the critical criteria for good 'people pictures' is that the subjects should appear relaxed and natural in the photograph, rather than stiff and posed. Most gardeners are quite apprehensive about having their photograph taken, so I always try to relax them by chatting to them about their gardens for a while before taking their picture. My approach very often is to use a zoom lens so that I am a fair distance away from the subject, making them more at ease. Like this I can use large apertures – say f2.8 or f4 – focusing on the person's eyes, using high shutter speeds to freeze their movements.

Simon Charlesworth, opposite, owner of Downderry lavender nursery in Kent, was used to being photographed and knew instinctively what clothes would look good on film. Dressed in faded lavender-blue French-style top and denims, he represents the archetypal image of a French lavender grower. We tried various shots, with and without the beaten up straw hat, and this was the best of them.

Simon Charlesworth. Downderry Nursery, Kent, England. Nikon F90X with 80-400mm zoom lens. Fuji Velvia ISO 50, 1/60 second @ f8.

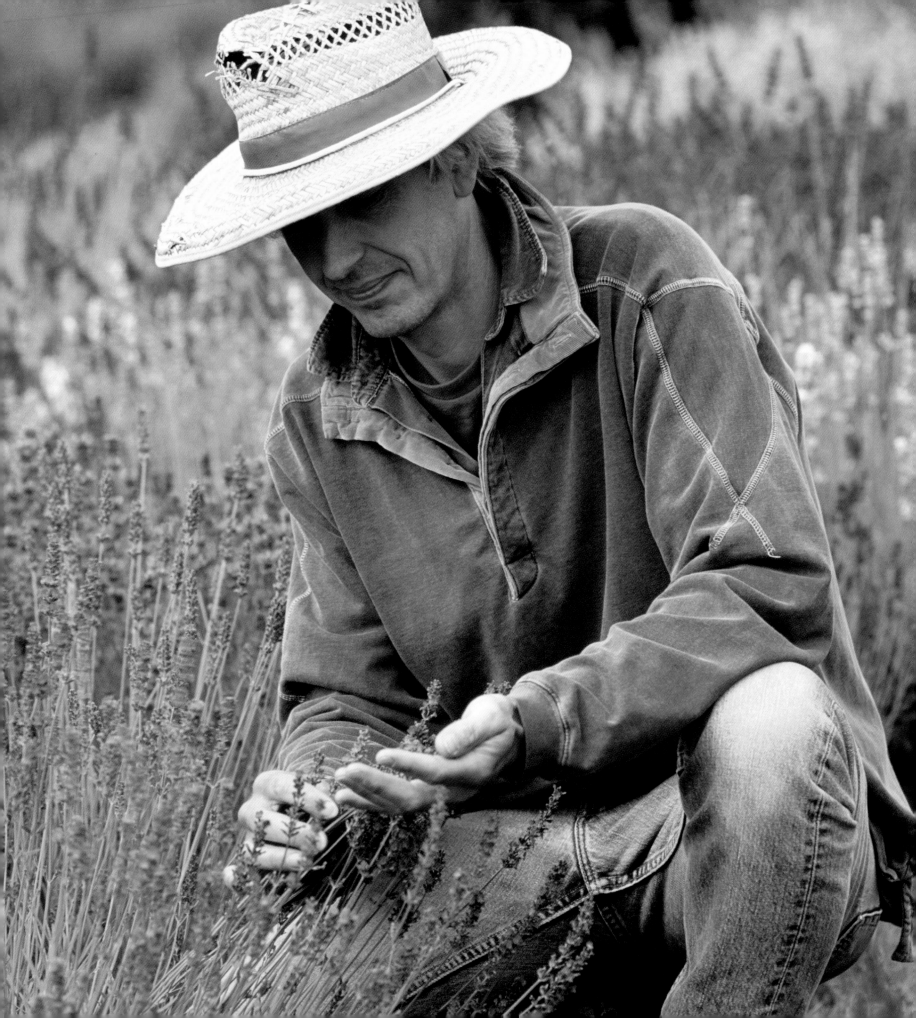

Children soon relax and become more photogenic once they start to engage in an enjoyable activity. I find running water, provided by, say, a fountain or a hosepipe, never fails to amuse them.

Children

I find children easier to photograph than adults, as they tend to be much less nervous and generally act in a more natural way when in front of the lens. They do, however, tend to get bored more easily so it is important to give them an activity that they are going to enjoy if you want to get the most out of them. Having my own children is a real advantage as they are now used to me photographing them and take no notice of me and my camera. When photographing other people's children for magazines or books, I obtain a signed model release form from the parents or guardians of the children and I always print up a set of pictures from the shoot, free of charge, for the children to keep.

Above left, this is my son Robert, photographed at a garden show in Sweden. He was having so much fun splashing around in the water that he was completely unaware that I was photographing him. I used a 70-300mm zoom lens so that I was far enough away from him not to notice me.

The seemingly natural image of my daughter Hazel, left, running through the spray from a hosepipe, captures genuine emotion, excitement and fun, despite being deliberately staged: Initially, I positioned the hosepipe and set my camera up on a tripod, pre-focusing at the point where my daughter would be as she ran through the spray. A fast shutter speed freezes the action.

Opposite, I particularly like to use backlighting, shooting towards the sun, when photographing children, as this light is very flattering to the subject. Here, low evening light adds an ethereal quality to this image of a young girl tending a pot of lavender in a shady courtyard.

Top: Robert. Hedens Lustgard. Stockholm, Sweden. Nikon F90X with 80-400mm zoom lens. Fuji Velvia ISO 50, 1/125 second @ f5.6.

Hazel. Private garden, Reading, Berkshire, England. Nikon F90X with 80-400mm zoom lens. Fuji Velvia ISO 50, 1/500 second @ f4.5.

Nancy. Private garden, Berkshire, England. Nikon
F90X with 80-400mm zoom lens. Fuji Velvia ISO 50,
1/125 second @ f8.

This picture, taken in early spring for a book called Great Gardens For Kids captures a magical moment in time as the children run spontaneously around a daffodil maze in a neighbour's garden. This time I opted for a wide-angle lens so that I could include the entire maze in the image and I used a shutter speed of 1/125 second to slightly blur the children's movements.

Robert, Nancy and Harriet. Private garden, Berkshire, England. Nikon F90X with18-35mm wide-angle lens. Fuji Velvia ISO 50, 1/125 second @ f11.

Garden designers

Above: Christopher Bradley-Hole. Private garden, London, England. Nikon F90X with 18-35mm wide-angle lens. Fuji Velvia ISO 50, 1/250 second @ f8.

Opposite: Sandra and Nori Pope, Hadspen Garden and Nursery, Somerset, England. Pentax 6x7 with 135mm macro lens. Fuji Velvia ISO 50, 1/15 second @ f16.

Christopher Bradley-Hole, above, has gained a reputation as one of the world's leading designers of minimalist, contemporary-style gardens. To reflect this, I chose to photograph him in quite a graphic way – in the middle of the frame, seated on a brick wall with box balls to either side. I resisted the temptation to crop in tighter on Christopher, as this would have conveyed less information about the designer to the viewer.

The happy, natural pose of Sandra and Nori Pope, opposite, in their flourishing *potager* at Hadspen Garden in Somerset immediately conveys their relaxed, informal style of gardening, an impression that is further enhanced by their casual, earth-coloured attire. Clearly at home with their surroundings, they were easy to photograph in the soft, early morning summer light.

Gina Price. Pettifers Garden,
Oxfordshire, England. Digital image.
Canon 1Ds Mark II with 180mm macro
lens. ISO 100 Raw, 1/30 second @ f8.

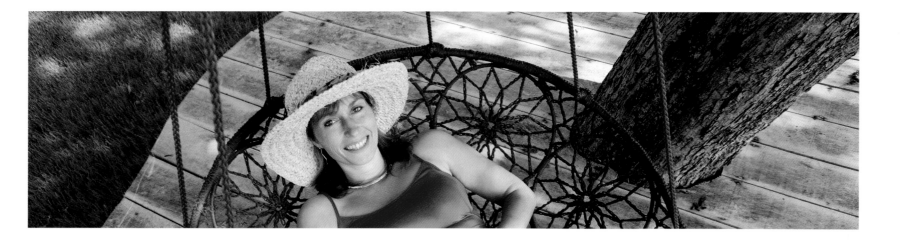

Cropping, either in camera or on the computer post-capture, allows me to frame a portrait in exactly the way that I want.

Framing and cropping

Sometimes I like to crop people pictures in a very precise way so as to add a frame around a person or to create a more interesting, slightly unusually shaped portrait. I now find with my digital camera that I am less concerned about cropping in-camera than I was when shooting on film, as I now know that I can crop any image once it is opened in Adobe Photoshop (I use Adobe Photoshop CS2).

I particularly wanted to photograph garden owner Gina Price, opposite, coming out of her back door, as this is how she often greets me in the morning when I arrive to take pictures. I framed her within the arch of the doorway, using a zoom lens for a tight crop. The soft, overcast light was ideal as it brought out the subtle tones in the stone archway, wooden door and cream dress. The simple, dark interior of the house makes Gina stand out from her surroundings, her smile adding to the happy atmosphere in the picture.

I have worked a lot with garden designer Clare Matthews, above, photographed here in her own private garden in Devon. To reflect her glamorous style and personality, I felt that I needed to photograph her in a non-classical way. I stood above her as she lay on a swing seat on a raised wooden deck and used a wide-angle lens to take an advertising, cinematographic-style shot of her, which I later deliberately cropped as a panorama in Photoshop.

Clare Matthews. Private garden, Devon, England. Digital image. Canon 1Ds Mark II with 16-35mm wide-angle lens. ISO 100 Raw, 1/125 second @ f8.

I find that a dramatic viewpoint –
photographing someone from above, for
example – makes for much more dynamic
portraits.

Tony Heywood. The Water Gardens, London,
England. Nikon F90X with 80-400mm zoom lens.
Fuji Velvia ISO 50, 1/250 second @ f8.

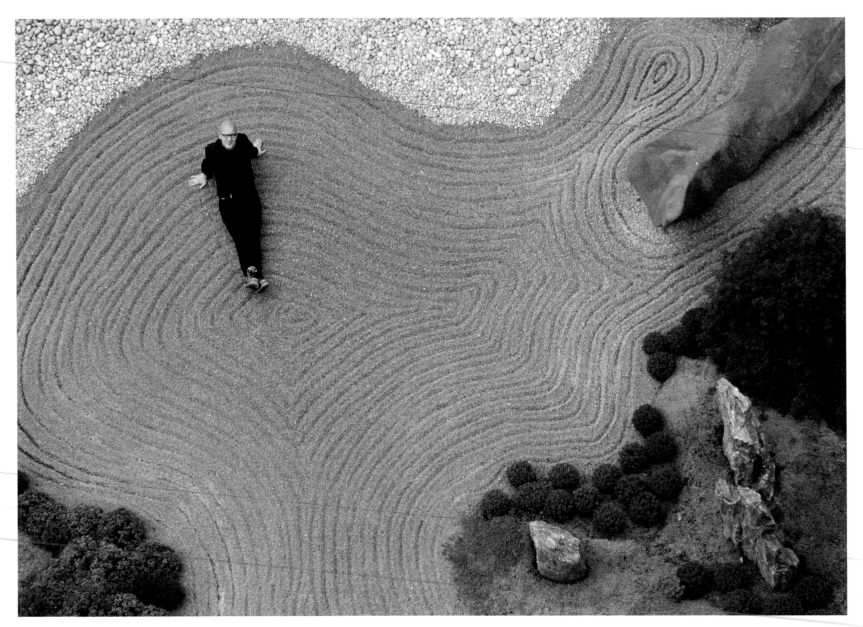

Humour and candids

Sometimes I like to add a sense of humour to my people pictures. These can be staged shots, like the overhead view of Tony Heywood reclining in one of his Japanese-style gardens, or found by chance, like the image above of Russian ladies perched on the back of a bench in a Russian park. The key to their success is that they evoke a positive response from the viewer – they make you smile or even laugh.

 Tony Heywood, opposite, is an instillation artist who combines sound garden design with an artistic flair. He was quick to suggest that I climbed to the top of a thirty-storey tower block in London in order to obtain an unusual bird's-eye view of the Japanese-style dry garden that he had recently built. To add scale and a bit of wit, we decided that he should lie down on his back and look straight up into the lens. I used a tripod to secure the camera and a zoom lens so that I could make a tight crop on the garden and shouted directions down to him so that I could place him exactly where I wanted in the frame.

 Unobserved, I approached quietly from behind to capture the amusing picture of four Russian ladies perched on a bench in Pavlovsk Park, near St Petersburg, Russia. Like peas in a pod, I shot them wrapped and huddled against the cold, a humorous image typifying daily life in the Russian winter.

Pavlovsk Park, St Petersburg, Russia. Nikon F90X with18-35mm wide-angle lens. Fuji Velvia ISO 50, 1/2 second @ f8.

Wildlife

I became much more aware of wildlife in gardens when I was asked by the publisher Frances Lincoln to illustrate Val Bourne's book, *The Natural Gardener*. Suddenly, from taking little interest in the subject, my lens started to focus on all manner of tiny creature. I soon realized that one of the secrets of successful wildlife photography is to keep your distance, so that the subject is left undisturbed. For this reason, I find zoom lenses and the longer focal length macro lenses the ideal choices for this kind of work. I now use a 180mm macro lens so that I can get tiny insects big in the frame without scaring them off. For close-up work I find that it is essential to use a tripod and I tend to use large apertures (f4, f5.6) in order to get the fastest shutter speed possible, which freezes the movement of many subjects. For larger subjects, like birds, I tend to use a 70 – 300mm zoom lens.

The ladybird, opposite, making its way along a leaf was photographed for Val Bourne's book *The Natural Gardener*. The ladybird itself is placed on the intersection of thirds to add strength to the composition, which is further improved by the arrow-like leaf cutting across the picture from top right to bottom left. Complimentary colours – the red of the ladybird against the green of the leaf, complete the composition.

Val Bourne's Garden, Oxfordshire, England. Nikon F90X with 200mm macro lens. Fuji Velvia ISO 50, 1/8 second @ f4.5.

Butterflies and insects

Butterflies and insects are particularly tricky to photograph because, unlike plants, they are nearly always on the move. As they are quite small, it is essential to use a macro lens if you want to get them large in the frame. I prefer to use a long focal length macro lens – 200mm or 180mm – as this enables me to fill the frame with subjects without being so close that they fly or jump away. Although I prefer to use manual focus for most floral subjects, I find myself switching to auto focus for butterflies and insects. This leaves me free to concentrate on capturing the subject without having to worry about focusing.

I liked the way that the golden yellow of the *Helichrysum*, above, makes the bright orange of the small tortoiseshell butterfly stand out. As the butterfly was moving around a lot, I switched my camera to auto focus and used a fast shutter speed of 1/500th second to freeze the movement of its wings.

I used a 200mm macro lens for this shot of a comma ('tatty tortoiseshell'), opposite, basking in early morning backlight. I waited for it to settle on a clump of asters that had nothing close behind that might clutter the background. I used a 200mm macro lens and opted for a shallow depth of field and a high shutter speed (1/1000 second at f4).

Overleaf, the image of a bee on *Verbena bonariensis* was shot on a misty morning, which has given the picture an almost dream-like quality. I resisted the temptation to fill the frame with the bee, but instead pulled back, using an aperture of f8 to allow nearby out-of-focus flowers to drift into the composition.

I use a macro lens with a focal length of 180mm or 200mm when photographing butterflies and insects so that I can get them fairly large in the frame without getting so close that I disturb them.

Phoenix Perennial Plants, Hampshire, England. Digital image. Canon IDs Mark II with 180mm macro lens. ISO 100 Raw, 1/30 second @ f8.

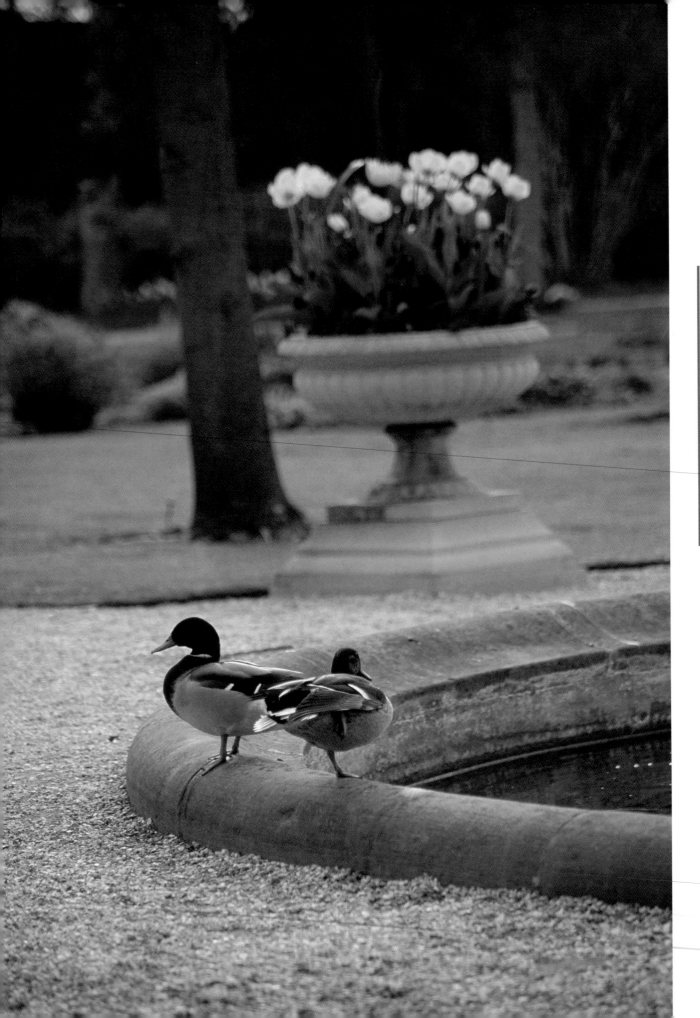

It is almost impossible to photograph birds with anything other than a zoom lens with a focal length greater than 200mm. Moving slowly and making as little noise as possible also reduces the danger that they will fly off before I have pressed the shutter release.

The University of Oxford Botanic Garden, Oxford, England. Nikon F90X with 80-400mm zoom lens Fuji Velvia ISO 50, 1/15 second @ f11.

Birds

Birds, though colourful additions to our gardens, are a nightmare to photograph as they are easily disturbed and often on the move. Also, many bird images taken in gardens look the same – most photographers use a birdfeeder to attract their subjects and simply photograph the birds as they are feeding. A much better approach, in my opinion, is to photograph birds in their natural setting, where they appear slightly more at ease.

The wood pigeon, above, perched on a garden fence, was easy to photograph as it was trying to keep warm, fluffing itself up against the cold weather. I took the picture just after dawn on a misty autumn morning at Pettifers Garden in Oxfordshire, making sure that I was shooting towards the sun.

The two ducks at the Oxford Botanic Garden, opposite, were really enjoying themselves and were completely oblivious to my presence. I used a zoom lens so as to maintain a good distance from them and I was careful to include an urn full of tulips in the background, which gives balance and scale to the composition.

Pettifers Garden Oxfordshire, England. Nikon F90X with 80-400mm zoom lens. Fuji Velvia ISO 50, 1/2 second @ f5.6.

Digital darkroom

In the past year digital capture and the scanning of transparencies for manipulation in Photoshop has transformed my photography, allowing me to become more creative and exert greater artistic control over the look of my finished work. Whilst I am not someone to whom complex computer maneuvres come naturally, I am amazed at the ease with which even I can have such creative fun, post-capture. The sophistication of Photoshop means that many previously highly skilled darkroom techniques like duotoning and sepia toning are now just a few mouse clicks away. Through trial and error, I have learnt to experiment and not to worry about making mistakes. Over the next few pages I will show you some examples of images that I feel have been enhanced post-production and the techniques that I have used to achieve these improvements.

Anthriscus sylvestris. Hedgerow near Banbury, Northamptonshire, England. Digital image. Canon IDs Mark II with 180mm macro lens. ISO 100 Raw, 1/15 second @ f8.

When shooting digitally I always shoot in RAW mode for ultimate quality. A raw file is the equivalent of a digital negative.

Digital workflow

Veddw House, Gwent, Wales. Digital image. Canon IDs Mark II with 75-300mm zoom lens. ISO 100 Raw, 1/8 second @ f32.

In the spring of 2005 I was asked by a fellow garden photographer if I would ever seriously consider switching from film to digital capture. My answer was a resounding 'Never'. But here I am, two years later, shooting only digital images – and I have to say that I am loving it! Digital imaging now allows me to view a picture immediately after I have taken it, something that was never possible with film. A quick check of the histogram means that I no longer have to bracket exposures – so I am able to take a picture and move on to the next one more quickly than I ever could with film. Digital photography, however, is not as simple as many people make it out to be. Yes, you do save on film purchase and processing, but with digital imaging I now have to do all the processing myself, which takes far more time than simply dropping some rolls of film down to the photo lab. Add to this the complexity that the new digital technology brings and you can see why the last two years has been a sharp learning curve for me.

I still have over 30,000 transparencies in my photo-library, even though I have now switched completely to digital capture, and I am currently in the process of scanning these transparencies so that they can be displayed on my website and used for reproduction in magazines, books and calendars etc. I use an Imacon Flextight 949 scanner which produces repro quality 60 megabyte tiffs direct from transparencies.

After downloading the files from my flash card onto the computer and opening them in the Adobe Raw Converter, I make basic changes to the contrast, brightness and shadows, before opening the image in Photoshop and, if needed, I will then fine tune the image using the Levels and Curves controls to lighten or darken the image. Next, I blow the image up on screen to 100% magnification (Ctrl, Alt and 0) and look for dust spots. If they are present I'll use the Clone Tool and the Healing Brush to remove them. Finally, I apply the M5oo Velvia setting, mainly to boost the greens, before interpolating the file up to 60 megabytes using Photoshop's Bicubic smoother and saving the file as a TIFF (Tagged Image File Format).

As above left, after digital manipulation.

Simple digital imaging techniques, which take only a few minutes on the computer, can be used to simulate the effect of traditional sepia toning which might have taken a whole day and involved harmful chemicals.

Above: *Rodgersia pinnata* 'Elegans'. Hadspen Garden, Somerset, England. Olympus OM2 with 90mm macro lens. Fuji Velvia ISO 50, 1/250 second f8.

Opposite: As above, after digital manipulation.

Toning

Sepia toning is a technique for processing monochrome photographic images so that the picture appears in shades of brown. Invented in the 1880's, sepia was first produced by adding the reddish brown pigment made from the sepia cuttlefish to the positive print of a photograph. Today, it is easily possible to replicate the look and feel of sepia in Photoshop. To convert this backlit *Rodgersia* leaf into sepia tone I opened the original, untouched photo (top left) in Photoshop. To add some texture I then clicked Filter > Sketch > Graphic Pen and set the stroke length at 15, the Light/Dark Balance to 57 and then pressed OK. Next I clicked Image > Mode > Grayscale and clicked OK to the command 'Discard Color Information'. I then clicked Image > Mode > RGB Color, then Image Adjustments > Hue > Saturation. I moved the Hue slider to 13, the Saturation slider to 25 and then darkened the image by setting the Lightness slider to −42.

 I felt that the strong, simple form of the frost dusted umbellifer (on page 143) could be accentuated by turning the original colour image into a duotone. I opened the picture in Photoshop, clicked on Image > Mode > Grayscale and pressed OK to the command 'Discard color information'. I then clicked Image > Mode > Duotone, clicked on the Ink 2 box in the Duotone Options and selected Pantone pastel coated from the Color Libraries Book. I then chose Pantone blue 0821c, clicked OK and then OK again in the Duotone Options Box.

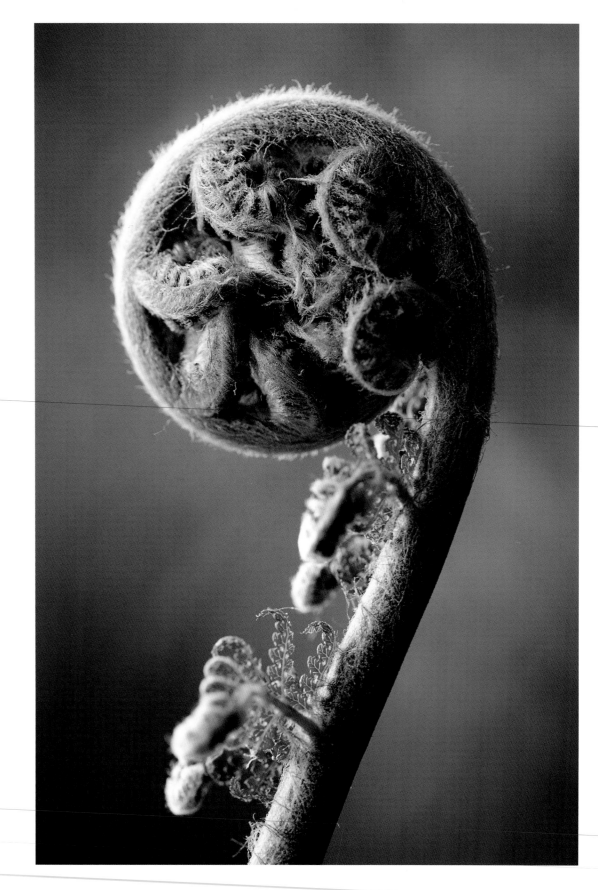

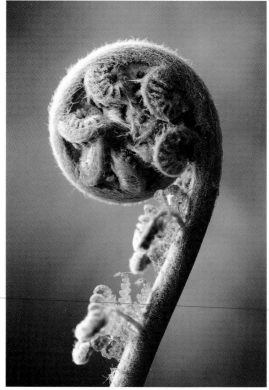

Above: *Dicksonia antarctica*. Royal Botanic Gardens, Kew, England. Digital image. Canon 1Ds Mark II with 180mm macro lens. ISO 100 Raw, 1/30 second @ f4.5.

Left: As above, after digital manipulation.

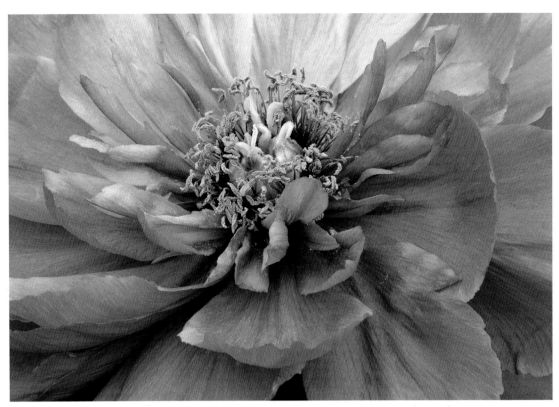

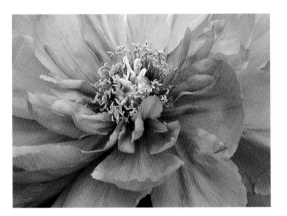

Altering colour

One of the easiest ways to change the overall feel of an image in Photoshop is to use the Hue/Saturation sliders to increase or reduce the amount of colour in the picture. For example, desaturated images have a timeless quality that is particularly suited to certain subjects. Take the stunning pink peony, above, for example. I felt the original smaller picture, taken at the Chelsea Flower Show, was rather too colourful and gaudy, so I opened the image in Photoshop and clicked Image > Adjustments > Brightness/Contrast. I then moved the Contrast slider to +20 and then clicked OK. Next I clicked Image > Adjustments > Hue/Saturation and moved the Saturation slider to the left, desaturating the image until it looked right – in this instance –75. Finally, I clicked OK and saved the image as a tiff file. The final image is a vast improvement on the original. The internal filaments of the flower appear more brittle and prominent because the eye is less aware of the strong pink colour of the original shot. The petals, too, have assumed a quite different demeanour, becoming softer and crumpled, fragile with the patina of age, not unlike the natural appearance of an ageing peony that has lost its shine.

The form and texture of this unfurling fern (opposite) became more prominent when I changed the colour saturation and tone of the original picture. I followed the same steps as above, increasing the contrast on this occasion by +20 and desaturating the image to –92. However, I also changed the Hue to +160 and this has given the image a slightly bluish feel which I felt worked well with the subject.

Above left: *Paeonia suffruticosa* 'Duchess of Kent'. Chelsea Flower Show 2006, London, England. Digital image. Canon IDs Mark II with 180mm macro lens. ISO 100 Raw, I second @ fl6.

Above right: As above left, after digital manipulation.

Sometimes I jump up and down with my camera whilst pressing the shutter. This results in a blurred image not dissimilar to that produced with the blur filter in Photoshop.

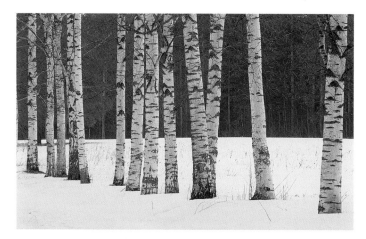

Above: Pavlovsk Park, St Petersburg, Russia. Digital image. Canon 1Ds Mark II with 75-300mm zoom lens. ISO 100 Raw, 1/4 second @ f16.

Right: As above, after digital manipulation.

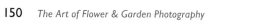

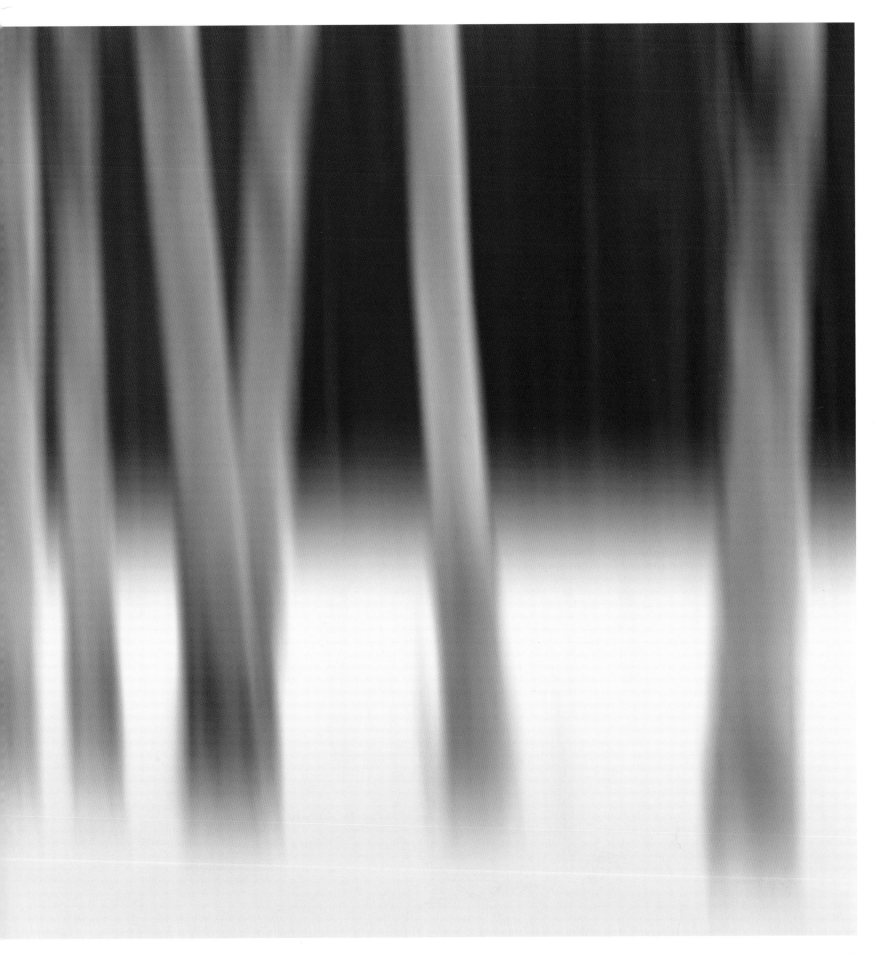

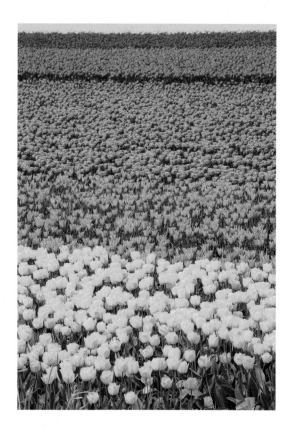

I look beyond gardens and flowers for inspiration. The work of artists such as Mark Rothko and Howard Hodgkin has encouraged me to produce images which are more artistic and abstract than most conventional horticultural photography.

Blurring

Holland in springtime is famous for its bulb fields. One bright, overcast morning I was driving to the Keukenhof Gardens when I was stopped in my tracks by one particular field that was planted with strips of yellow, orange, pink and red tulips. I parked my car and used a zoom lens to crop into the scene (top right). When I got back home and looked at the photograph on the computer, I decided to make an abstract image from it. Inspired by the paintings of Howard Hodgkin, I opened the picture in Photoshop CS2 and used box blur (Image > Blur > Box Blur) setting a radius of 204 pixels. The resulting image is more like a piece of modern art than a photograph, exactly the effect that I wanted to achieve.

I took the snowy image of birches at Pavlovsk Park in Russia (previous spread) whilst on commission for a magazine. Although the original transparency of the birch avenue is a strong image, I felt it could be given more atmosphere when scanned into Photoshop and digitally enhanced. I started by increasing the contrast a little (Image > Adjust > Contrast) and then used Filter > Blur > Motion Blur, setting the angle of blur at 90 degrees. I then moved the Distance slider until I achieved the desired amount of blur, which in this case turned out to be 724 pixels. The final, ghostly image has a more haunting atmosphere than the original 'straight' shot.

Above: Tulip field. The Netherlands. Digital image. Canon 1Ds Mark II with 75-300mm zoom lens. ISO 100 Raw, 1/4 second @ f32.

Opposite: As above, after digital manipulation.

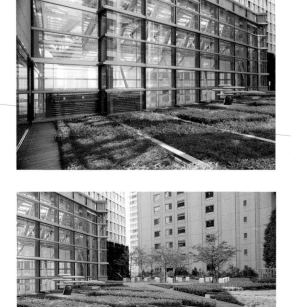

Photo-stitching

Marunouchi Hotel, Tokyo, Japan. Digital images. Canon 1Ds Mark II with 24mm wide-angle shift lens. lens. ISO 100 Raw, 1 second @ f16.

It is easy to produce panoramic pictures on the computer. The key is to use a specialist shift lens mounted firmly on a tripod. Here I used a 24mm f3.5L wide-angle shift lens to produce this digital panoramic view of a hotel garden in Tokyo, Japan. I set the camera on a tripod then shifted the lens as far to the left as it would go (above left). Without moving the camera, I then shifted the lens as far as it would go to the right (below left). To create the panorama, I opened both images in Photoshop and clicked Image > Automate > Photomerge. Finally I highlighted the two images that I wanted to merge and clicked OK and then OK again. The final image is a perfect photo-stitch without any manual retouching.

The two images on the left stitched together
on computer.

Contacts and websites

Flower and garden photo libraries

www.flowerphotos.com
Photo library specializing in beautiful images of plants.

www.gardenpicture.com
Part of the Photo Library Group. Photo library specializing in all things horticultural.

www.gpauk.org
The Garden Photographers Association website showcasing the work of over 100 professional garden photographers including Andrea Jones, Nicola Browne, John Glover and Marianne Majerus.

www.gapphotos.com
Photo library specializing in high quality plant and garden photography.

www.gardenworldimages.com
Probably the largest horticultural picture library in the world with over one million pictures.

www.garden-collection.com
Features the work of many of Britain's leading garden photographers including Andrew Lawson, Derek Harris and Jonathan Buckley.

RHS gardens

RHS Garden Hyde Hall
Hyde Hall, Rettendon, Chelmsford, Essex, CM3 8ET
Tel: +44 (0)1245 400256

RHS Garden Rosemoor
Rosemoor, Great Torrington, North Devon EX38 8PH
Tel: +44 (0)1805 624067

RHS Garden Harlow Carr
Crag Lane, Harrogate, North Yorkshire, HG3 1QB
Tel: +44 (0)1423 565418

RHS Garden Wisley
Woking, Surrey, GU23 6QB
Tel: +44 (0)845 2609000

Photographers

www.howardschatz.com
Howard Schatz's floral photography is unique. His images of flowers and leaves in his book *Botanica* are a visual feast, appearing to glow from within with colour and light.

www.ronvandongen.com
Simplicity is the key to Ron Van Dongen's beautiful plant studies in both colour and black and white. He is the modern day Karl Blossfeldt.

www.suebishop.co.uk
Sue Bishop's exquisite images of flowers blur the boundaries between photography and art. She is the author of *Photographing Flowers*.

www.andrewlawson.com
Andrew Lawson is one of Britain's best known garden photographers with over 200,000 images in his photo library.

www.harpurgardenlibrary.com
Jerry Harpur has photographed more gardens around the world than anyone else. He has contributed to over 300 books and in 2001 he was given the prestigious 'Lifetime Achievement Award' by the Garden Writers' Guild.

www.clivenichols.com
My own personal website.

Competitions

www.take-a-view.co.uk
Landscape Photographer of the Year.

www.rhs.org.uk/news/photocomp.asp
Annual Photographic competition held by the Royal Horticultural Society.

www.gpoty.org
Garden Photographer of the Year competition.

Weather

www.weather.com
Very good for international weather. Ten-day forecasts are surprisingly accurate.

www.bbc.co.uk/weather
Superb forecast gives 5-day and 24-hour weather forecasts for British locations. Very reliable. Very good for wind speeds as well. I use this website all the time.

www.sunrisesunset.com
Gives sunrise and sunset times for many cities around the world.

www.windguru.cz
Amazing windsurfers website which gives very accurate wind speeds around the world.

www.metcheck.com
Again, good on wind speeds but only UK.

Books

Adam, Hans Christian, *Karl Blossfeldt*
Taschen, 1999. ISBN 3 8228 7438 8.
The best book ever published on the work of this amazing photographer. Stunning black and white images of plants.

Bishop, Sue, *Photographing Flowers*
Photographers' Institute Press, 2004. ISBN 1 86108 366 1.
Very artistic book with emphasis on macro photography.

New Views: *International Garden and Plant Photography*
Third Millenium Publishing, 2004. ISBN 1 903942 36 5.
100 horticultural images from around the world taken by members of the Garden Photographers Association.

Nichols, Clive, *New Shoots*
New Shoots Ltd, 2000. ISBN 0 9538318 0 9.
Inspirational graphic close ups of plants.

Nichols, Clive, *Photographing Plants & Gardens*
David & Charles, 1994. ISBN 0 7153 0715 0.
My first photography book – strong on technique but nothing on digital.

Patterson, Freeman, *The Garden*
Key Porter Books, 2003 ISBN 0 5263 517 1.
Patterson feels deeply about the environment and this beautiful book on his own garden in New Brunswick is a visual feast.

Rokach, Allen and Millman, Anne, *Focus on Flowers: Discovering and Photographing Beauty in Gardens and Wild Places*
Abbeville Press, 1990. ISBN 1 55859 066 8.
A superb book which deals with every aspect of horticultural photography. The best guide to the subject although it was unfortunately published too early to contain anything on digital photography.

Schatz, Howard, *Botanica*
Bulfinch Press, 2005. ISBN 0 8212 6173 8.
Stunning close up images of plants with rich detail and startling colours

Index

I dedicate this book to the memory of my mother, Margaret.

I would like to thank all the people who have been involved in the production of this book: My wife Jane, for putting up with my ego! Jacky Hobbs and Eluned Price, for help with the text for the book. Allan Pollock-Morris for the author photograph. Amanda Patton for the colour wheel. Anne Jennings and Julie Kelly, for scanning and artistic insights: Stephen Johnson, for his immense knowledge of all things technical: Susannah Charlton and Simon Maughan at the Royal Horticultural Society for supporting the book and finally, Eddie Ephraums and Piers Burnett at Argentum for their trust and patience.

I would also like to thank all the garden owners and organizations featured in this book for allowing me to spend long hours in their gardens. Without their support this book could never have been produced and I would have had to follow a very different career path.